IMAGES
of America

OCEAN CITY
BABY PARADE

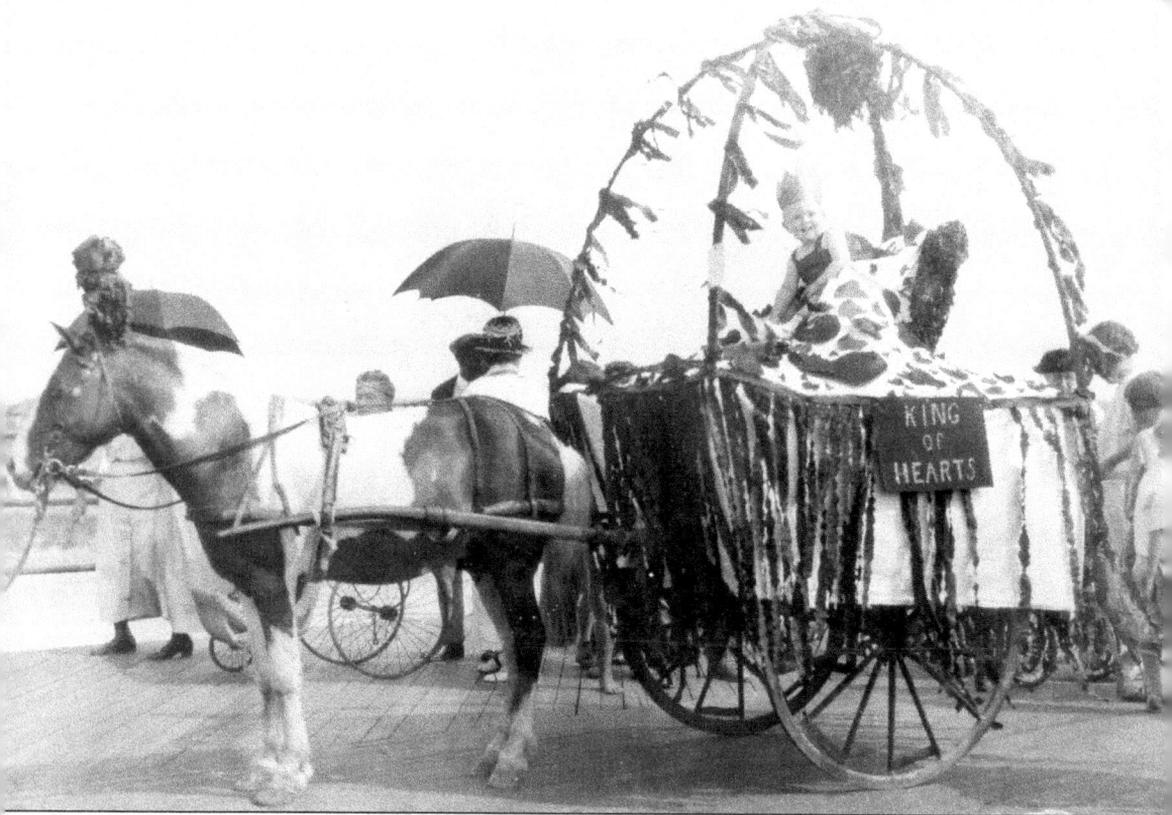

One-and-a-half-year-old I. Scott Johnson Jr. is "King of Hearts." Johnson is riding in his pony cart during the August 13, 1924, baby parade. By August 10, almost 100 children were entered in the parade, some from as far away as Florida. Small floats and several bands also participated. There were separate divisions for judging the children and the floats. One of the children's divisions was pony carts. (Courtesy of Mrs. I. Scott Johnson Jr.)

On the cover: August 18 was the date of the 1955 Ocean City Baby Parade. Over 200 children were entered. Mothers, older sisters, or friends accompanied the children. Mary Louise Hayes is the first in line in this photograph. Family friend Joyce Caruno escorts Hayes. Next in line are twins Bobby and Gerry Longwell pushed by their mother, Doris Longwell. The Commuters Club sponsored the parade. Twenty-five local women, both year-round and summer residents, served as judges. (Courtesy of Mary Louise Hayes.)

IMAGES
of America

OCEAN CITY BABY PARADE

Fred and Susan Miller

ARCADIA
PUBLISHING

Copyright © 2009 by Fred and Susan Miller
ISBN 978-1-5316-4254-9

Published by Arcadia Publishing
Charleston SC, Chicago IL, Portsmouth NH, San Francisco CA

Library of Congress Control Number: 2008942596

For all general information contact Arcadia Publishing at:
Telephone 843-853-2070
Fax 843-853-0044
E-mail sales@arcadiapublishing.com
For customer service and orders:
Toll-Free 1-888-313-2665

Visit us on the Internet at www.arcadiapublishing.com

*This book is dedicated to all of the volunteers who, through the years,
worked to make the Ocean City Baby Parade the best in the world.*

CONTENTS

ACKNOWLEDGMENTS

We want to thank Stu Sirott for his technical know-how and hard work and Susan's sister and brother-in-law, Joan and Allan Okin, for their editing help. The Ocean City Historical Museum (OCHM) has graciously provided many of the pictures used in this book. Unless otherwise noted, all other images come from the collection of the authors.

Mark Soifer, director of public relations for Ocean City, has provided pictures, knowledge, and encouragement. Don Kravitz, Ocean City's official photographer, has taken and generously lent many of the later photographs, as has Dave Nahan, editor and photographer of the *Ocean City Sentinel*. Jane French has kindly shared many pictures from her years helping with the baby parade. Priscilla Parker has shared pictures and information. Friends and acquaintances have also supplied pictures. We are grateful to each of them for making this book such a pleasure to write.

INTRODUCTION

The Ocean City Baby Parade can be traced back to August 10, 1901, and Ocean City's First Baby Show. Except for the years in the early 1900s, the infantile paralysis epidemic of 1916, and the years during the two world wars, the event has been held every year since 1901, making it the longest running baby parade in the country. It has been held continuously since 1946.

In 1901, Frank E. Darby and Col. John Glaspell decided that what was missing in Ocean City was a way to showcase the many beautiful babies who lived or summered here. Since Glaspell managed the Casino Pier on the boardwalk, the men decided the pier would be the perfect place to hold Ocean City's First Baby Show. With the support of other prominent citizens, the baby show was advertised. So many inquiries poured in to Glaspell that he appointed a committee, headquartered at Chalfant's Pharmacy, to dispense information on the show.

Forty-six babies were entered in the show, with gold medals as prizes given for prettiest, cutest, and fattest baby. Each of the spectators was given one ballot and allowed to vote for one child in each category. The judge of elections was Jerry Neill, a member of Philadelphia's common council and a guest at the Strand Hotel. According to the *Ocean City Daily Reporter*, it was "the greatest attraction that has yet been provided for summer visitors."

The baby show was held annually through 1904. Although it was successful, growing larger each year, by 1905, those in charge had tired of it, and the baby show ended. It was not until 1909 that Leo Bamberger, a summer resident from Philadelphia, resurrected the baby show as the Ocean City Baby Parade.

Although Bamberger was able to get Lit Brothers and Strawbridge and Clothier, two Philadelphia department stores, to donate loving cups for prizes, the 1909 Ocean City Baby Parade had only a small number of entrants. The children had fun parading down the boardwalk wearing paper hats, tooting toy horns, and carrying paper flags. This parade only hinted at the lavish displays the Ocean City Baby Parade would have in later years.

Wildwood also held its first baby parade in 1909. A good-natured dispute, run mostly by the public relations directors of Ocean City and Wildwood, takes place every year, weeks before the parades are held, about which city actually does have the longest continuously held baby parade.

Mark Soifer, Ocean City's longtime public relations director, answered that question pretty conclusively in an article he wrote in August 2008 for the *Ocean City Gazette*. In the article, Soifer claimed that Ocean City's baby parade was actually started by the Lenni-Lenape tribe who populated the area in the 1700s. According to Soifer,

> While the men were out fishing, hunting, and gathering shells for their flourishing costume jewelry business, the women grew restless. Cooking and cleaning tepees was not enough to keep them occupied. In a burst of creativity, they decided to start the first annual Papoose

Parade and Diaper Changing Competition to show off their little ones. The diaper changing portion of the competition proved rather messy and was soon fazed out, but the grand tradition of showing off babies continues today.

Within a few years, Ocean City's First Baby Show evolved into what it remains today: a baby parade like no other. Ocean City's Queen Infanta rules over the parade. At a gala celebration, usually held the evening before the parade in Ocean City's famed Music Pier, the queen and her court are crowned. These young women, beautifully dressed, ride down the parade route on an extravagantly decorated float, with Queen Infanta on her throne. Members of the Ocean City Beach Patrol, in uniform, accompany the float down the boardwalk, as they have for all the years of the parade.

An article in the August 31, 1929, issue of the New York Times stated, "Thousands lined Ocean City's Boardwalk . . . to view the annual Baby Parade. Children from two years old up to thirteen were in the parade, headed by city officials. Lifeguards escorted Queen Infanta, Miss Irene Ahlverg of New York, who was crowned last night."

Evelyn and Russell Hanscom are credited with restarting the baby parade after World War II and were in charge until 1979 when they retired from the event. Their son Russell Hanscom Jr. continues to help with the parade, and the coveted Hanscom Award, in honor of the Hanscoms, is given each year. There is often a Hanscom grandchild or great-grandchild in the parade.

Priscilla Parker took over the parade when the Hanscoms retired. Although she was only in charge a few years, it was under her leadership that many more commercial floats were added, and she brought cartoon characters such as Miss Piggy and Mr. Peanut to the parade. Dutch and Doris Dalhausen took over the direction of the parade from Parker and ran it for many years. Both couples and Parker built the baby parade into the spectacular event it is today. Although the Dalhausens are no longer active in the parade, their son Bob still volunteers, and each year he is on the boardwalk at the start of the parade gently guiding the contestants, bands, and floats into line.

For many years, local civic organizations sponsored and ran the parade. The Commuters Club, a group of men who commuted during the summer from Philadelphia to their families in Ocean City; the Ocean City Hotel Keepers' Association; the board of trade; the Young Men's Progressive League; and the Ocean City Fishing Club were some of the organizations. The judges were groups of 25 or 30 women, invited by the sponsors, who volunteered their services. Today the city sponsors the event, but many volunteers still organize and help on parade day.

Each year, a different grand marshal of the baby parade is named, including famed baseball player Joe DiMaggio, who drew a record crowd of 100,000 spectators to the parade; former area resident and actress Marla Adams, star of the television soap opera the Secret Storm; former congressman and ambassador to Panama William J. Hughes; and television personality Don Tollefson. Television legend Sally Starr and children's television show host Captain Noah were also grand marshals, as was the Philadelphia baseball team's mascot, the Phillie Phanatic.

Honored guests at the parade have included New Jersey governor Jim Florio, former Miss America Bess Myerson, and Jack Kelly. Kelly, a summer resident and former member of the Ocean City Beach Patrol, gained world fame when he won the Diamond Sculls event of the Royal Henley Regatta in England, the premier sculls rowing event in the world. When he was honored, he brought along his sister Grace. She became the award-winning actress Grace Kelly and, later, the princess of Monaco when she married Prince Rainier.

In the beginning, babies in costumes or decorated carriages made up the parade, but through the years, floats and bands have joined the fun. Many of the floats are handmade, often ferrying several children at a time, pulled by a strong dad, uncle, or older brother.

The baby parade has always reflected what is going on in the country and the world. During the Great Depression, many of the children's floats and costumes echoed the economic concerns of the day. When the parade was first held after World War II, peace was a common motif. Later the country's bicentennial was one of the topics in the parade of 1976.

Even the history of the city once called Peck's Beach has played a part with one early entry called "Peck's Beach or Bust." Since the Lenni-Lenapes were early inhabitants of the area, children's floats have frequently had a Native American theme with tepees and children dressed in Native American outfits. Ocean City's 1954 diamond jubilee was the subject of many of the children's floats during that year's parade.

Popular movies and movie stars, songs of the day, advertisements, and stories have all served to spark the creativity of the parents, grandparents, or friends who plan and make the costumes and floats for the children. All of them are proud of their entries, whether they win a prize or not.

Local merchants and organizations later added commercial floats to the event. Ocean City resident Phil Turner, owner of Phillip Turner Individualized Decorations, made many of them. Turner not only made floats for Ocean City's baby parade and other Ocean City events, but he went on to make floats for the Miss America pageant and then for the presidential inaugural parades of John F. Kennedy and Lyndon Johnson. Blondie Brasberger, owner of Blondie's Floats on Parade, and her daughter Stacey have made many of the commercial floats over the past 15 years.

Bands make up an eagerly anticipated part of the parade as well. School bands march proudly down the boardwalk, as does the renowned Hobo Band. Philadelphia Mummers string bands often take part. The bands are interspersed among the different divisions so music is now an integral part of the parade.

Ocean City's baby parade continues to draw a large number of entrants and spectators. In 2008, there were almost 300 babies and young children entered, as well as several marching bands and commercial floats. The parade, which is staged in the sports and civic center off the boardwalk, comes up the ramp to the boardwalk at Sixth Street and continues south on the boardwalk to Twelfth Street. The judging stand is in front of the Music Pier between Eighth Street and Ninth Street. Prizes are awarded immediately after the parade at the pier, and every child who participates receives a small trophy. In addition, the Bamberger Founders Award is given each year. Spectators, numbering well into the thousands, line both sides of the boardwalk from Sixth to Twelfth Streets.

With its slogan of "America's Greatest Family Resort" and its world-famous boardwalk as the venue, Ocean City is the perfect place for a baby parade. If you have been to a baby parade, or even if you have not, come enjoy the memories or see what you have been missing. After all, it is not too late to enjoy the grandest baby parade of them all—the one in Ocean City.

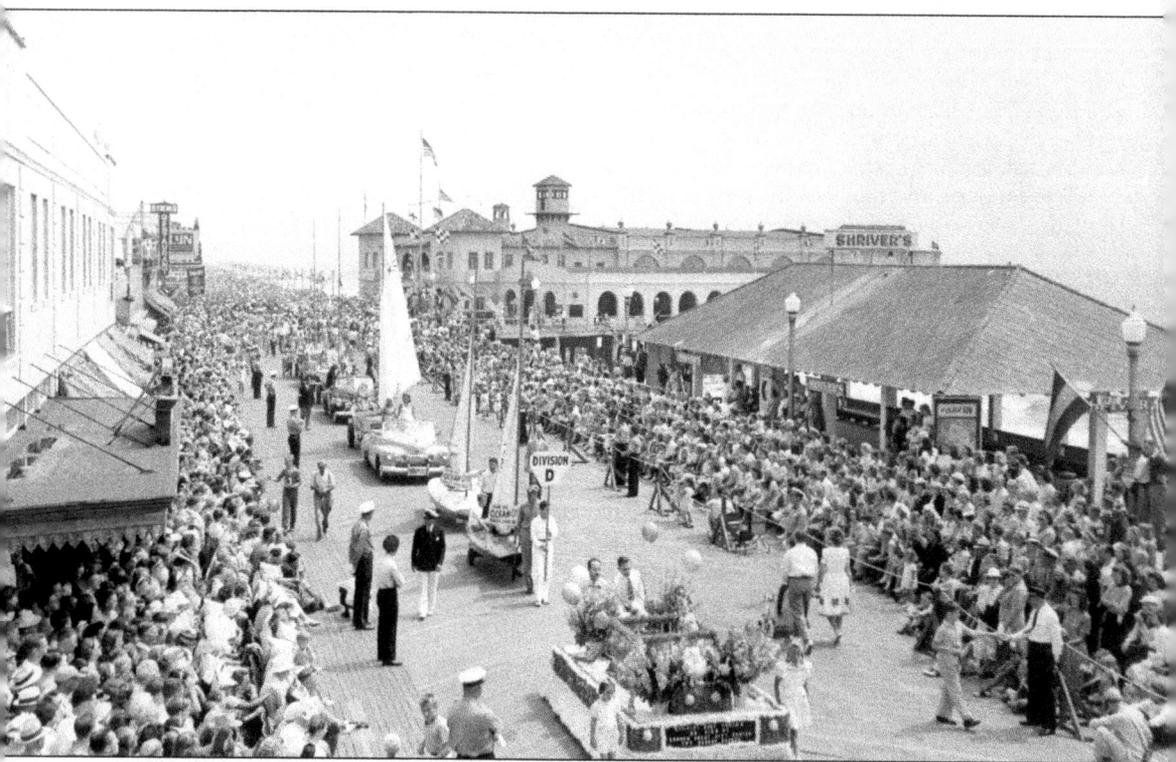

The August 14, 1946, baby parade was part of the biggest one-day celebration in the history of the resort, honoring the first anniversary of V-J Day. Philadelphia Day was also part of the festivities, a day to celebrate Ocean City's close ties to nearby Philadelphia. This float, with a baby in a decorated playpen, leads off the parade. The Ocean City Yacht Club was a proud participant, with three sailboats in the parade. Sailboat and speedboat races were scheduled as part of the afternoon's entertainment, and they were to take place on the Great Egg Harbor Bay in front of the yacht club. Thousands of people lined the boardwalk for this first baby parade since 1942. (Courtesy of Russell Hanscom.)

One

Baby Steps

Showcasing beautiful, cute, chubby, and adorable babies has long been a summer tradition at the Jersey Shore. Asbury Park held what was the earliest baby parade in New Jersey on July 22, 1890, with a band accompanying the marchers, Queen Titania and her court as judges, and a grand prize of a deluxe baby coach. The babies were judged on their costumes and the decorations on their coaches.

Soon to follow was Ocean City's First Baby Show, held on August 10, 1901. This baby show had three divisions: cutest, fattest, and prettiest baby. Forty-six mothers thought they had the cutest, fattest, or prettiest baby. The baby show continued as an annual event through 1904. In 1909, Ocean City held its first baby parade. This was a modest affair with children marching down the boardwalk in paper hats waving paper flags. Each succeeding year, the parade got bigger, the number of entrants larger, and the decorations more elaborate.

Wildwood also held its first baby parade in 1909 and to this day vies with Ocean City as to which town has the oldest parade. Queen Oceania and her court rule over Wildwood's baby parade, helping to choose the winning entrants. Sea Isle City, seeing the success of its neighbors to the north and south, had its first baby parade in 1916. Cape May, not wanting to be outdone by the other, newer resorts, had what it billed as a juvenile jubilee and baby parade in 1928. The juvenile jubilee part of the event gave older children the opportunity to participate, to wear costumes, and to march in the parade. Cape May had Queen Maysea and her court riding on a float down the parade route.

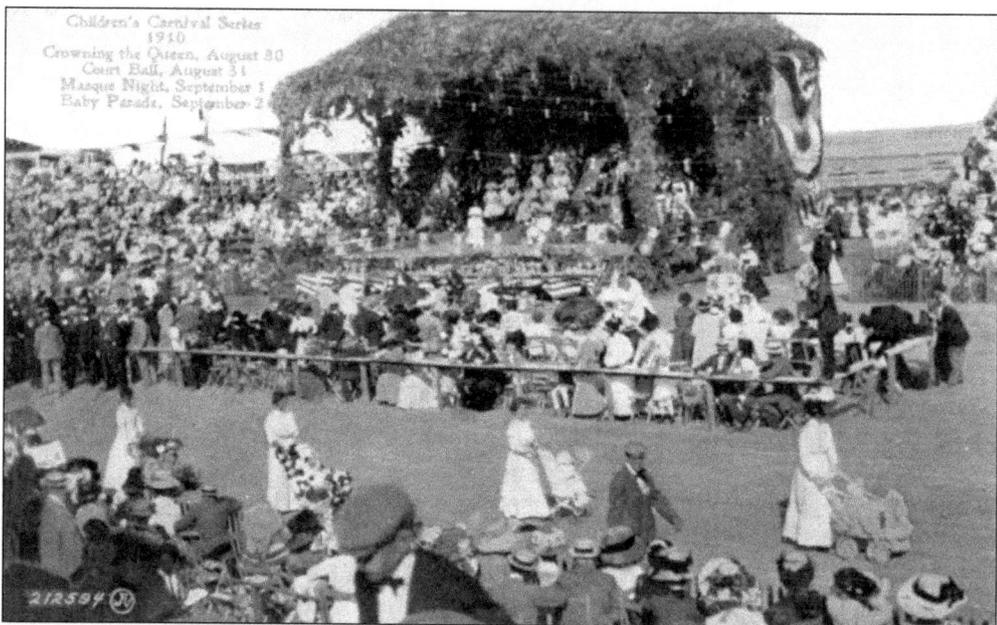

Asbury Park held its first baby parade on July 22, 1890. A band accompanied the marchers, playing tunes such as "Rock-a-Bye Baby" and "Baby Mine." The parade founders named local young women as Queen Titania and her royal court to judge the contestants. Over 100 babies were entered, competing for the grand prize of a deluxe baby coach. The judges wisely awarded the prize based on the quality of decorations and costume rather than on the beauty of the baby.

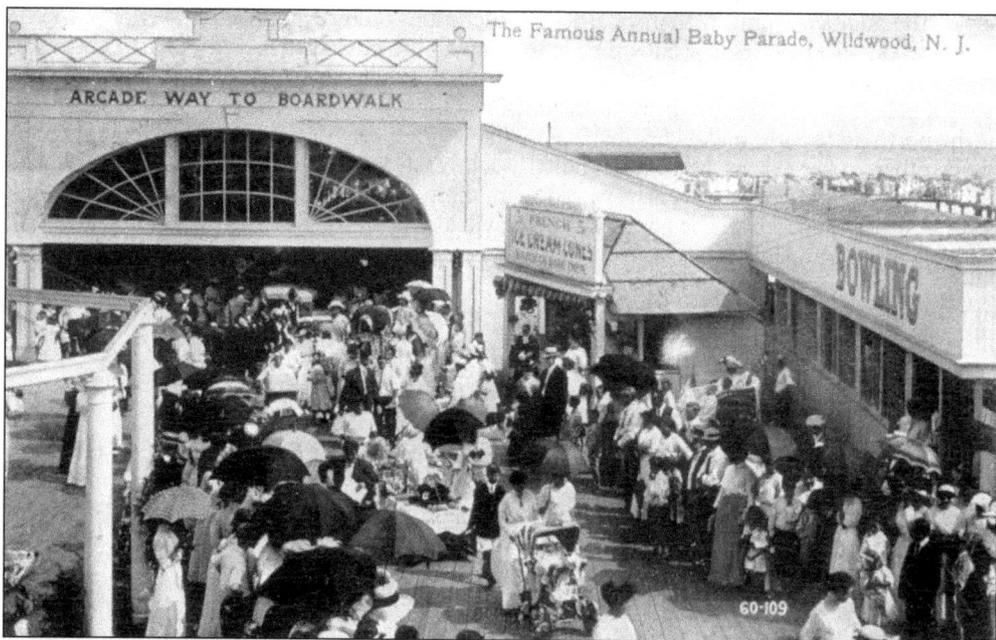

Wildwood held its first baby parade in 1909. It celebrated its 1950 parade on August 4 with 11 bands and 16 former Queen Oceanias. The oldest living Queen Oceania, Alice Hendee Stauffer, who reigned over the 1915 parade, was in attendance. The 16 former queens rode on a large decorated float accompanied by four Wildwood lifeguards.

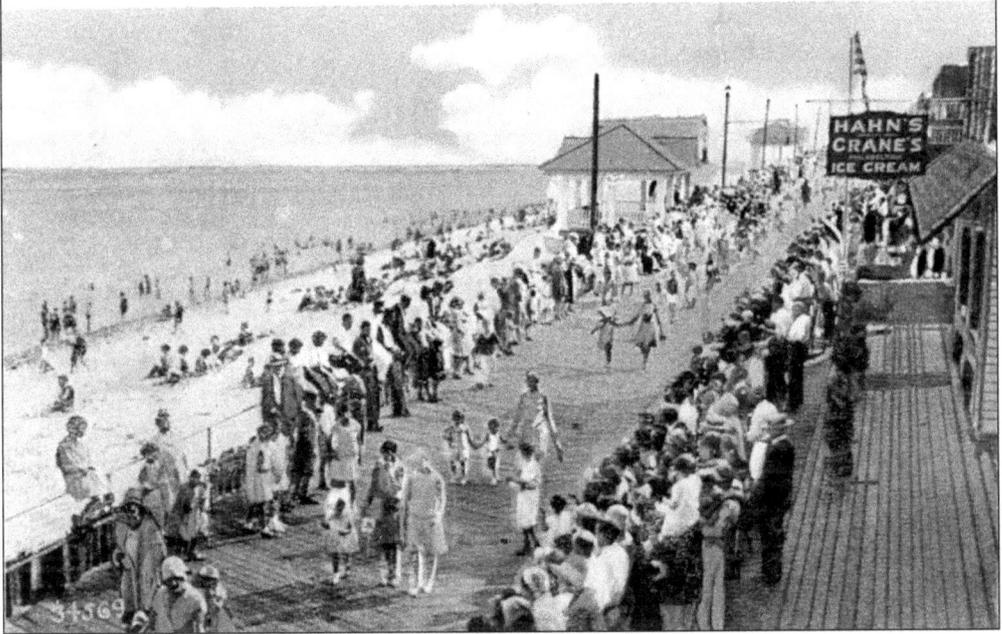

Watching the Baby Parade, Sea Isle City, N. J.

Sea Isle City held its first baby parade in 1916. The parade became a highlight of the summer season. First held on the boardwalk, the parade continues on the promenade.

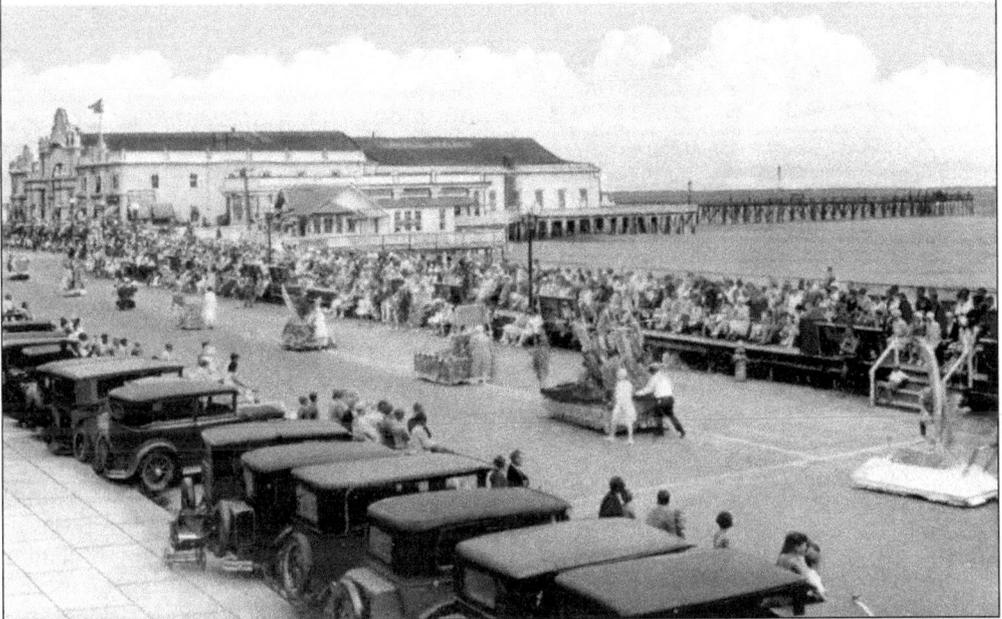

BEACH AVENUE AND BOARDWALK, CAPE MAY, N. J.

Cape May, not to be outdone by the other resorts, held its juvenile jubilee and baby parade in 1928. Bleachers for spectators were set up, and the entrants paraded down Beach Avenue. Not only for babies, the juvenile jubilee gave older children the chance to dress up and march down the parade route.

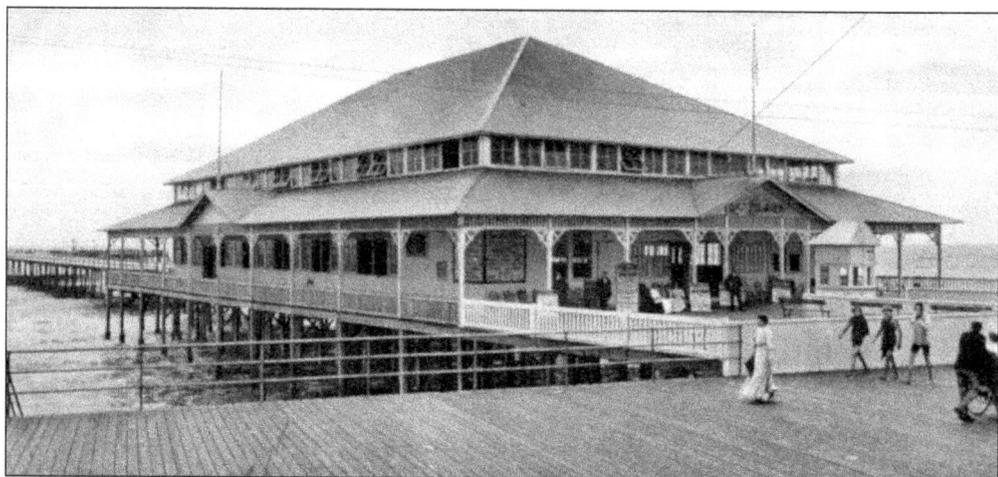

The Casino Pier on the Ocean City Boardwalk at Ninth Street was the setting in 1901 for Ocean City's First Baby Show. Led by Col. John Glaspell, manager of the Casino Pier, and Frank E. Darby, the show was a great success. Forty-six babies were entered. Prizes were awarded to Frances Bayard for prettiest baby, Richard Wilson Sooy for cutest baby, and twins Dorothy and Wilson Tibbala for fattest babies.

August 23, 1902, was the date of the second annual baby show. Posters like this were put up all over the city advertising the show. Helen Quay Chalfant, daughter of Ocean City druggist W. W. Chalfant, was declared the prettiest baby, Millard Jeffries Paul of Philadelphia was the cutest baby, and Blanch E. Murphy of Ocean City was the fattest baby. The *Ocean City Sentinel* declared it the "Largest and Most Successful Baby Show Ever Held in the City."

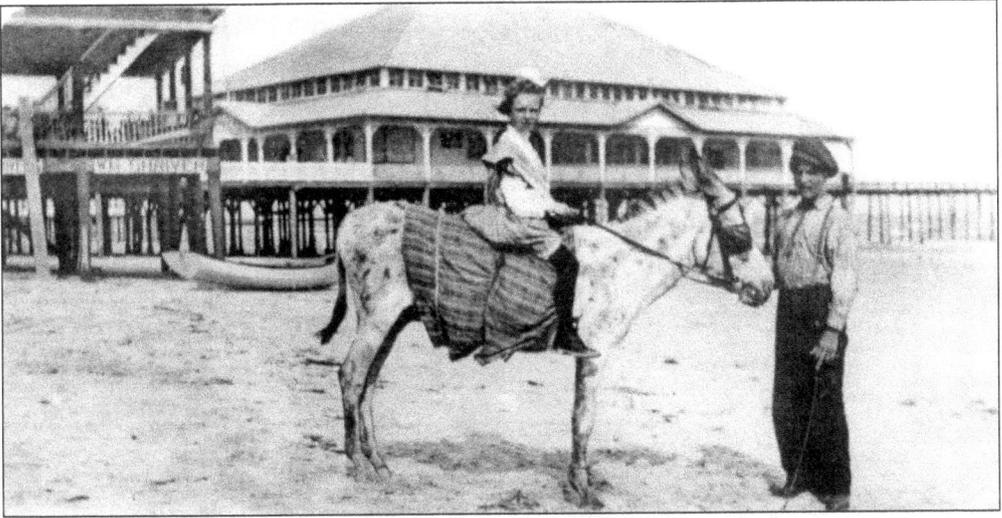

Young's Pier, in the background, was where the August 27, 1904, Ocean City Baby Show was held. John Lake Young, a member of the Lake family, Ocean City's founders, owned the pier. This little girl won a ride on a pony as her prize in the baby show.

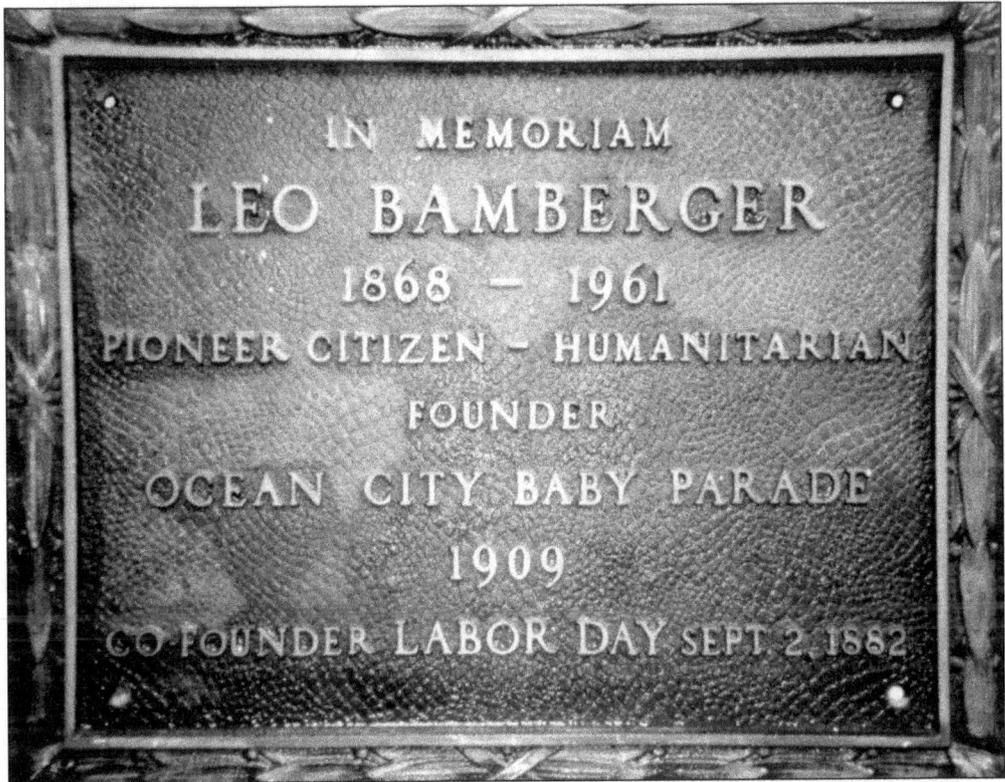

IN MEMORIAM
LEO BAMBERGER
1868 — 1961
PIONEER CITIZEN - HUMANITARIAN
FOUNDER
OCEAN CITY BABY PARADE
1909
CO-FOUNDER LABOR DAY SEPT. 2, 1882

This in memoriam plaque is on the wall of the Music Pier auditorium on the boardwalk in recognition of Leo Bamberger's service to the city. Bamberger started the Ocean City Baby Parade in 1909. Bamberger was a retired photograph engraver and printed up the first souvenir book of views of Ocean City. He was part of a group that started the movement to make Labor Day a national holiday.

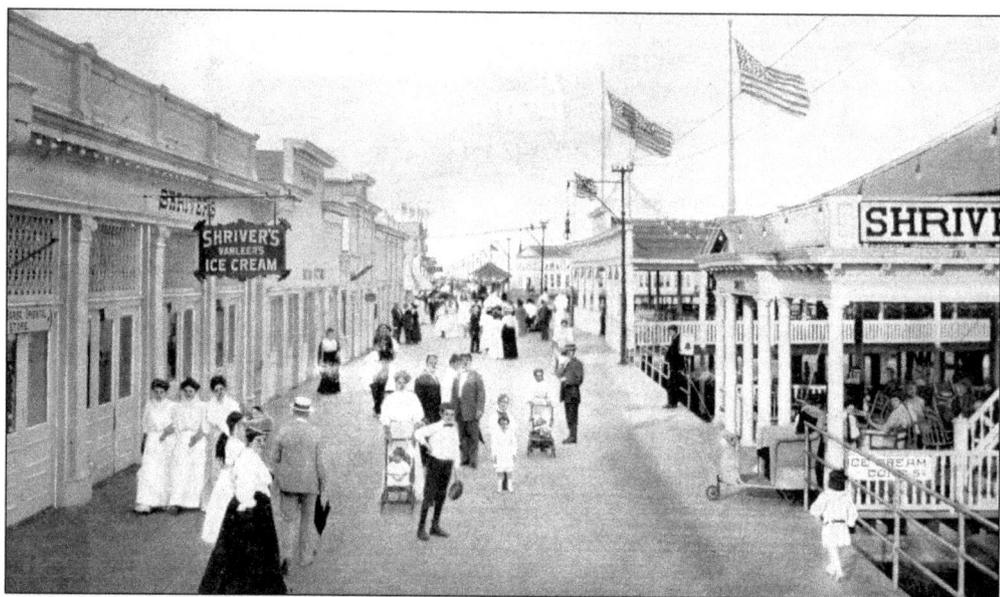

The first baby parade, held in 1909, was a modest affair. Although Leo Bamberger had managed to get two sterling silver loving cups donated by Philadelphia department stores Lit Brothers and Strawbridge and Clothier, he was unable to generate much interest in this first parade. However, the youngsters who participated had a grand time marching down the boardwalk. Bamberger also managed to get the newspaper to write about the parade in hopes of gaining public interest in next year's event.

The Beachfront Association sponsored the September 5, 1910, baby parade, and a spectacular event it was. Held Monday evening, the parade attracted one of the largest crowds ever seen on the boardwalk. Mayor Lewis M. Cresse awarded silver cups to the cutest boy, Harvey Goff; the cutest girl, Dorothy White; and the best float, a tepee carrying Jack and Kendall Shoyer and Frances Lambert. Ocean City lifeguards pulled one of their boats carrying Marguerite and Virginia Craven and Gertrude Wick.

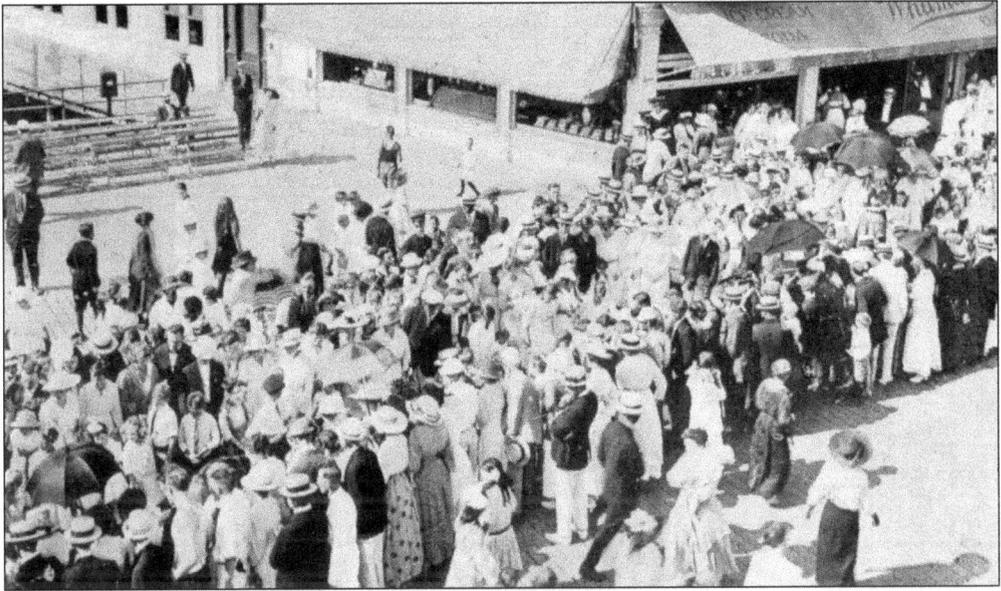

Hundreds of spectators gathered on the boardwalk to watch the August 30, 1913, baby parade. These people are standing near the Music Pavilion at Ninth Street. Shriver's, opened on the boardwalk at Ninth Street in 1898, can be seen at the top of the picture. It sold ice cream, soda, and Whitman's candy. The children marched in four divisions: children, walking to age 15; babies in coaches and wagons pulled by children; twins, either in coaches or walking; and youngsters in comic costumes. (Courtesy of Don Doll.)

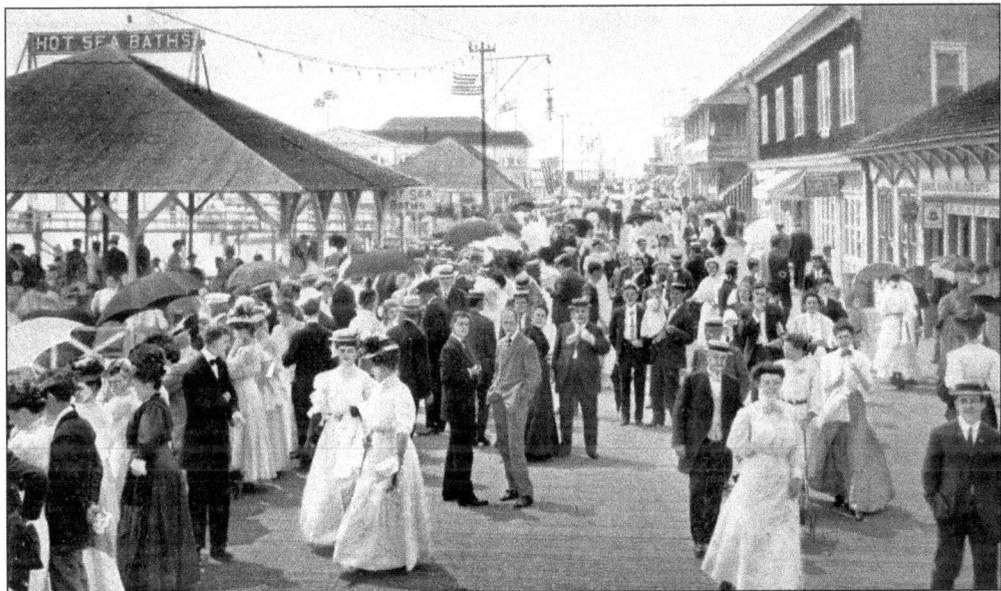

Friday, September 3, was the day the eagerly awaited 1915 baby parade was held. Scheduled for Saturday, August 28, the parade was postponed because of inclement weather. The Hotel Proprietor's Association sponsored the parade, and committee members came from the Ocean City Hotel Keepers' Association, the Ocean City Board of Trade, the Young Men's Progressive League, and some of the churches. Led off by Harrison's Band, the parade drew large crowds to the boardwalk. This is a view looking south from Seventh Street.

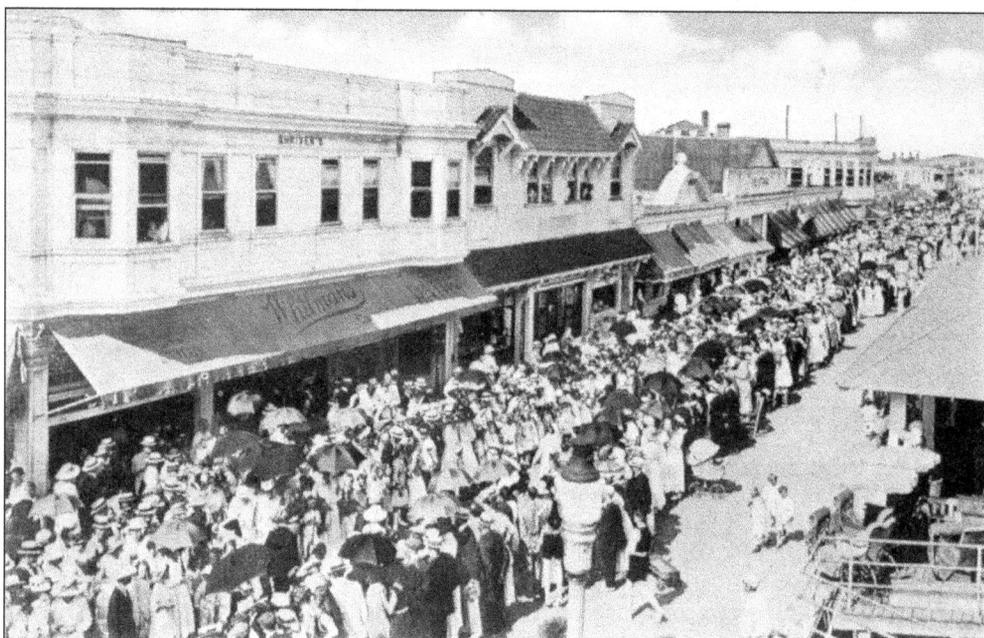

"BABY PARADE ON THE BOARD WALK, OCEAN CITY, N. J.

On Saturday afternoon, August 18, 1917, spectators crowd the boardwalk to watch the baby parade. Nearly 75 children participated in the parade, which was held under the auspices of the women's branch of the Public Safety Committee of Ocean City. Prizes were awarded for prettiest baby, fattest baby, best-decorated coach, twins, Hawaiian children, and pony carts.

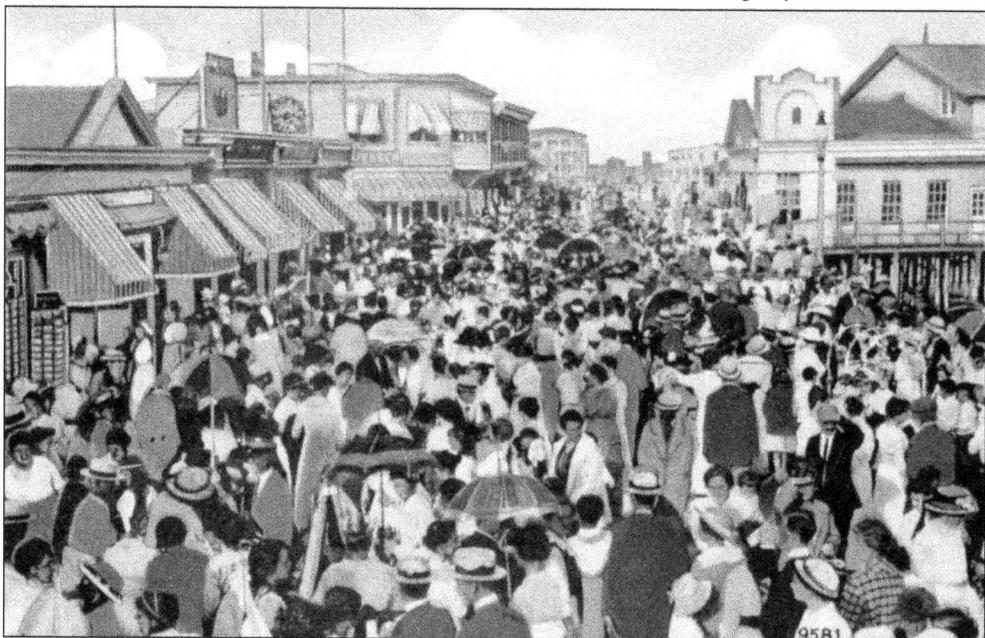

The 1919 baby parade was held on August 23. It was a chilly day, but the parade drew a large crowd of spectators who thronged the boardwalk for most of the day. Ocean City Hotel Keepers' Association member William H. Deisroth, who had been active in planning the parade before the war, was in charge.

Capt. Alfred R. Smith and his wife, Bessie Williams Smith, hold their son Alfred R. Smith Jr. after he won the second-place trophy in the best-decorated float division of the September 2, 1920, baby parade. Smith was a captain in the U.S. Army and had been captain of the Ocean City lifeguards. Five hundred children participated in the event. The City Silver Band of Vineland led the parade with Boy Scout Troop No. 1 of Bridgeton acting as honor guard. Two hundred singing children marched along the parade route.

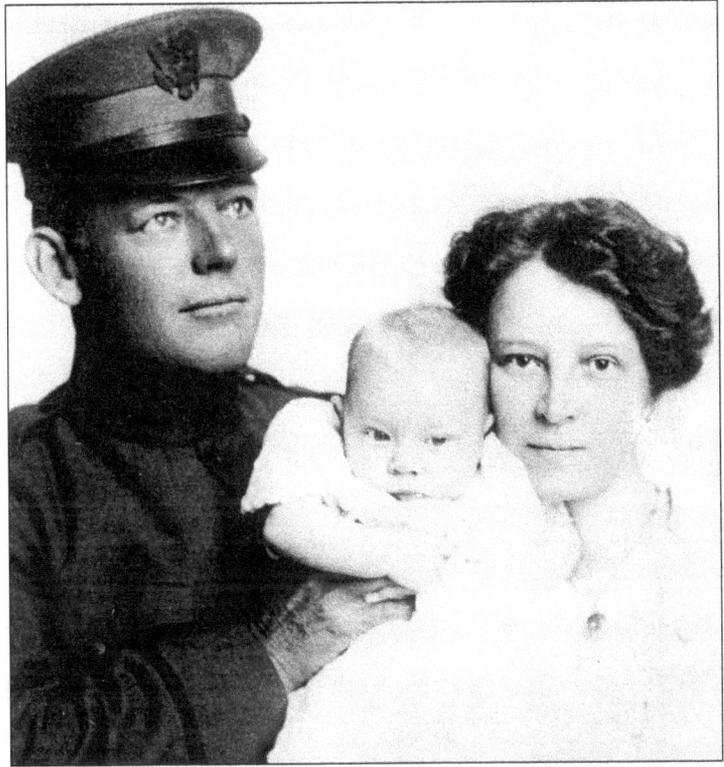

May McFarland pulled her three-year-old daughter Kay in the August 10, 1921, baby parade. Kay was entered in the best-decorated coach category. Some of the other categories in the 1921 parade were walking girls, fat babies, and most original costume. There were also several floats in the parade.

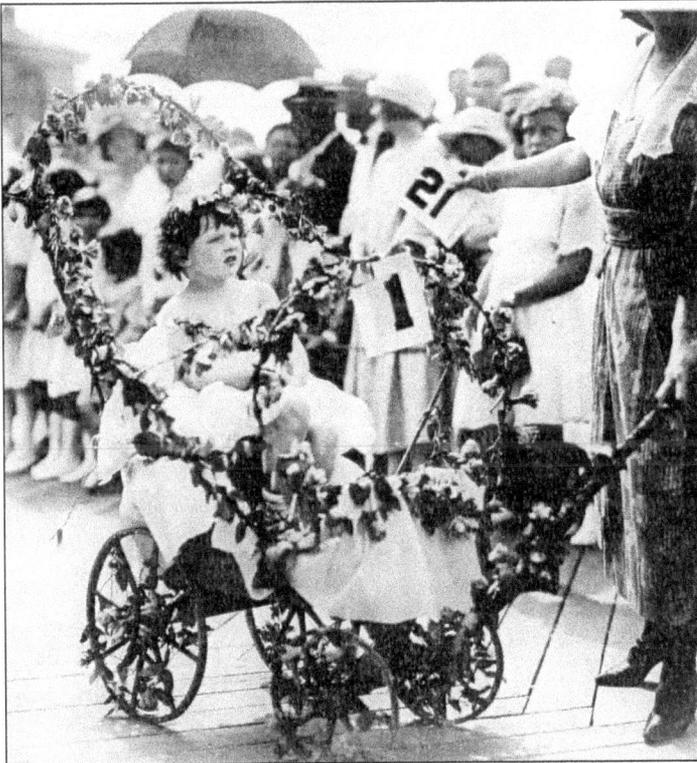

19

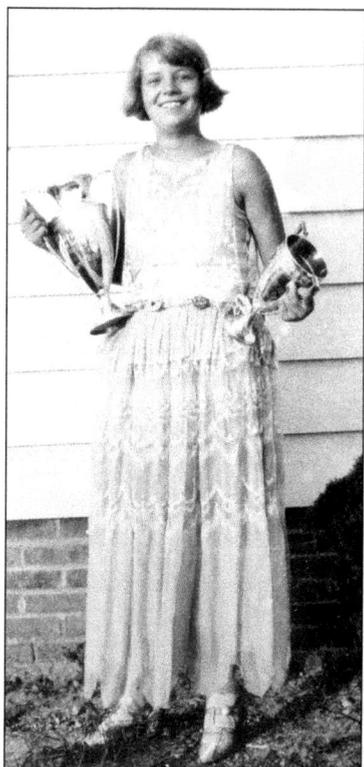

Helen Breckley holds the loving cup that she was awarded as queen of the baby parade on August 8, 1923, in one hand. In the other, she is holding the cup she won when she was most perfect bathing girl in an earlier parade.

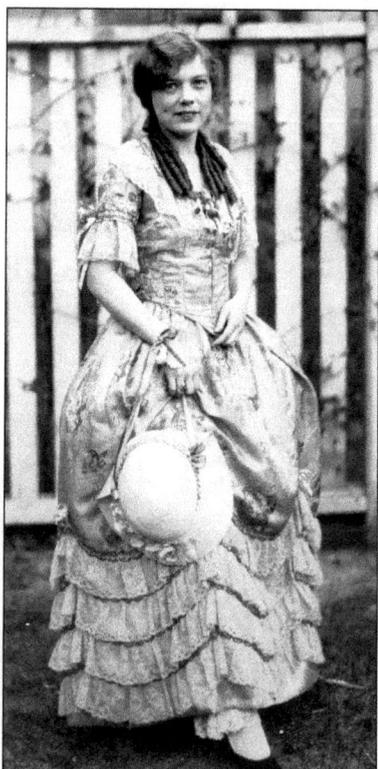

Jeanette Darby is dressed in the costume she wore as queen of the baby parade on August 13, 1924. It was an honor for a young woman to be named queen. Most of the women were year-round or summer residents of Ocean City.

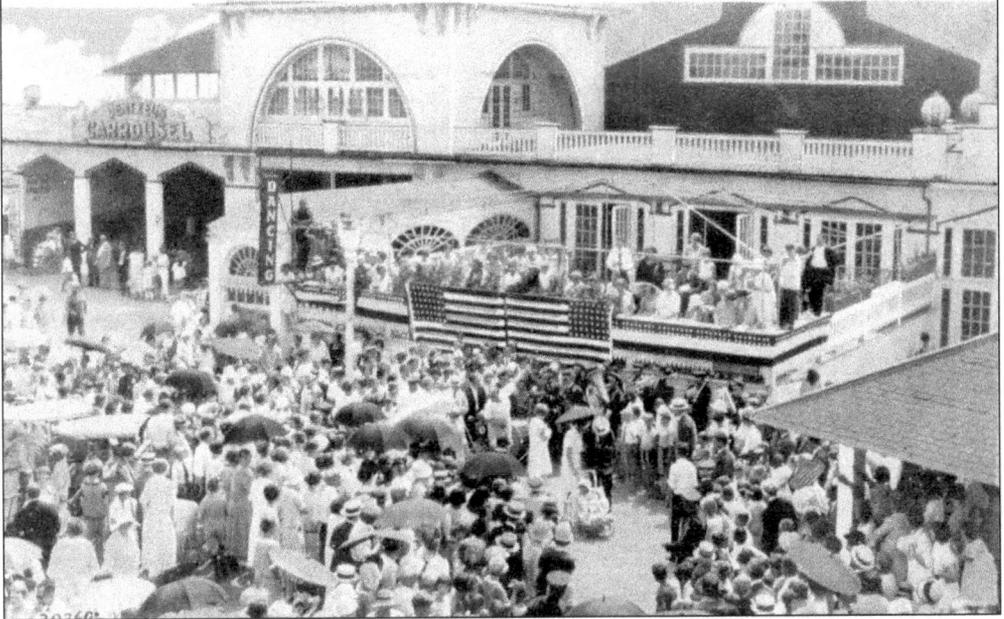

The 1924 baby parade was held on August 13 in front of a huge crowd of spectators. The Ocean City Fishing Club sponsored the parade that year. The judging stand was in front of the Hippodrome Pier. Local children, as well as those from Washington, D.C., Baltimore, Philadelphia, and as far away as Palm Beach, Florida, were entered in the parade.

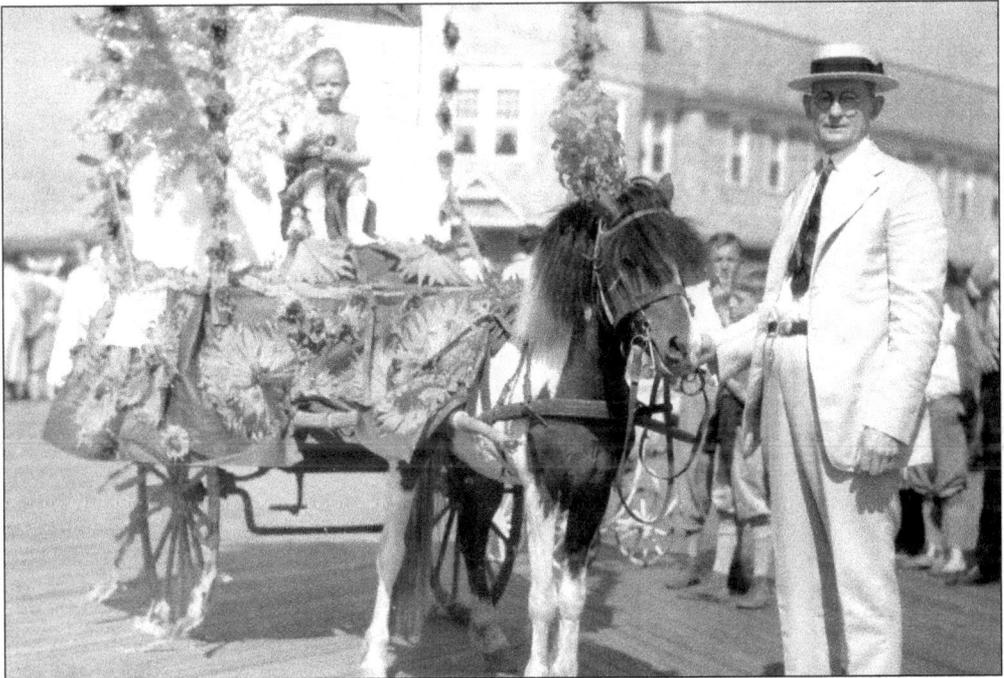

James Edward Johnson holds the reins of his grandson I. Scott Johnson Jr.'s pony before the start of the July 29, 1925, baby parade. Ponies were common in the parade. There was usually a separate division for pony carts. (Courtesy of Mrs. I. Scott Johnson Jr.)

21

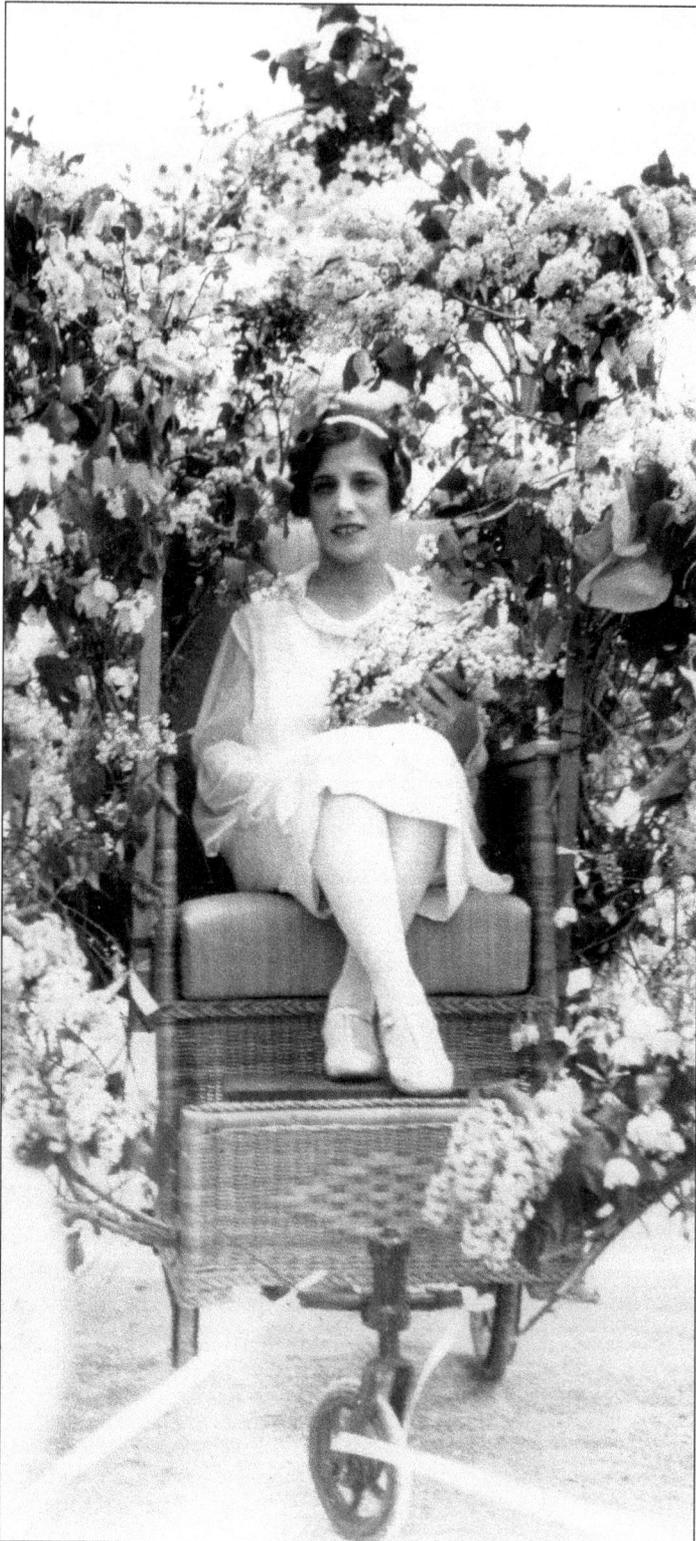

Members of the Ocean City Fishing Club were in charge of the 1925 baby parade. Here Anna Longo, chosen queen of the July 29, 1925, baby parade, sits on the decorated rolling chair she will ride in the parade. Longo is at the staging area waiting for the parade to start. W. Ward Beam, a well-known physical education instructor in Philadelphia, spent his summers leading exercise classes on the beaches of Ocean City. During the 1925 baby parade, Beam, using a megaphone, walked along the parade route inviting donations to the baby parade fund. A group of young women, carrying an outstretched cloth to catch the contributions thrown at them, walked behind him. They collected $695.21 for the fund. (Courtesy of OCHM.)

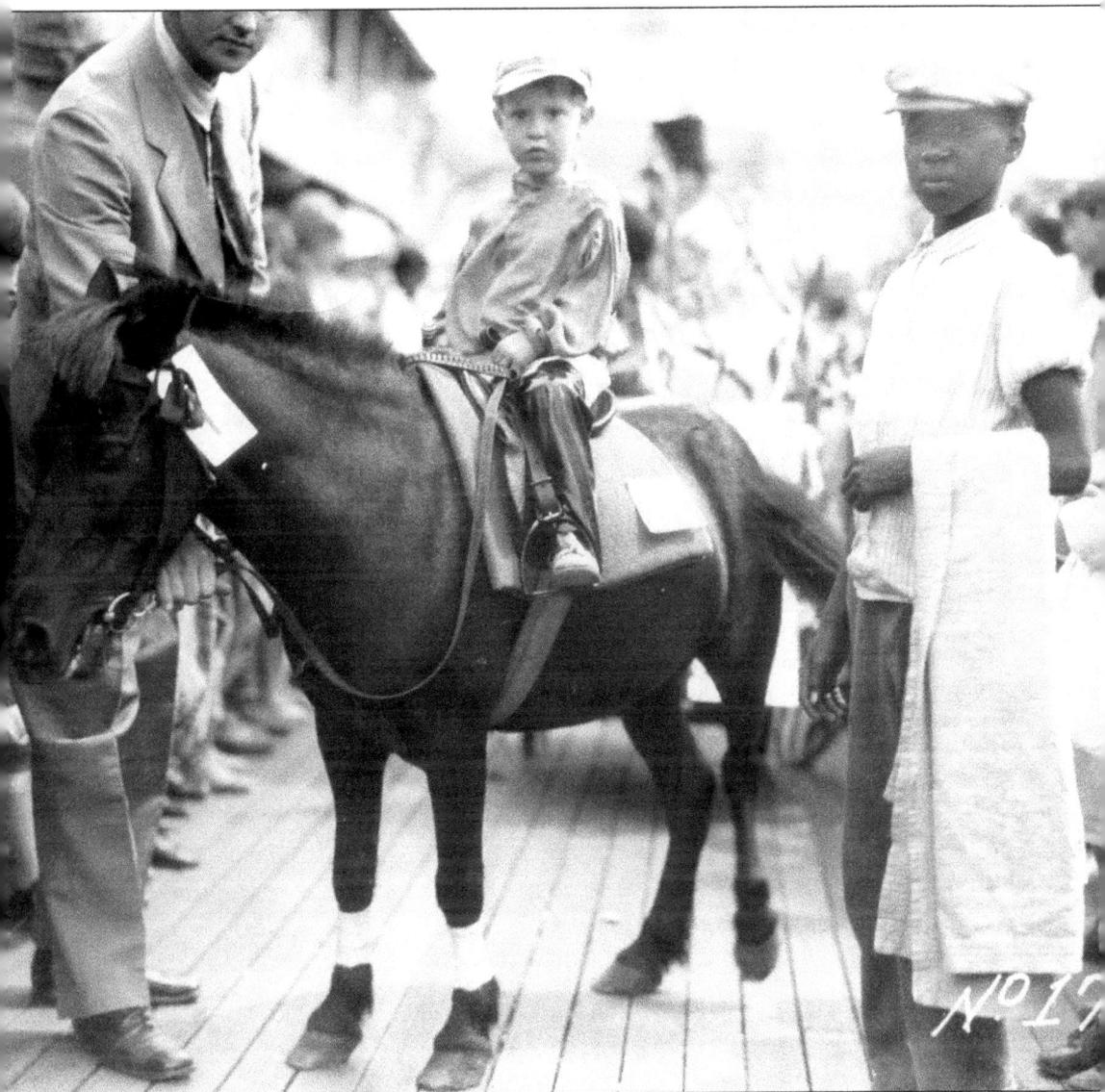

Ira Scott Johnson Sr. waits with his son I. Scott Johnson Jr. after the July 28, 1926, parade. I. Scott Jr. is on a real pony and dressed as a jockey. The African American young man in the picture may have walked with Johnson Jr. He appears to be dressed as the pony's trainer, but he is unidentified. Although there was a special division for pony carts, children could ride ponies as part of any of the divisions. Over 200 babies and children participated in the parade. Many of the boardwalk merchants paid to have bands playing in front of their businesses during the parade. (Courtesy of Mrs. I. Scott Johnson Jr.)

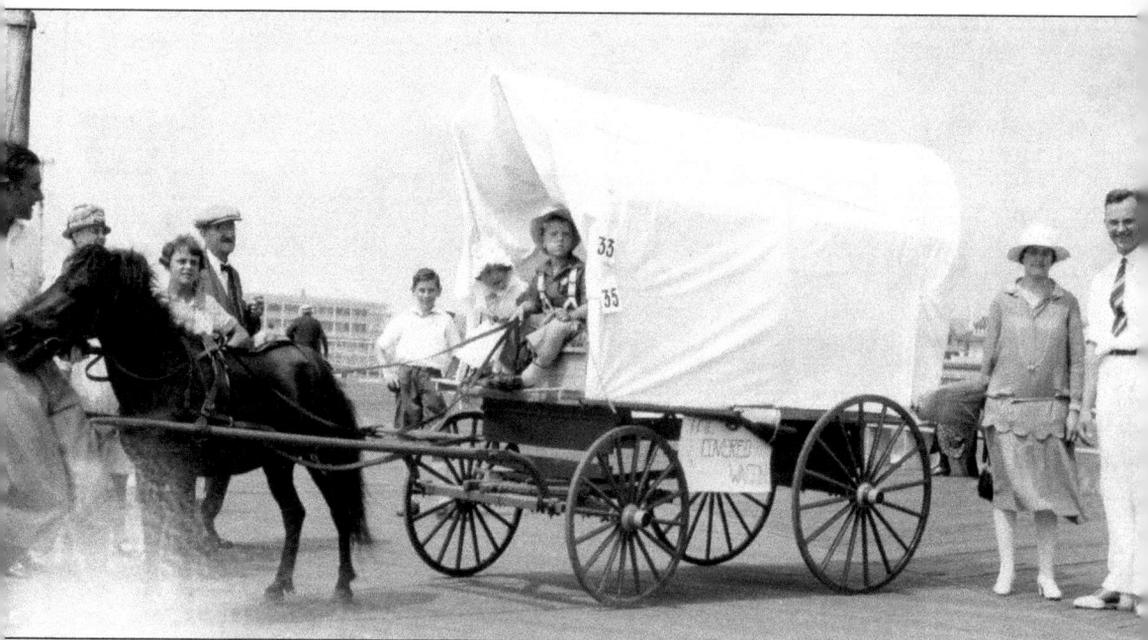

I. Scott Johnson Jr. and his brother Edward won first prize in the most original division of the July 27, 1927, baby parade. They are riding in a covered wagon pulled by a real pony. In the 1920s, there was a special division for pony carts. A sign on the side of the wagon read, "Peck's Beach or Bust." Before its founding in 1879 by the Lake brothers and two other Methodist ministers, Ocean City was known as Peck's Beach. Edward is on the left in the wagon, and I. Scott Jr. is next to him. The boys' parents, Emma Barclay Johnson and Ira Scott Johnson Sr., stand to the right. The Johnsons owned a sweet shop on the boardwalk. (Courtesy of Mrs. I. Scott Johnson Jr.)

Two

GET IN LINE, KIDDIES

October 11, 1927, is an unforgettable date in the history of Ocean City. At 7:13 that evening, a spark under the boardwalk at Ninth Street started what stands as the worst fire the city has ever had. Within minutes, flames were billowing hundreds of feet in to the air, and strong winds sent the fire westward toward the city center and north and south along the boardwalk. Firefighters from all over the region helped fight the inferno. Two full blocks of the boardwalk, hotels, stores, and homes were destroyed, but there was no loss of life.

Rebuilding the boardwalk and the downtown began immediately. From Sixth to Twelfth Streets, the old boardwalk, even the area not damaged by the fire, was torn out, and a wider, concrete-based boardwalk was built. This proved a boon to the baby parade. The old boardwalk, supported by wood pilings, had been deemed too weak to withstand vehicular traffic, but with the new boardwalk now resting on a cement foundation, this was no longer a problem. Suddenly the idea of cars and large floats pulled by trucks were possible entrants in the baby parade.

Although there were parade queens in the past, starting with the 1929 baby parade, a large, lavishly decorated float carrying Queen Infanta and her royal court became a fixture. Commercial floats and cars carrying lovely young women who had won one contest or another were suddenly the rage as well. More bands were added, the number of entrants continued to grow, and the crowds of spectators got even larger. The baby parade on Ocean City's famous boardwalk became bigger and better than ever.

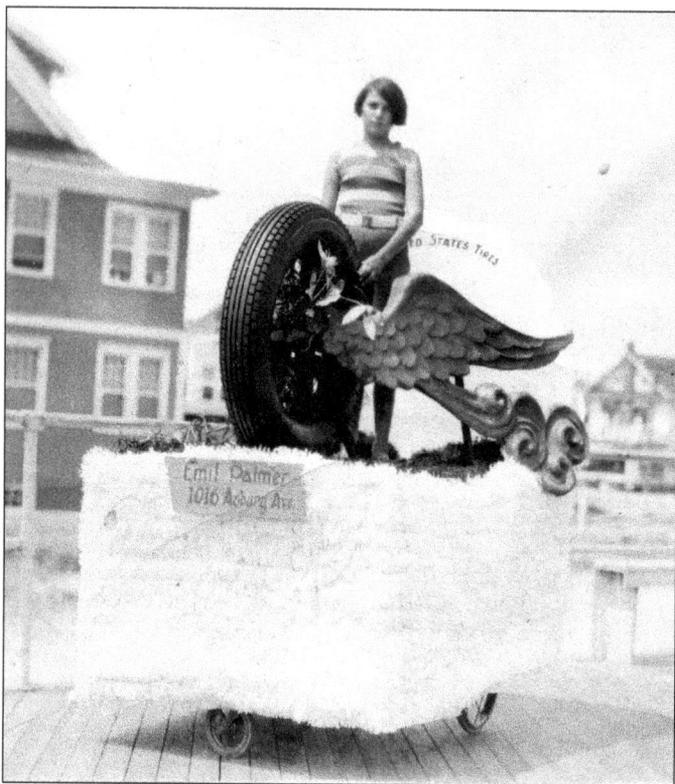

Twelve-year-old Lorenza Palmer rides on her father's float in the commercial float division during the August 10, 1928, baby parade. Her father, Emil, owned Emil Palmer Tire Shop. The Ocean City Chamber of Commerce sponsored that year's parade. Although the parade proved to be a success, an editorial in the *Ocean City Sentinel-Ledger* on August 3 suggested that the city should take over the parade. According to the newspaper, it was unfair to expect any businessman to take the time to plan and run the parade. (Courtesy of Cathy and John Flood.)

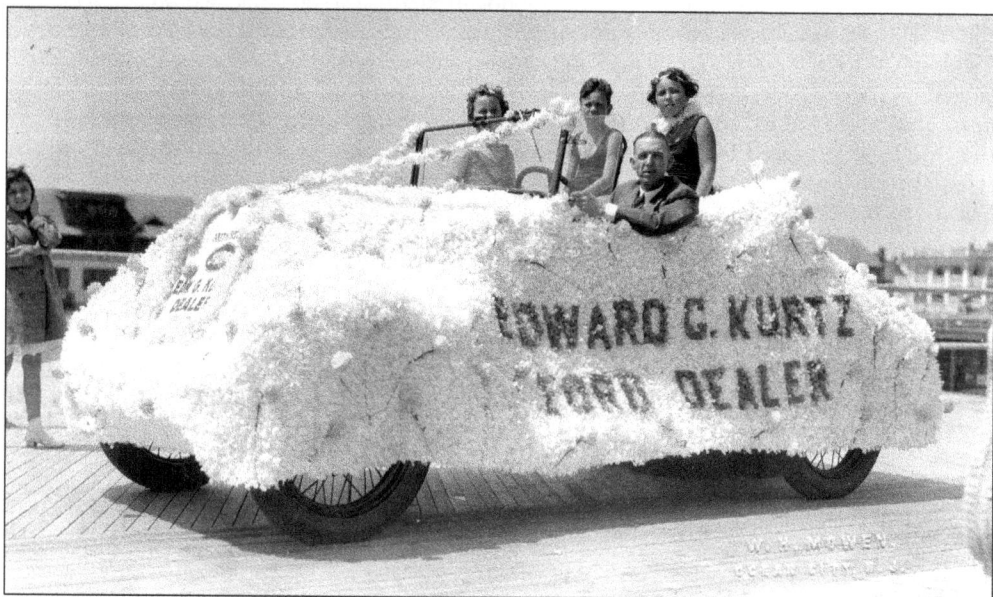

Edward G. Kurtz used this float in the 1928 baby parade to help advertise his Ford dealership. He opened the first car dealership in Ocean City in 1921. His showroom was at 14 Atlantic Avenue. Other commercial floats as well as children's floats were in the parade. Music was furnished by the state American Legion band and by the Reading Railroad band, whose members wore striking red, gold, and white uniforms. (Courtesy of OCHM.)

26

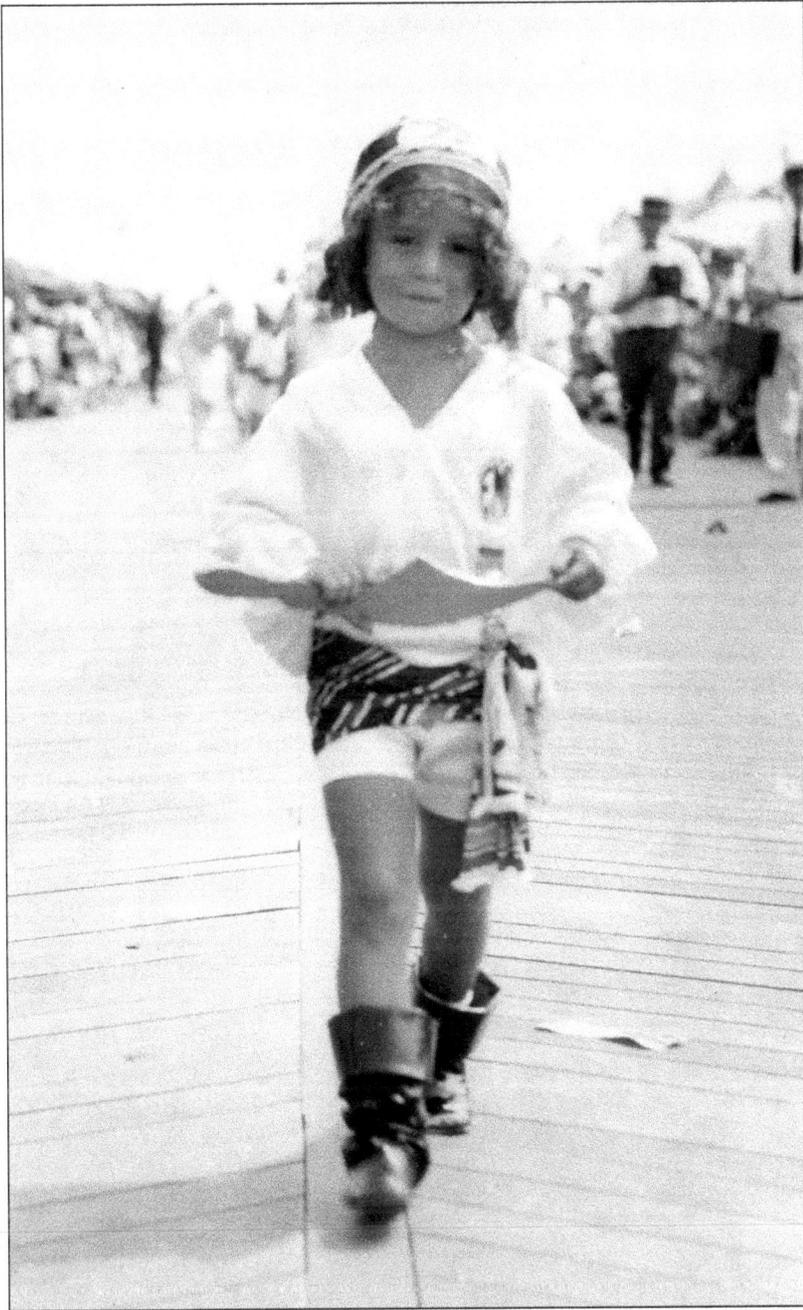

Pirate Eloise Morris, three and a half years old, won the title of champion baby in the August 10, 1928, parade. She won a prize of a $100 gold coin and designation as Ocean City's entry in other baby parades and contests held along the Jersey Shore during the year. Other children were dressed to impersonate prizefighters, gypsies, and fairies. Among the comic entries were children dressed to represent billy goats. Ocean City's only leap year baby, Alice Ginther, born on February 29, 1928, was one of the hits of the parade. According to an article in the *New York Times* the next day, it was so hot that several women fainted in the heat during the parade. (Courtesy of OCHM.)

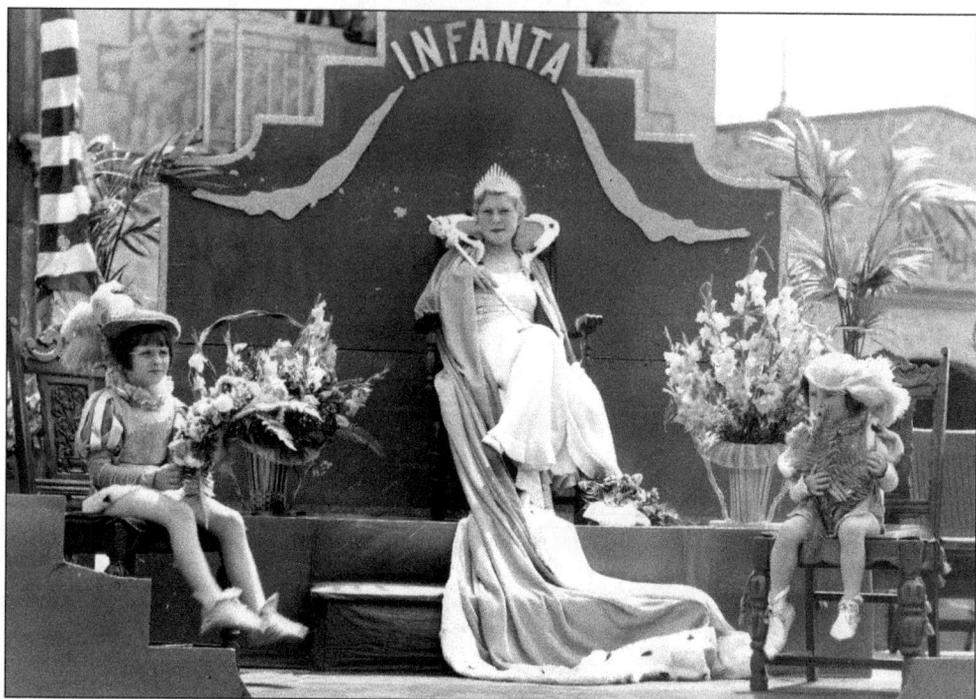

On August 29, 1929, Irene Ahlverg of New York City, winner of the Miss United States title in the International Beauty Pageant, was crowned the first Queen Infanta. The coronation, with Ocean City mayor Joseph G. Champion presiding, was held in a specially erected outdoor amphitheater on the beach at Sixth Street. Riding on a float carrying her throne and court, Queen Infanta reigned over the baby parade, held the next day, August 30. (Courtesy of OCHM.)

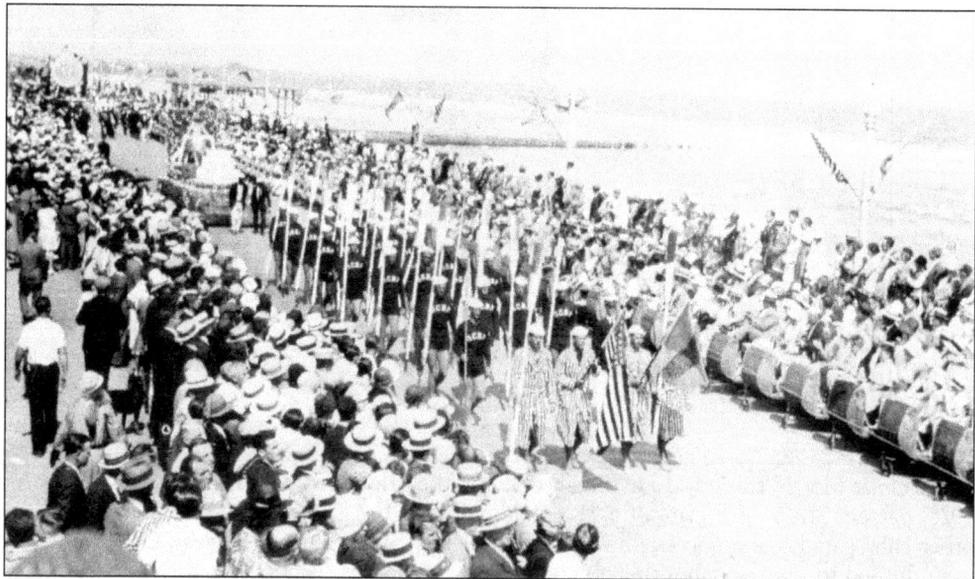

The Ocean City Beach Patrol leads the march down the boardwalk during the August 30, 1929, baby parade. The parade began at 4:00 p.m. The judges were all newspapermen from Philadelphia and New York City. Every entry received a souvenir badge. (Courtesy of Ocean City Lifesaving Museum.)

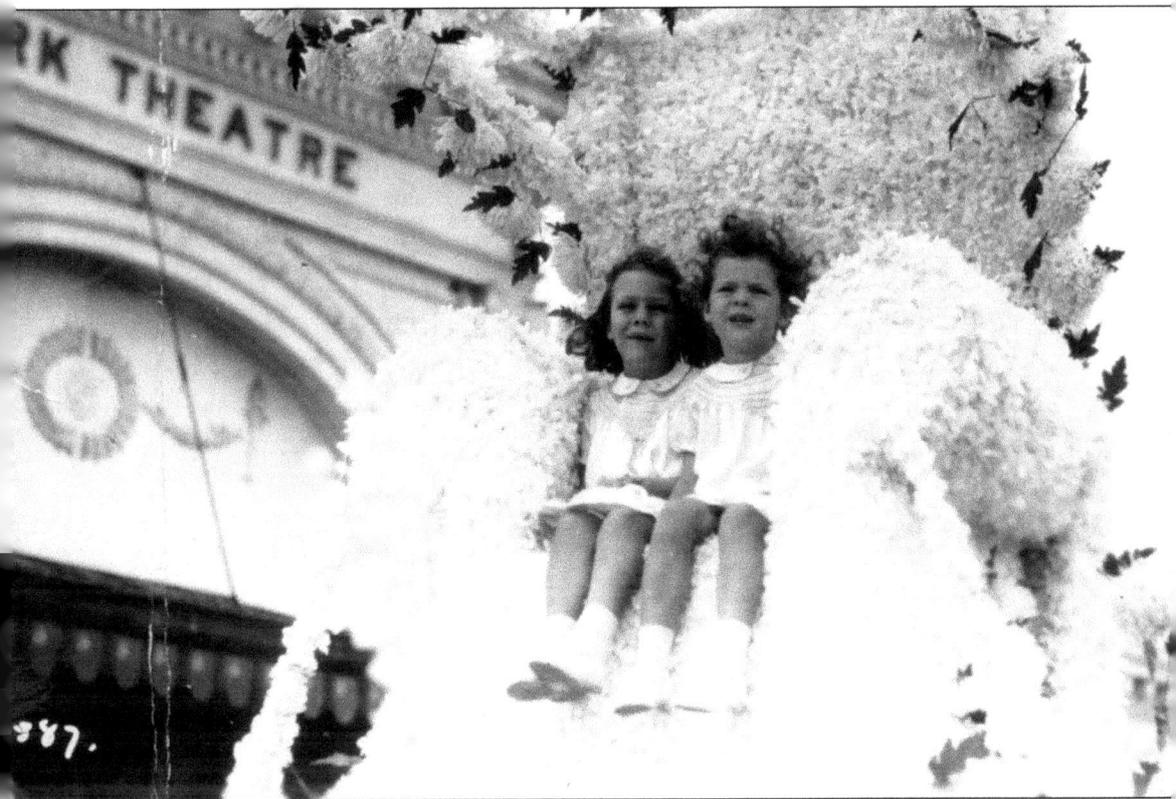

Jeannette and Doris Smith took first place in their division, decorated floats and rolling chairs, during the August 30, 1929, baby parade. The other divisions were all children walking, baby coaches and go-carts, doll coaches and wagons, comic dress, and fancy dress. Grand champion of the parade was five-year-old Tootsie Gishk from New York City. She and her mother were spending the summer in Ocean City at 955 Boardwalk. The weather was cool for the parade, but the crowd was still reported to be the largest ever. The Smiths are passing the Park Theatre at Park Place and the boardwalk, as they are pushed down the parade route. The theater was destroyed in a fire on September 9, 1930. (Courtesy of OCHM.)

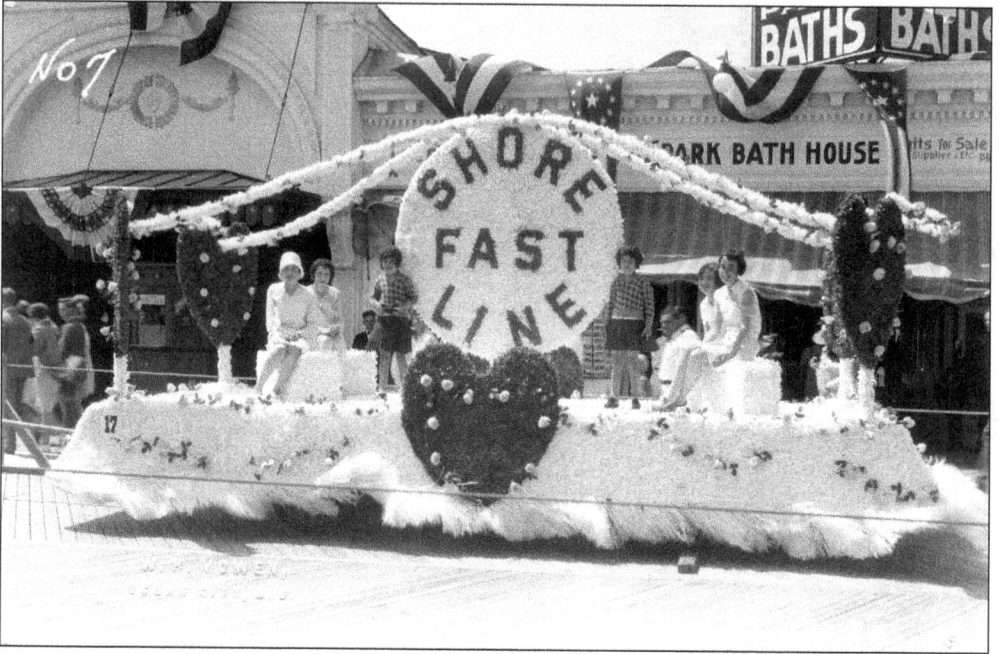

The Shore Fast Line float won an award in the 1930 baby parade. The parade, held on August 22, was seen by 50,000 spectators and had nearly 200 entries. The Shore Fast Line was an electric trolley linking Ocean City with Atlantic City and the mainland communities of Somers Point, Linwood, Northfield, and Pleasantville. (Courtesy of OCHM.)

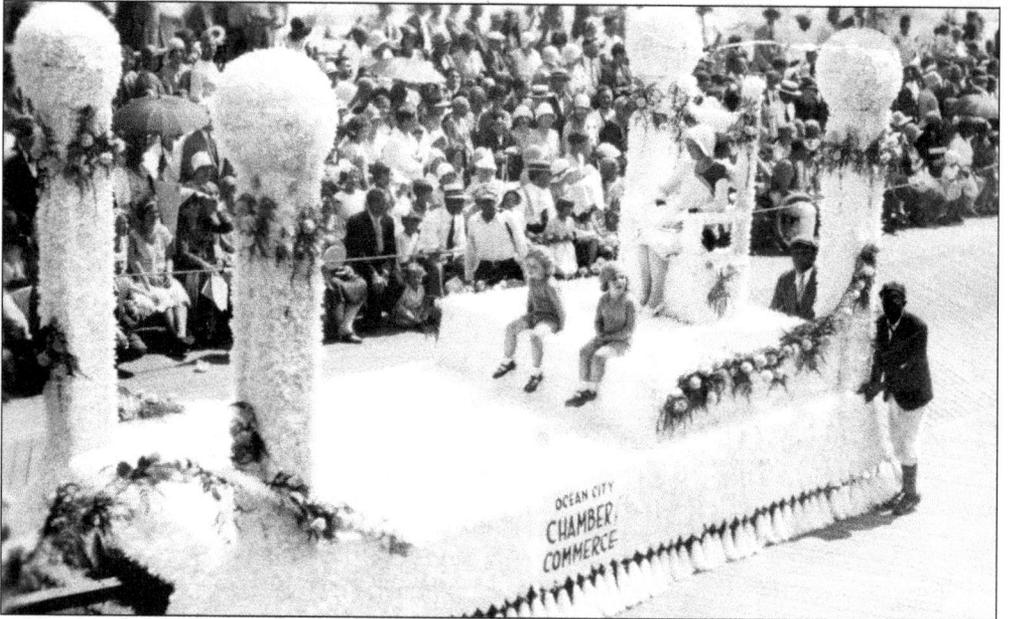

It was a chilly day for the 1930 baby parade, held on August 22, when this Ocean City Chamber of Commerce float went down the boardwalk. The evening before, 25,000 people braved a chilly wind to watch the coronation of Helen Morgan as Queen Infanta. Morgan, a motion picture star, was dressed in the "ultra modern style" at her coronation, according to the *Ocean City Sentinel-Ledger* newspaper.

Jean Bamforth is in front of her house before her family leaves for the August 22, 1930, baby parade. She was the winner in the baby coaches division. Other divisions were comic and burlesque, fancy dress and college colors, and pony turnouts. (Courtesy of OCHM.)

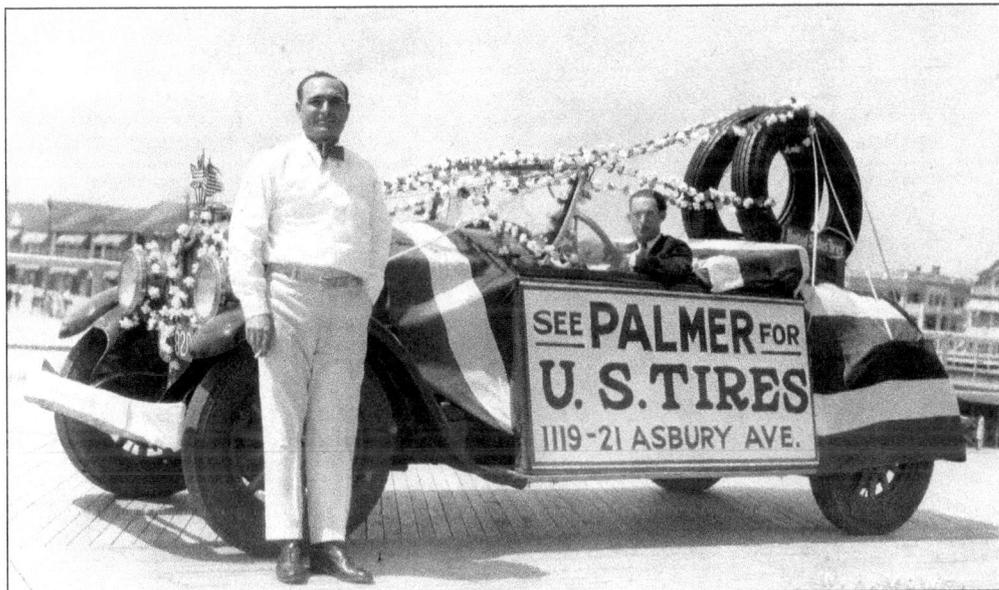

The *Ocean City Daily* headline on September 4, 1931, read, "Thousands to View Baby Parade Here Today! Largest Parade of Its Kind in the City's History." With Ocean City publicity director Ray B. Dean in charge, the hype for the parade started early and continued until parade time. The parade started at Second Street and continued south on the boardwalk to Twelfth Street. This float by Palmer's Tire Service was a second-place winner in the commercial float division. Owner Emil Palmer stands on the left. (Courtesy of Cathy and John Flood.)

This parade entry tag came from the 1931 baby parade. The tag, for "Ocean City's Famous Baby Parade on the World's Finest Boardwalk," was used by little Therese C. Canter, who was staying at 812 Boardwalk. She was the 10th entrant in Division B, all children walking. (Courtesy of OCHM.)

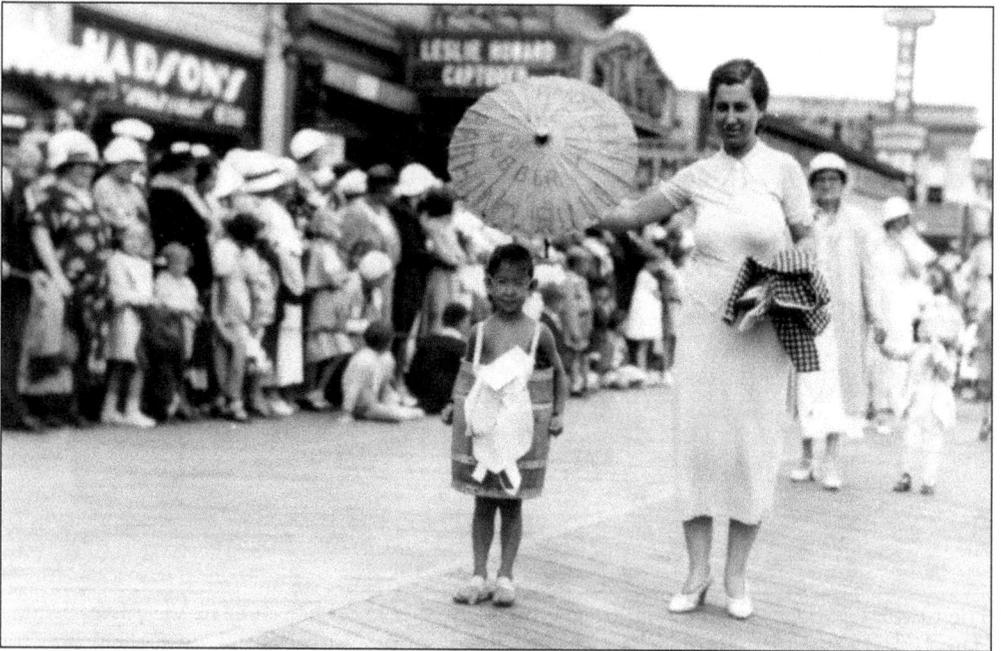

Lillian Mayer accompanies Therese C. Canter, her daughter, down the boardwalk during the August 26, 1932, baby parade. The umbrella held by Mayer says, "Another victim of a rubber bathing suit." This parade was the first held in the morning rather than in the afternoon. (Courtesy of OCHM.)

32

"Little Douglass" Longenecker was awarded a trophy for second place in his division in the August 26, 1932, baby parade. Longenecker was the son of the owners of the Douglass Candy Store at 700 Boardwalk. (Courtesy of Doug Longenecker.)

Sung by Eddie Cantor, a popular tune in 1933 was "At the Baby Parade," by Little Jack Little, Dave Oppenheim, and Ira Schuster. The chorus of the song goes, "Here they come, Dressed in brown and blue and jade, Little boys and girls showing off their curls, at the baby parade. Little eyes, looking wise, Realize the hit they've made, When they get a hand at the Judge's stand, at the baby parade!" The 1933 parade was held on August 29.

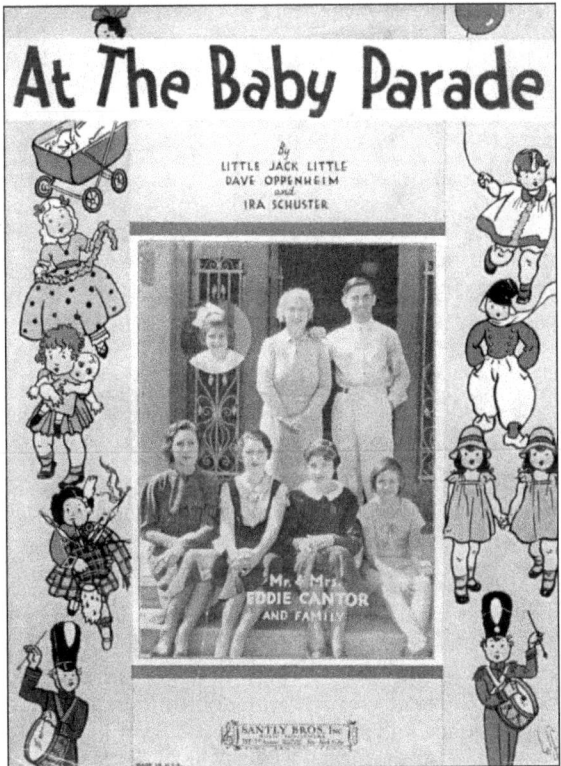

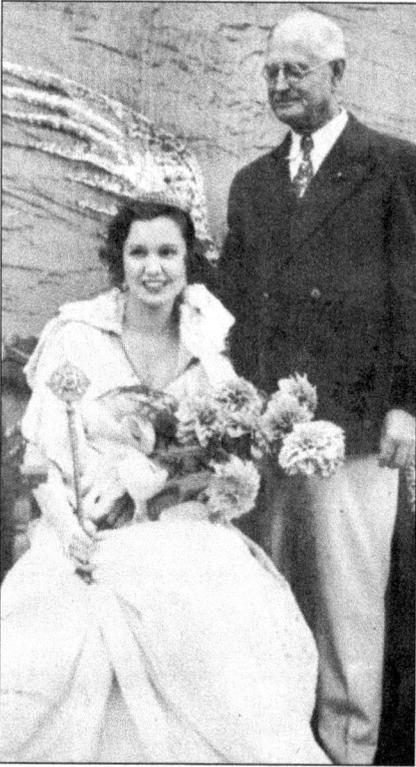

Ocean City mayor Harry Headley crowned Iona Beverley Queen Infanta on August 28 at her coronation the evening before the 1933 baby parade. Beverley, a Florida State University student and beauty queen winner there, had summered in Ocean City since she was a young child. (Courtesy of OCHM.)

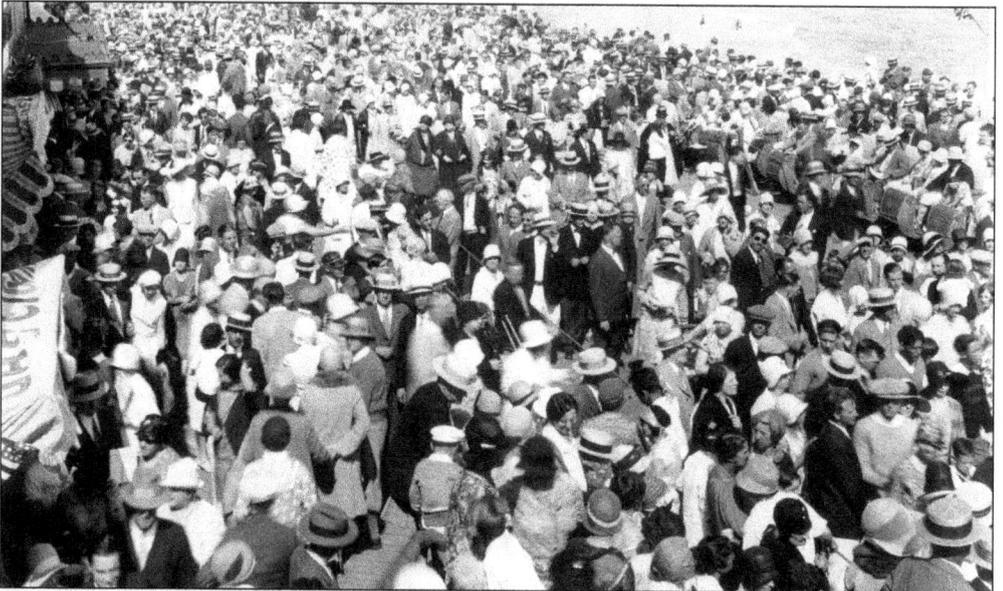

The August 24, 1934, baby parade was sponsored by the Ocean City Seashore Home for Babies. Ten thousand people watched as 250 babies were paraded down the boardwalk. The Seashore Home dispensed with Queen Infanta and her court that year. It sponsored a talk by Victoria Booth Demarest, granddaughter of the founders of the Salvation Army. She spoke the afternoon of the parade and again the next day on "God's Sweetest Gift." A special prize was awarded for "healthiest, most normal baby" in the parade.

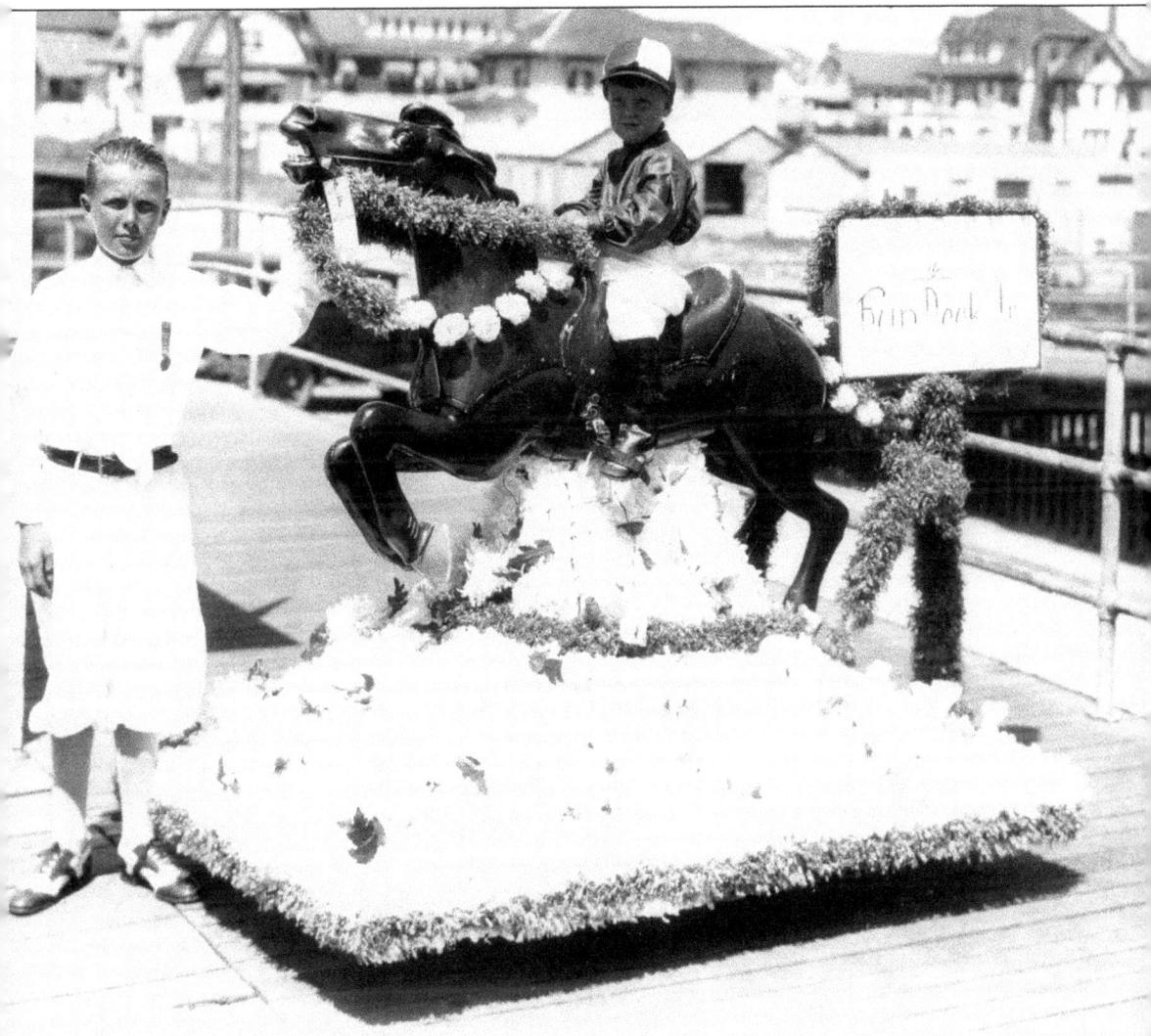

Robert Gillian stands with his brother Roy before the August 24, 1934, baby parade. Their Fun Deck Jr. float was a winner in the children's float division. The boys' father, David Gillian, owned the Fun Deck on the boardwalk at Plymouth Place. Gillian opened his amusement center in 1929 with a Ferris wheel as the only ride. The next year, he added a merry-go-round. Each year, Gillian added another ride until the Fun Deck was the most famous and inviting place on the boardwalk. Robert and Roy followed their father into the business and gradually took over when David Gillian semiretired. (Courtesy of Jay and Michele Gillian.)

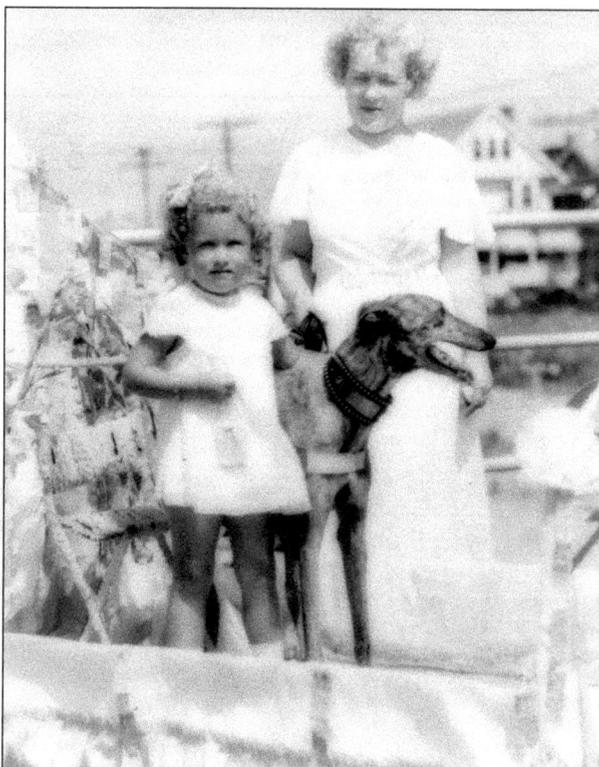

Freda Irene Lafferty and her dog won a second-place silver trophy in the August 24, 1934, baby parade. Here she stands with her mother before the start of the parade. That year, 250 babies and children participated in the parade. (Courtesy of Eileen Barr and Billie Noble.)

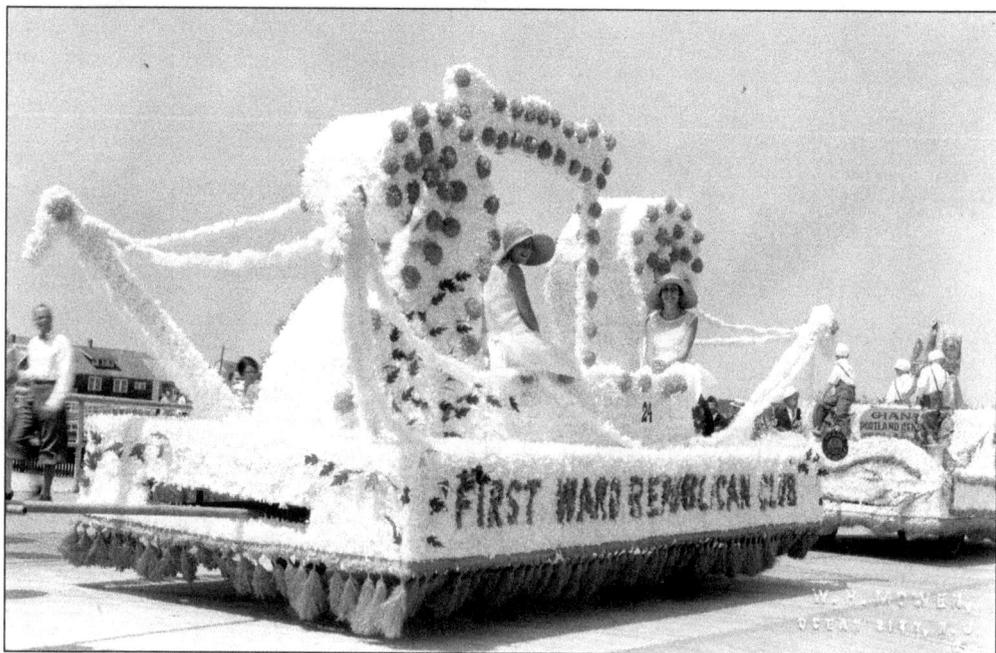

This First Ward Republican Club float was in the August 24, 1934, baby parade. The First Ward covered the north end of the island. Political floats had never been allowed in the parade, and this one was almost refused entry. Since this car had no actual political statements on it, it was permitted to stay in the parade. (Courtesy of OCHM.)

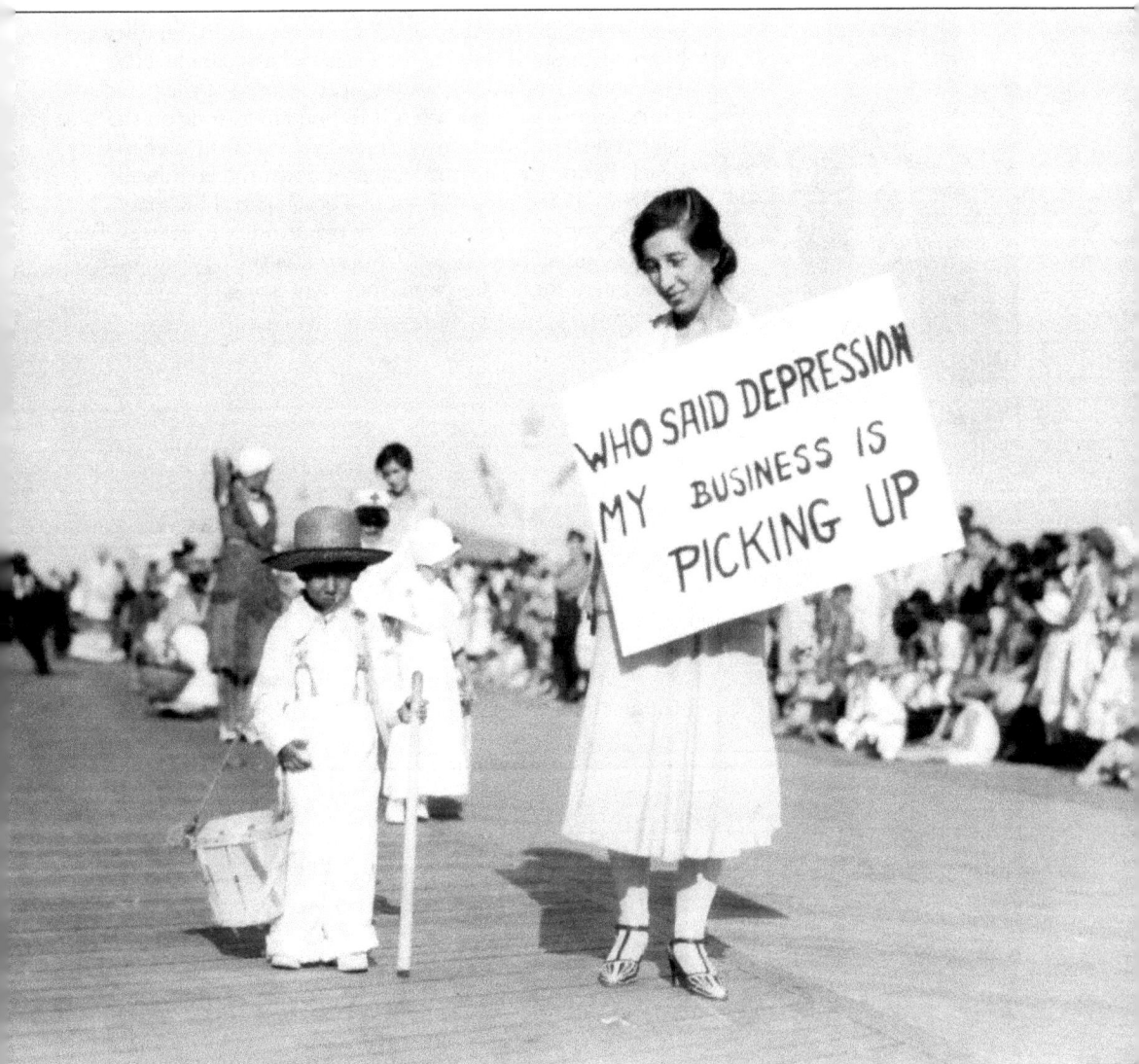

The costumes of many of the baby parade contestants echo the concerns and happenings of the day. Here Therese C. Canter, accompanied by her mother, Lillian Mayer, participates in the August 24, 1935, parade. Mayer carries a sign reading, "Who Said Depression, My Business Is Picking Up." Canter is dressed as a trash picker. Despite the grave economic situation still facing the country, the baby parade was very festive. Six bands and bugle corps marched. To entertain the spectators before the parade began, local comedians Maurice and Lewis Gandy provided stunts. There were also clowns and harlequins and fancy dancing. (Courtesy of OCHM.)

New Jersey governor Harold G. Hoffman and his family were honored guests at the August 23, 1935, baby parade. His 14-year-old daughter Ada was Queen Infanta of the parade while her two younger sisters, Lily and Hope, rode on the queen's float as ladies-in-waiting. Members of the Ocean City Beach Patrol accompanied the float down the boardwalk. Hoffman, posed here in front of a beach patrol lifeboat holding one of the oars, took the opportunity to praise Ocean City commissioner Henry O. Roeser and the city's finance department for the fine work they were doing.

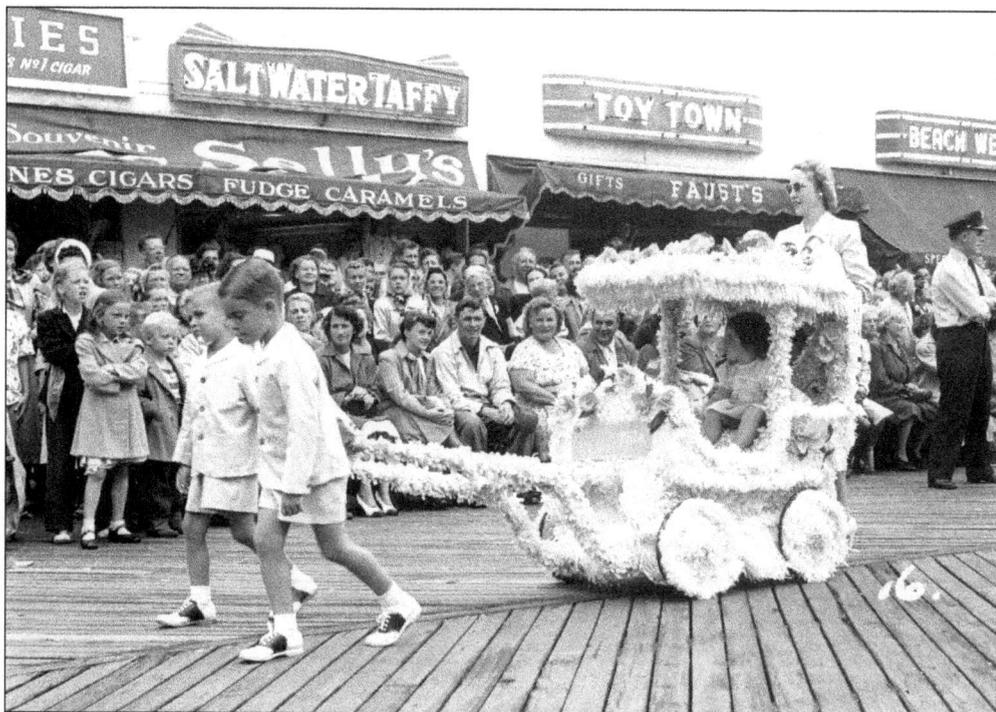

Michael and John MacIntosh of Philadelphia pull their sister Helen down the boardwalk during the August 23, 1935, baby parade. They were hoping for a prize. (Courtesy of OCHM.)

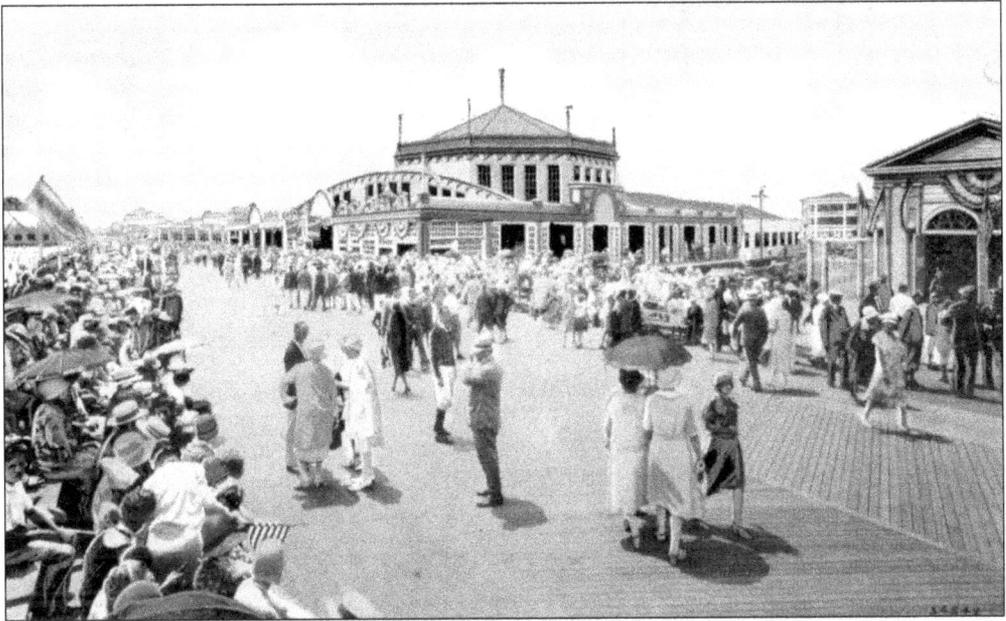

The scheduled August 28, 1936, baby parade brought large crowds to the boardwalk. The parade began forming at 10:30 a.m. with preliminary judging taking place at Sixth Street and the boardwalk. Three hundred children and seven bands participated.

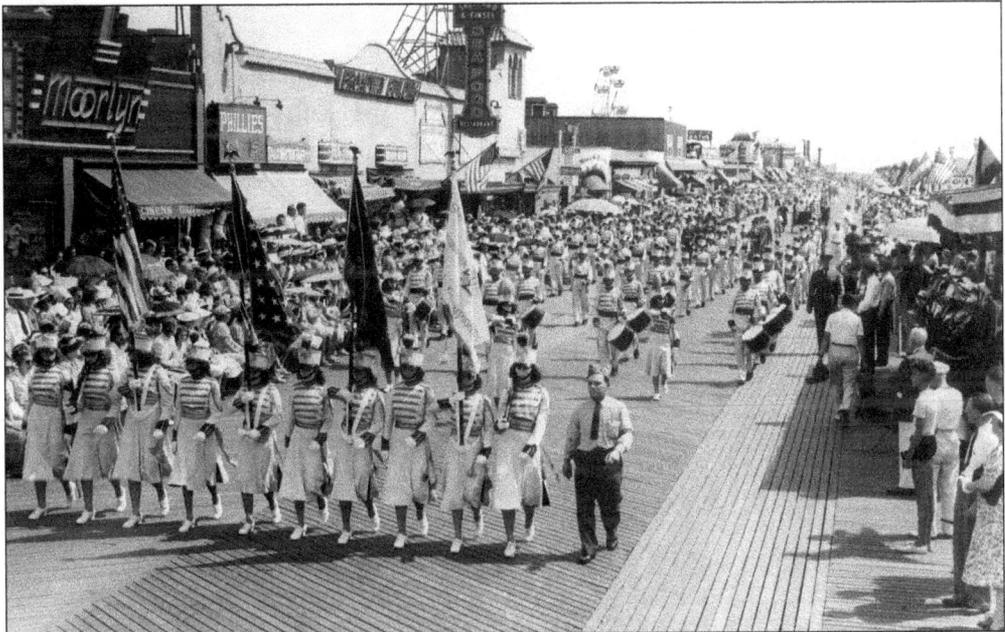

This all-woman color guard marches down the boardwalk during the August 28, 1936, baby parade. It was a very hot day, and the parade went on for several hours. Many of the women used umbrellas to shield themselves from the sun.

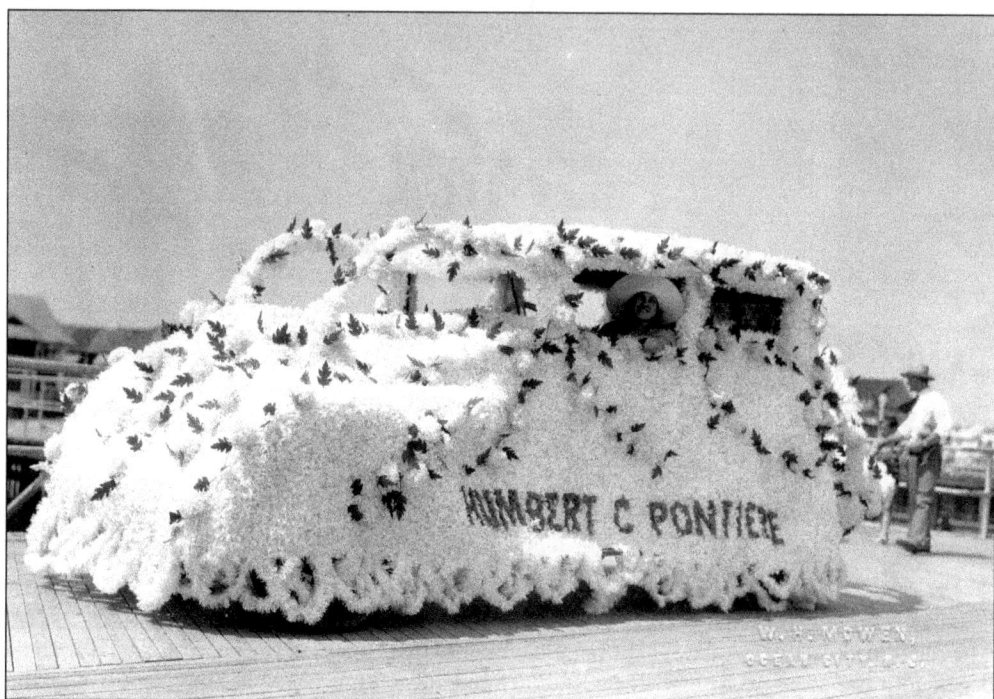

Humbert C. Pontiere was a local builder. This car, completely covered with tissue paper flowers and carrying his name, was driven down the boardwalk during the August 28, 1936, baby parade. Pontiere built many homes in the Gardens, a section in the northern end of Ocean City. (Courtesy of OCHM.)

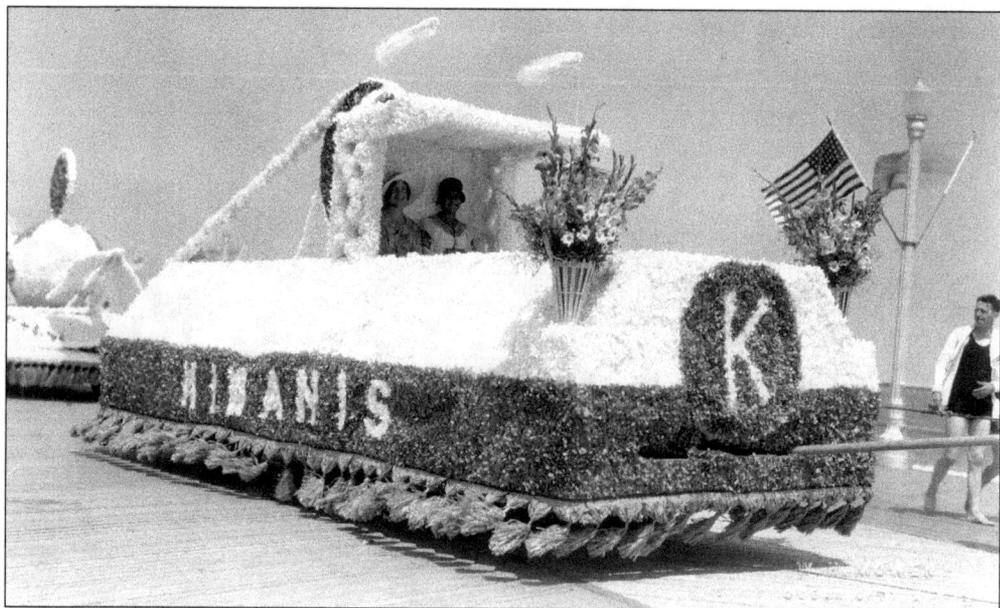

This Kiwanis Club float was in the August 27, 1937, baby parade. The Ocean City Kiwanis Club, part of a national service club for businessmen and professional men, held its first Ocean City meeting on April 25, 1922. By 1937, it was well established in town with many prominent citizens as members. (Courtesy of OCHM.)

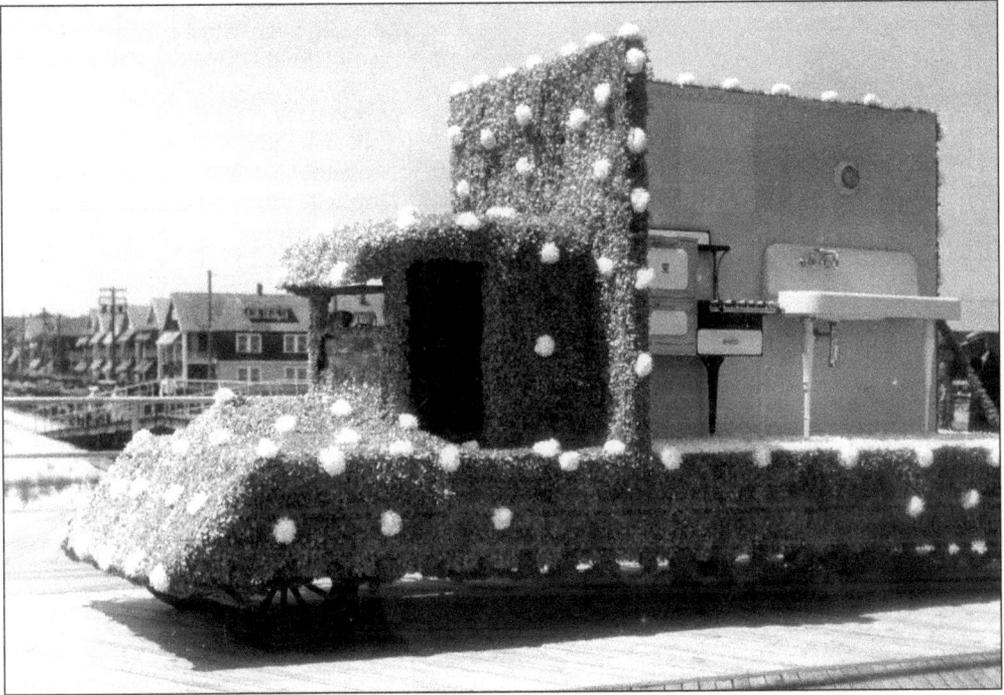

This Johnson Plumbing Contractor's float, showing off some of its wares, is being readied to join the August 27, 1937, baby parade. Many of the local businesses put floats into the parade during the 1930s. Many of them still do. The floats in the commercial float division have gotten more and more elaborate over the years. (Courtesy of OCHM.)

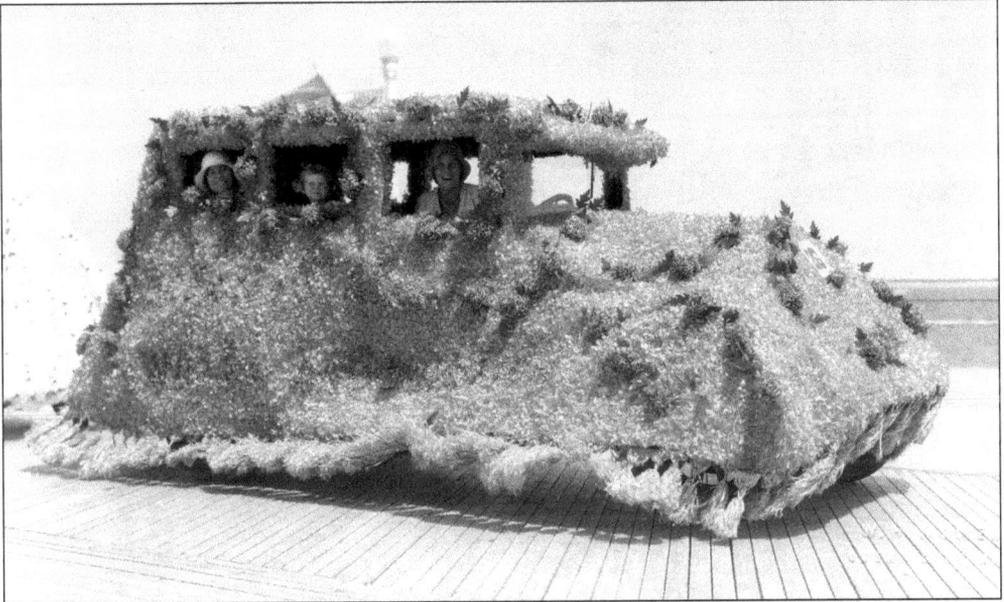

Not every household owned a car in 1937. This one, which seemed to have sprouted a full covering of grass, was quite a novelty during the August 27, 1937, baby parade. It drew a lot of interest from the parade spectators, especially from the men in the crowd. The children riding in the car were the envy of every little boy there. (Courtesy of OCHM.)

Ocean City mayor Joseph G. Champion crowns Cornelia Buckman Queen Infanta for the 1938 baby parade. Buckman was the daughter of Pennsylvania state senator Clarence J. Buckman and his wife. She and her court of five were all longtime summer residents hailing from Philadelphia or Bucks County, Pennsylvania.

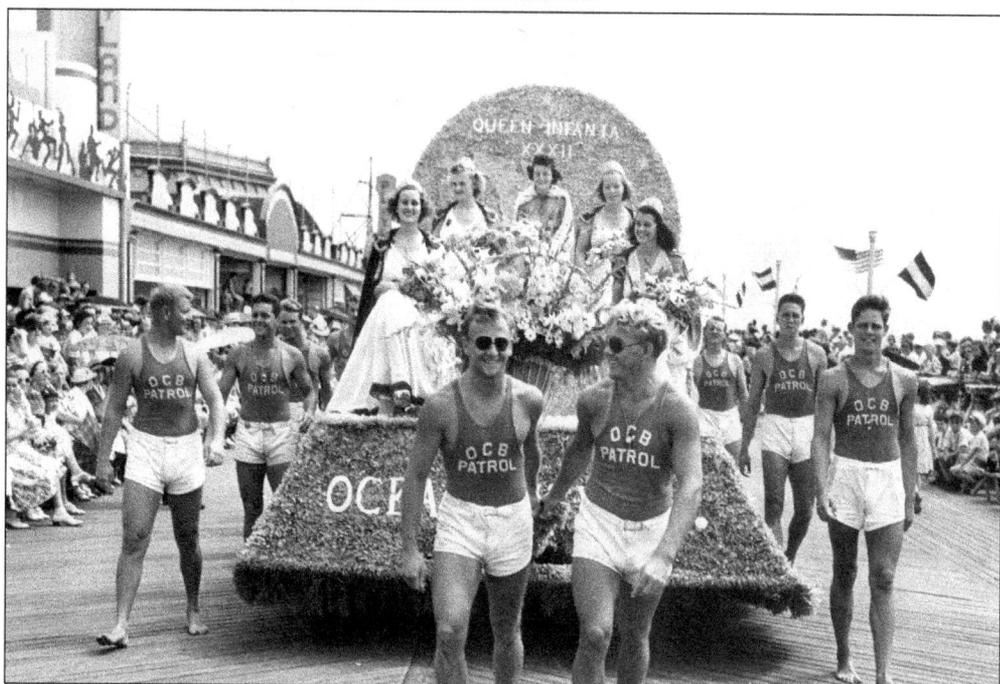

Cornelia Buckman and her royal court ride on the queen's float during the August 11, 1938, baby parade. Members of the Ocean City Beach Patrol have always escorted Queen Infanta's float. (Courtesy of Ocean City Lifesaving Museum.)

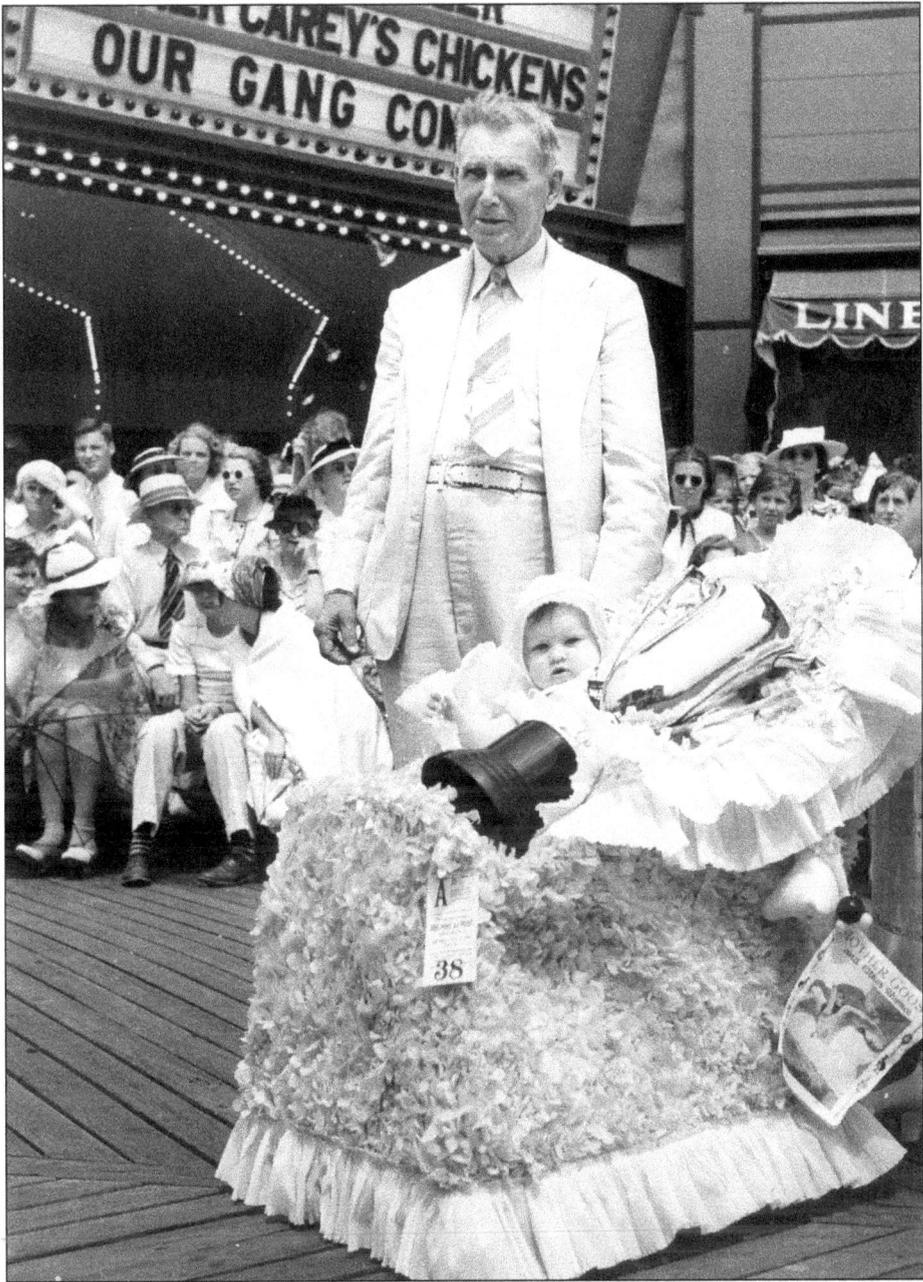

Elizabeth Eleanor Arrison was champion baby of the August 11, 1938, parade. A committee of four local doctors, Allen Corson, C. Eugene Darby, John B. Townsend, and Herschel Pettit, chose the champion baby for her healthful appearance. Here Mayor Joseph G. Champion admires Arrison and her trophy after the parade. Arrison, daughter of Mr. and Mrs. Horace Arrison, was an Ocean City native. Almost 250 babies and children were in the parade as well as 600 musicians in 10 bands and bugle corps. There were eight divisions: babies in fancy decorated coaches and carts, babies in comic-decorated coaches and carts, children in fancy costume with doll coaches, children in comic costume with doll coaches, children walking in fancy costume, children walking in comic dress, characters and impersonations, and floats.

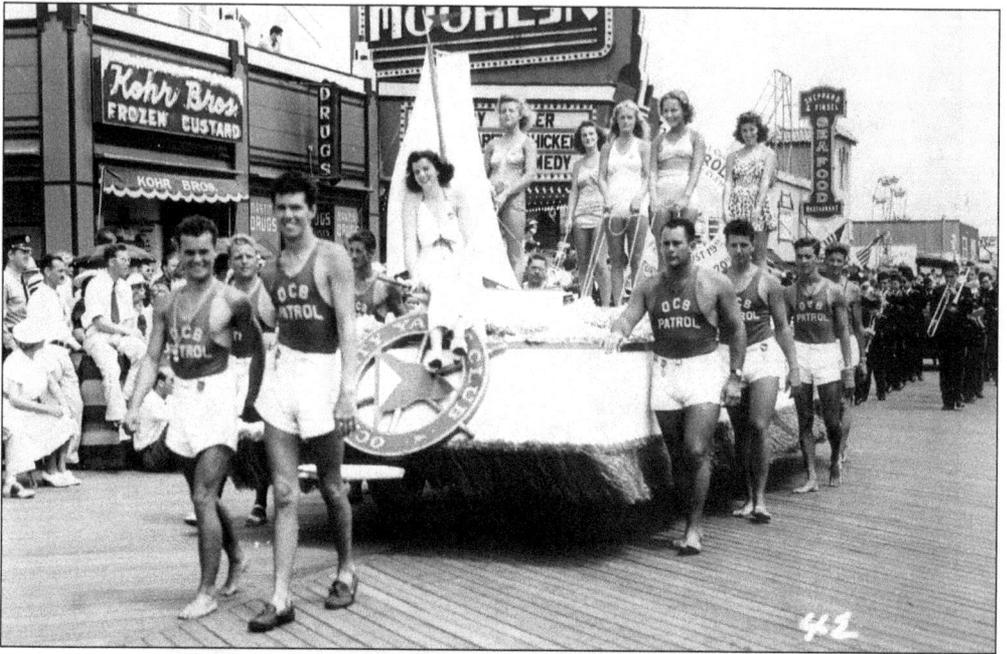

According to the *Ocean City Sentinel-Ledger*, "Ocean City devotes itself to the most colorful and eagerly awaited pageantry of the season—the annual Baby Parade." Members of the Ocean City Beach Patrol accompany the Ocean City Yacht Club float as it participates in the pageantry during the August 11, 1938, baby parade. (Courtesy of Ocean City Lifesaving Museum.)

Lenore Horner of Ocean City got a big response from the crowd as she marched down the boardwalk during the August 11, 1938, baby parade. (Courtesy of OCHM.)

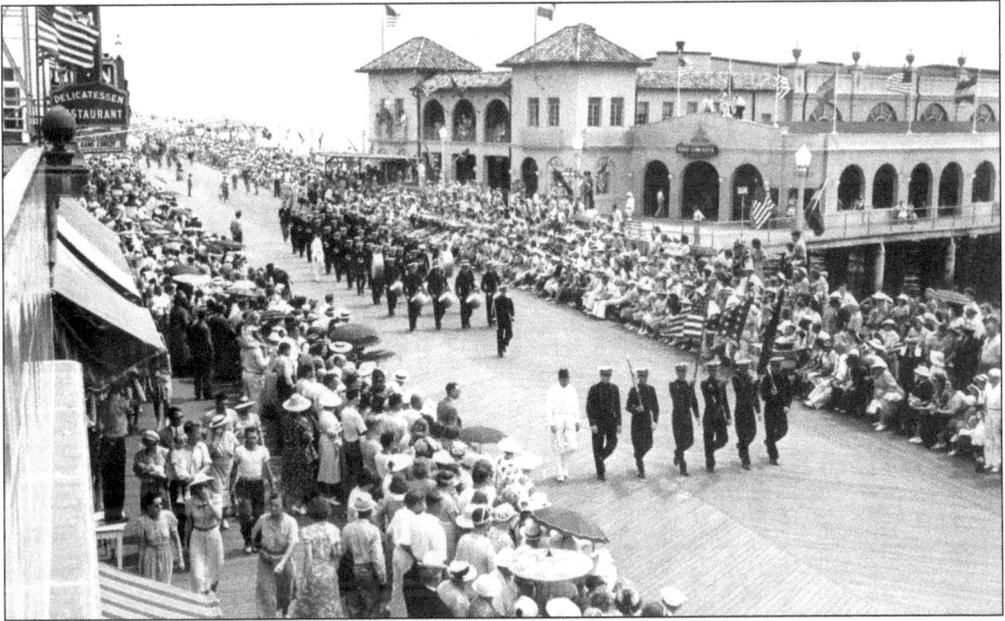

The Cape May County American Legion band passes the reviewing stand in front of the Music Pier during the August 18, 1939, baby parade. The American Legion band entertained spectators on the boardwalk for an hour before the parade. Fifteen championship bands and bugle corps, interspersed between groups of contestants, participated in the parade, the most musical groups ever. (Photograph by Atlantic Studios, courtesy of OCHM.)

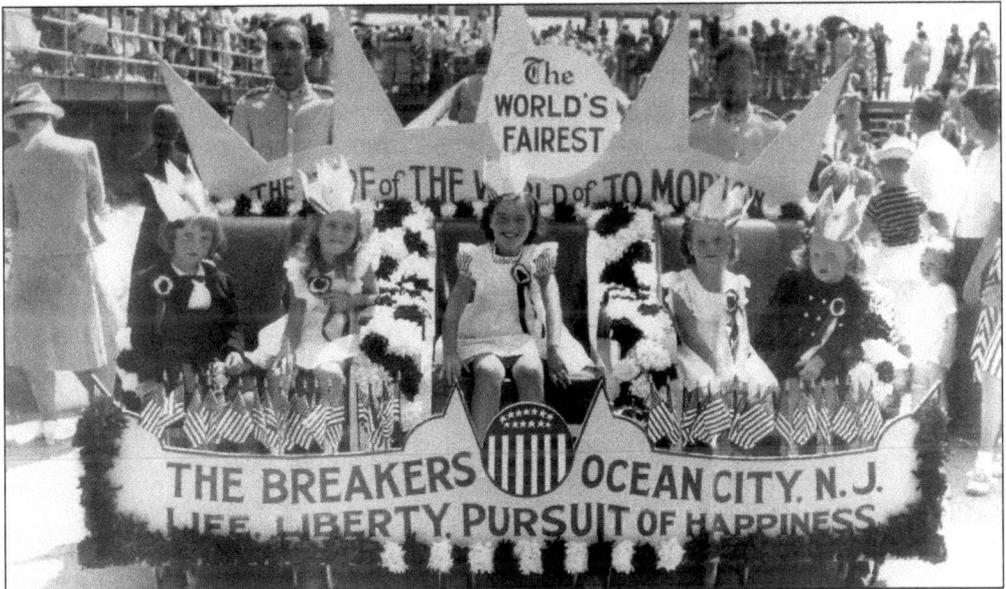

The Breakers Hotel, located at Delancey Place, was the first hotel on the boardwalk. In 1939, it sponsored this prize-winning entry in the August 18 baby parade. The 1939 New York World's Fair opened a few months before the parade, and borrowing from the fair's theme, the float was called "the World's Fairest, the Hope of the World of Tomorrow." The children, from left to right, are Jay Waterfield, Eleanor Sheridan, Jane Porter, Betty Isen, and Lynne McDevitt. (Courtesy of OCHM.)

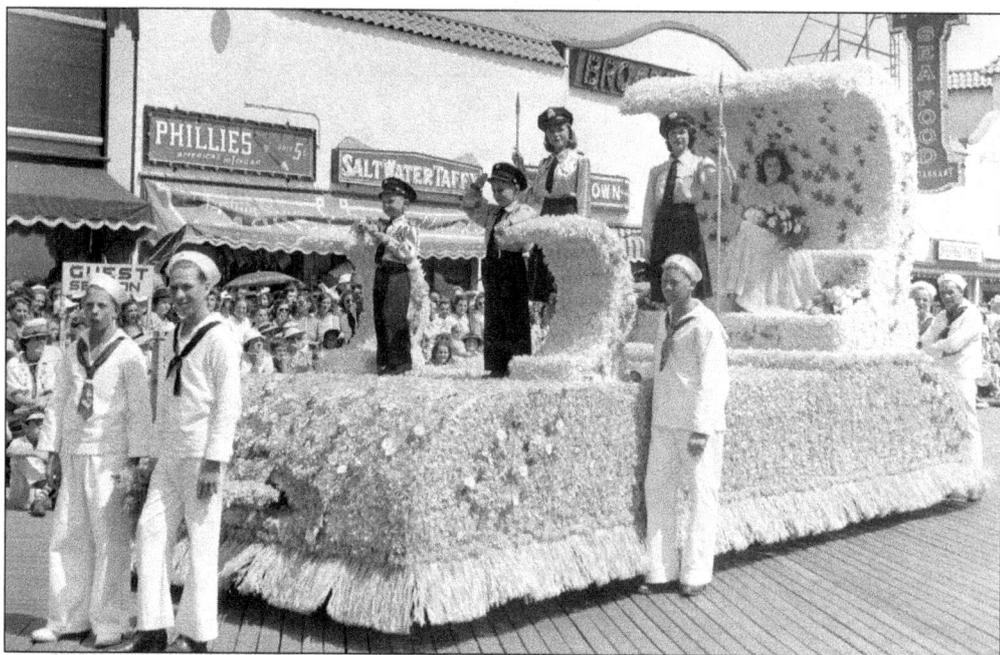

This public safety float was in the August 16, 1940, baby parade. From left to right, Sea Scouts Mike Blizzard, Jack Jernee Jr., and Ben Dungan accompany the float down the boardwalk. Garry Powel, on the float, salutes. Seven award-winning bands and bugle corps, marching between the contestant divisions, played for the crowd of spectators.

Peggy Ann Huff, at 23 months old, won the grand prize in the August 16, 1940, baby parade. A committee of five physicians, Dr. Herschel Pettit, Dr. John B. Townsend, Dr. C. Eugene Darby, Dr. Aldrich C. Crowe, and Dr. Allen Corson, chose Huff as the champion baby.

The 1941 baby parade was held on August 15. Helen Elizabeth Ryan of Lakewood, Ohio, was Queen Infanta. She is holding nine-month-old Eleanor Ann Steelman, who was named grand champion gold cup winner of the baby parade, and Steelman's trophy. The 1941 parade was the first to be broadcast on the radio. WBAB out of Atlantic City had two radio commentators giving a running description of the parade.

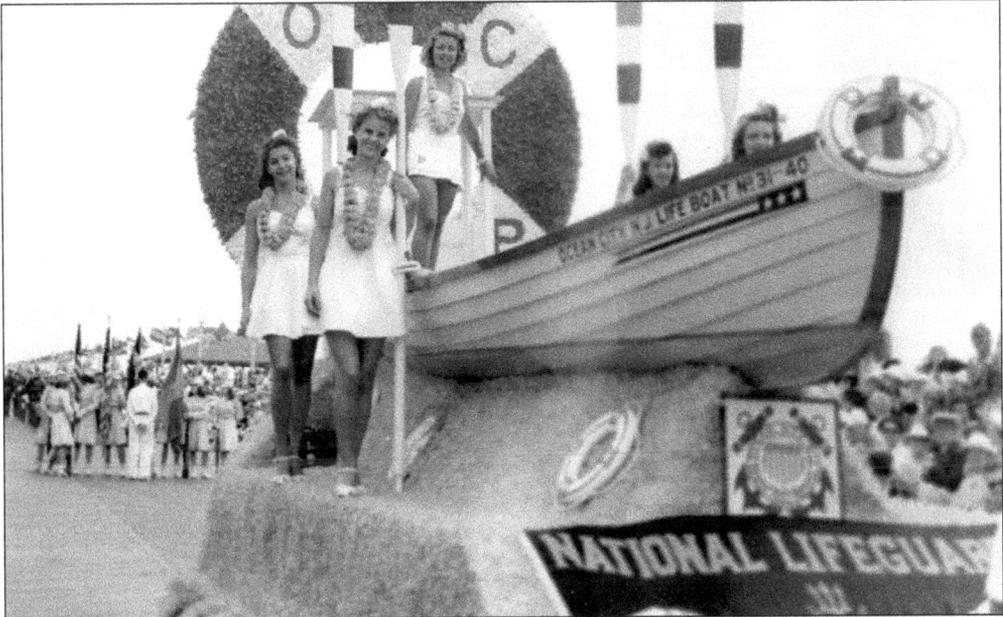

This Ocean City Beach Patrol float, one of four floats entered by city government departments, appeared in the 1941 baby parade. The Ocean City lifeguards dominated the national lifeguard tournaments during the 1930s. This float celebrated the beach patrol's national lifeguard championship teams. Standing at the top of the float is Laura Lee Courtney, Miss Ocean City Beach Patrol. (Courtesy of Ocean City Lifesaving Museum.)

The Annual Baby Parade

This page from the 1942 *Ocean City Guide* features pictures of the 1941 baby parade. Shown from left to right are the Ocean City Beach Patrol float, one of the entries, and Queen Infanta Helen Elizabeth Ryan holding grand champion Eleanor Ann Steelman. The 36th annual baby parade was held on July 29, 1942, but it was smaller than usual. Many parents felt that, because of the war, they could not afford costumes or decorations that year, so special divisions for undecorated coaches and for children walking without costumes were added. Both of these divisions were judged, and the children were awarded prizes.

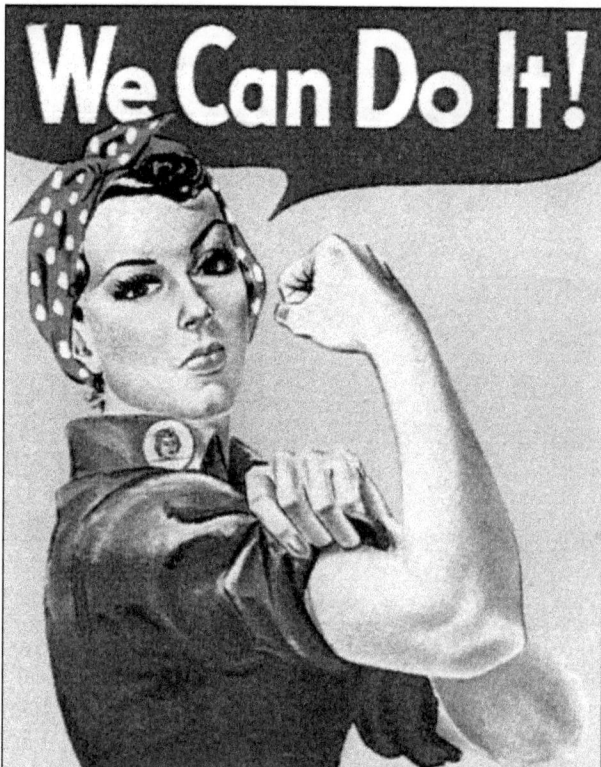

On this World War II poster, Rosie the Riveter says, "We Can Do It!" But in Ocean City, it was "we can't do it!" It was decided that the baby parade would not be held in 1943 because of the war.

Three

BABY BOOMERS
LOVE A PARADE

Ocean City, like every other city in America, suffered during World War II. Local men and women were fighting on both fronts, and the townspeople were doing what they could to aid the war effort. But the business of the city had to go on, and the main business of Ocean City was tourism.

One of the biggest attractions for the summer crowds was the baby parade, but, after much discussion, it was decided the parade of 1943 would not be held. So many of the city's workers, policemen, firemen, and public works men were in the military, that Mayor Clyde W. Struble and publicity director Norman V. Sargent felt the baby parade could not have the help needed to run it properly. The parade was also not held in 1944 and 1945.

By 1946, with the world at peace, Ocean City was again ready to hold its famous baby parade. Russell and Evelyn Hanscom, summer residents who owned a home facing the Great Egg Harbor Bay in the Gardens section of the city, volunteered to be in charge. The Hanscoms had big ideas for the first baby parade to be held since 1942, and all of their ideas were realized.

The day of the parade was August 14, 1946, V-J Day, and a citywide celebration was held. Dignitaries from Philadelphia were honored guests, and Philadelphia Day was observed. The baby parade, with many lavishly decorated floats, began the day. It was followed by a demonstration of a helicopter rescue at sea in front of the Music Pier. Later in the afternoon, sail and speedboat races took place in the bay. A scrumptious dinner at the Hanscom Hotel was then served to the visiting and city officials followed by a wonderful fireworks display. It was the biggest one-day celebration in the history of the resort.

Under the Hanscoms' leadership and with a dedicated parade committee, the Ocean City Baby Parade continued to grow and to attract ever-increasing crowds of spectators.

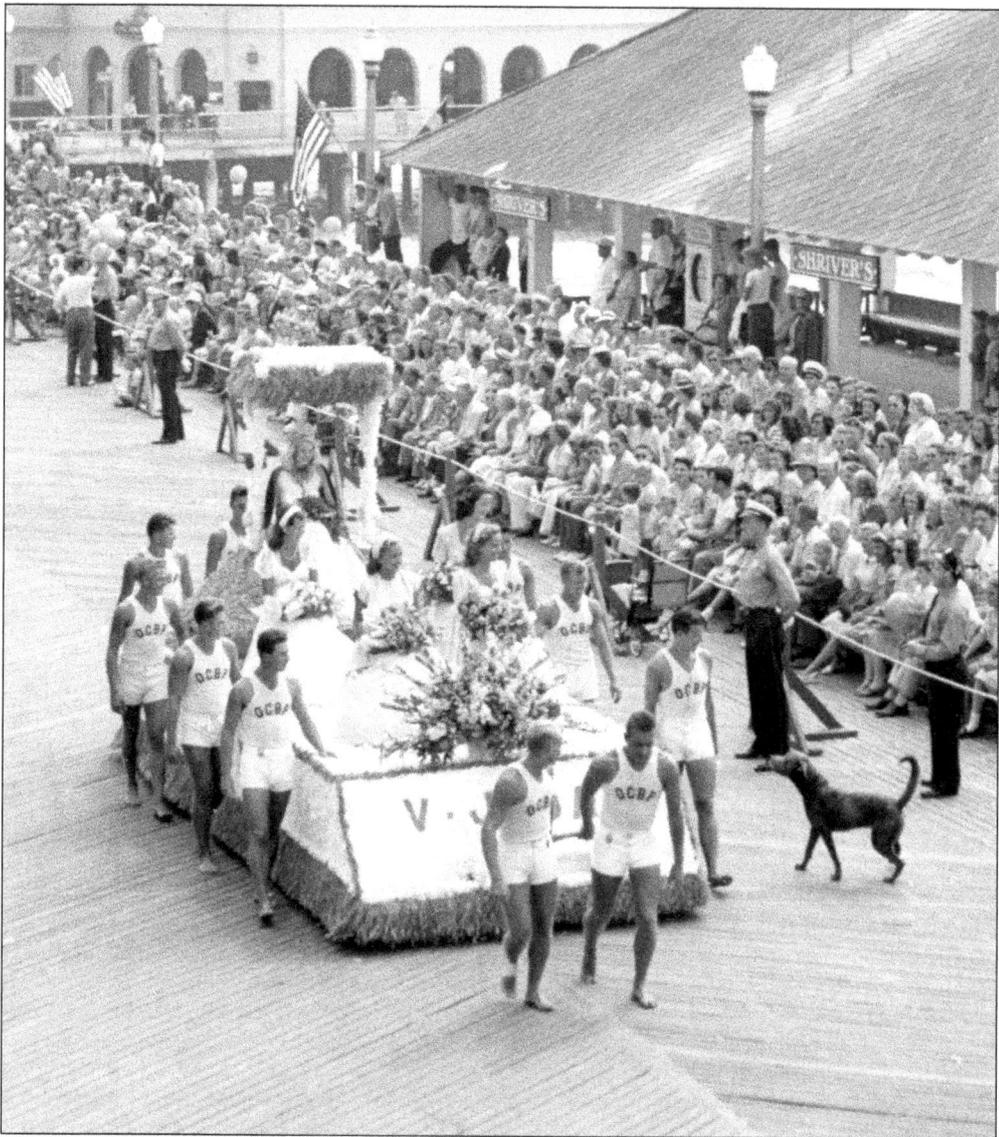

Ocean City's first baby parade since the end of World War II was held on August 14, 1946. It was part of a gala festival celebrating the first anniversary of V-J Day and Philadelphia Day. Officials from Philadelphia, headed by Mayor Bernard Samuel, came to town in a motorcade accompanied by police on motorcycles. Ocean City lifeguards accompanied Queen Infanta's float. Charlotte Benkert was Queen Infanta, and her ladies-in-waiting were Sally Kinnard, Carleen Lohmeyer, Barbara Furlong, and Virginia Sykes. The parade organizers decided that because of the large number of entrants and the size of the expected crowd of spectators, all judging would be done before the parade started. This allowed the spectators along the parade route to recognize the winners. (Courtesy of Ocean City Lifesaving Museum.)

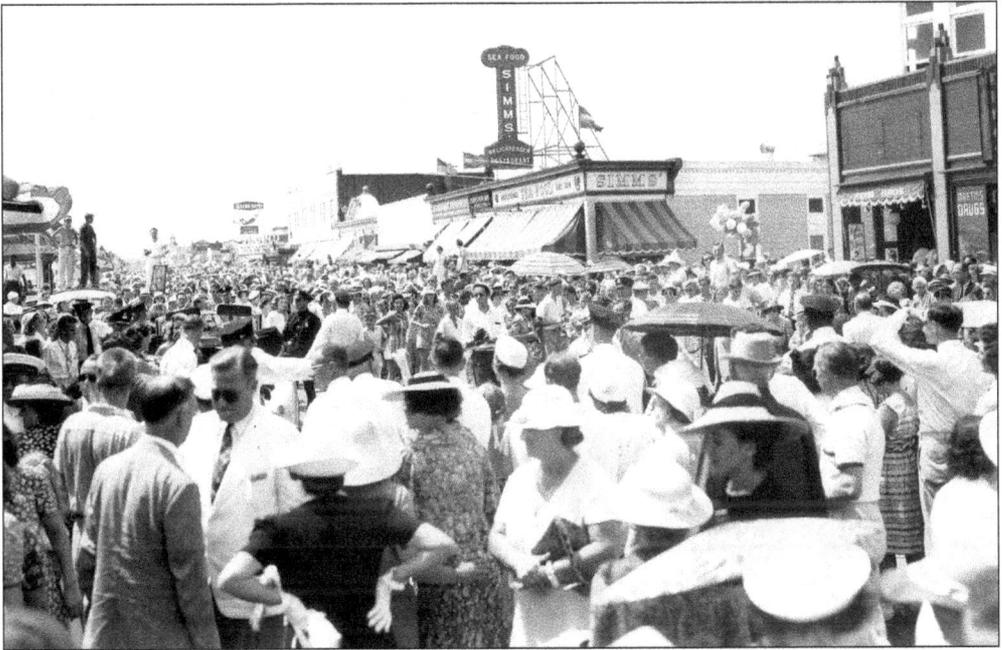

August 14, the day Ocean City held the 1946 baby parade, was the biggest one-day celebration in the history of the resort. The day was a celebration of the first anniversary of V-J Day; Philadelphia Day, a way to celebrate Ocean City's close ties to Philadelphia; and the first baby parade since the end of World War II. The crowds on the boardwalk were enormous.

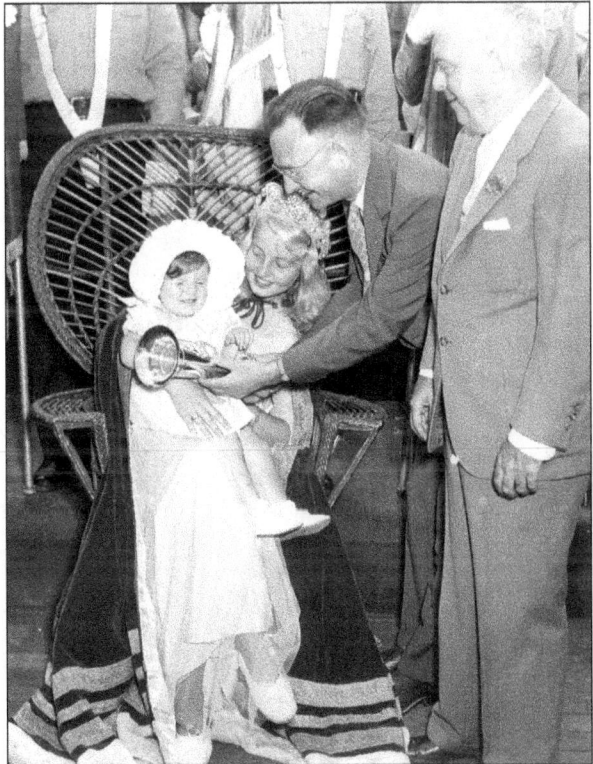

Queen Infanta Charlotte Benkert holds champion baby Virginia Marie Gensemer as Ocean City mayor Clyde W. Struble (left) and Philadelphia mayor Bernard Samuel admire Gensemer's trophy during the August 14, 1946, parade.

Part of the festivities of August 14, 1946, was a simulated rescue of a man from the ocean. A helicopter, piloted by Maj. Frank Cashman, took off from the beach in front of the Music Pier and hovered over the "victim," Ocean City lifeguard James Duncan. Lifeguard Lou Woyce, in the helicopter, tossed Duncan a life buoy tethered to a hook in the plane and then leaped into the ocean to help the victim. The two lifeguards, clinging to the buoy, were then dragged to the beach by the helicopter. Queen Infanta Charlotte Benkert was a passenger in the helicopter during the rescue. (Courtesy of Russell Hanscom.)

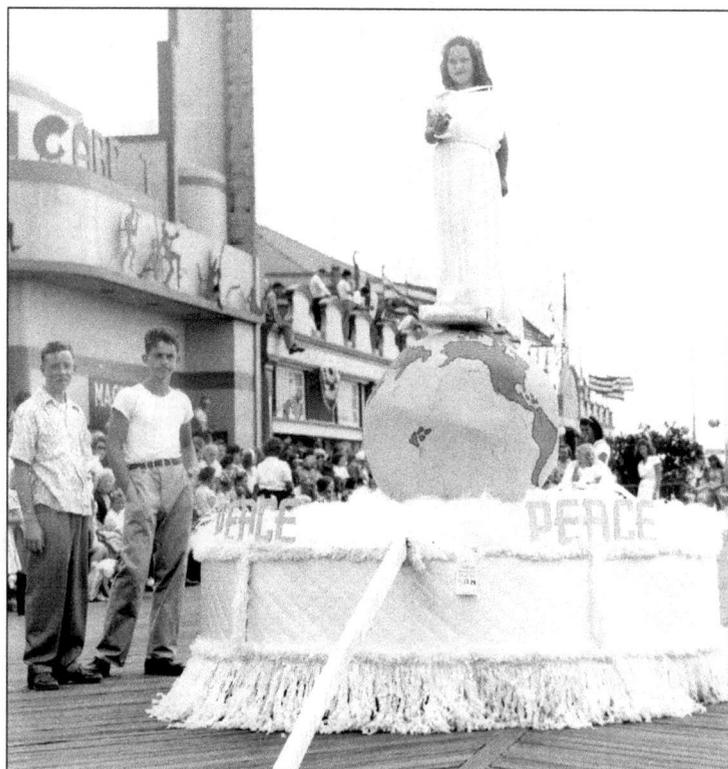

Peace was a common theme in the August 14, 1946, baby parade, the first held since the end of World War II.

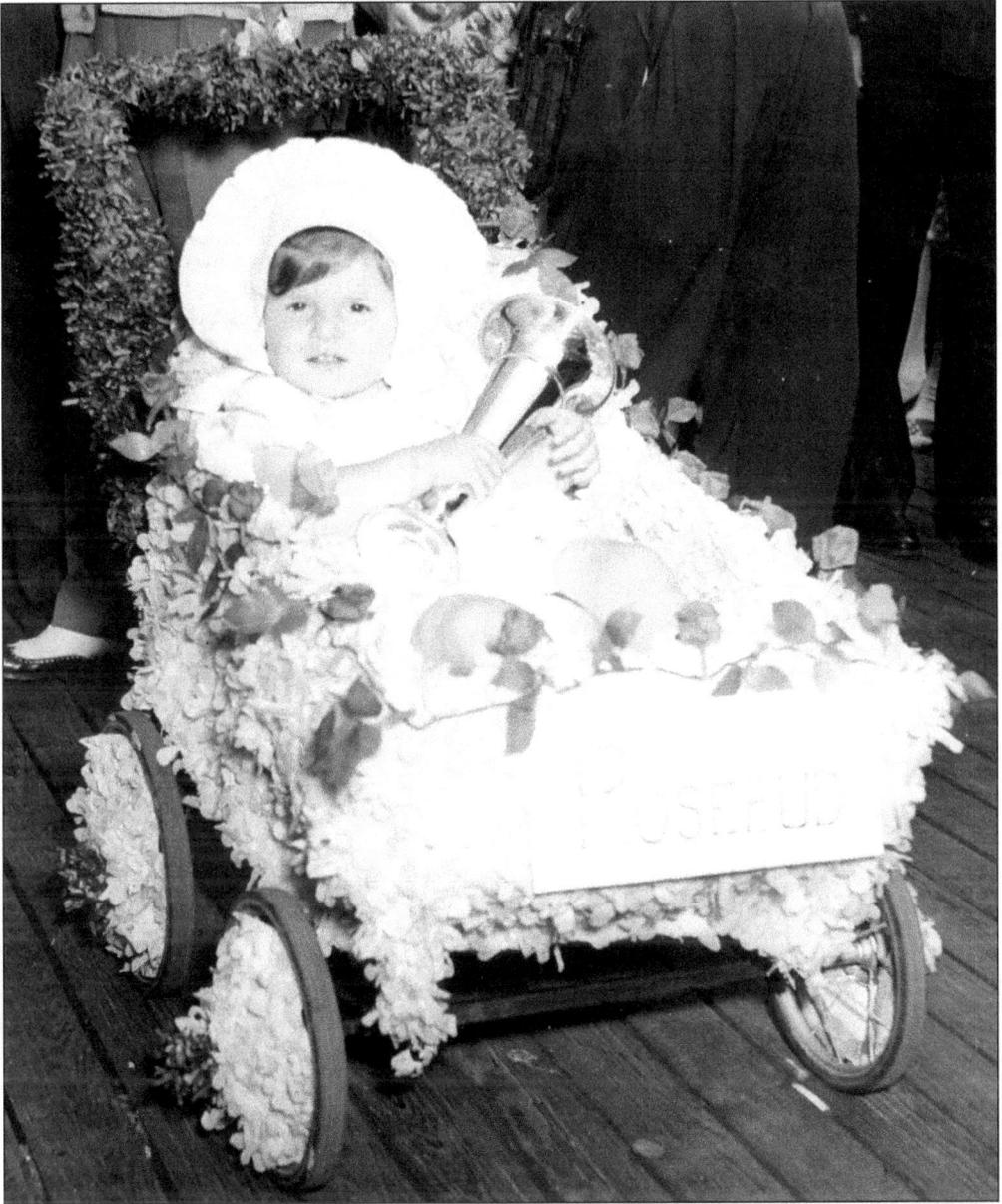

Virginia Marie Gensemer, "Rosebud," of Ocean City, was named champion baby of the August 14, 1946, baby parade. She was chosen by a committee of physicians who judged on the basis of health and general physical condition from more than 300 entries. Her father, John Gensemer, was a former B-29 pilot in the Pacific theater. The family lived at 147 Asbury Avenue. Champion baby could be chosen from any of the divisions on the basis of health and general physical perfection. Besides champion baby, awards were to be given to the best entries in the fancy, comic, and float divisions. A blue ribbon was awarded to the best commercial entry.

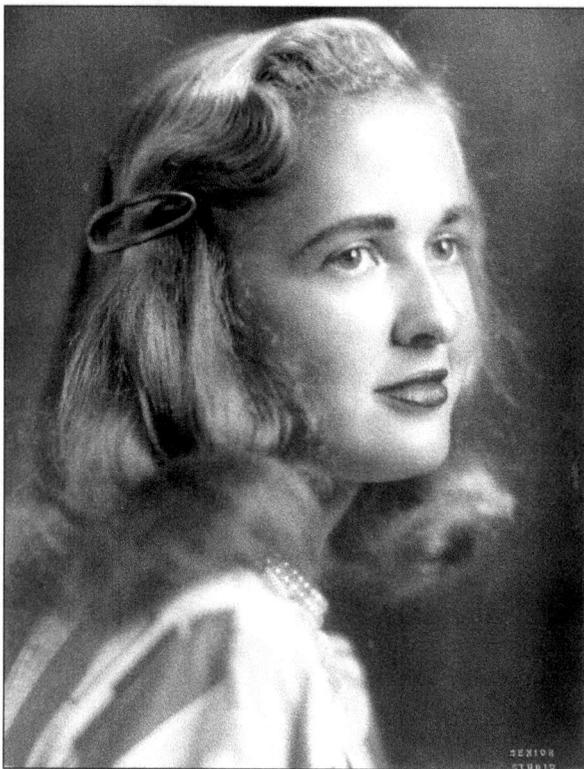

Carleen Lohmeyer of Philadelphia reigned as Queen Infanta during the V-J Day and Philadelphia Day baby parade of August 14, 1947. The parade, considered the "event of the season" by the *Ocean City Sentinel-Ledger*, was the first to be covered for television. A cameraman from WFIL in Philadelphia took movies for a later broadcast. Jack Stock of WFIL introduced honored guests over the public address system.

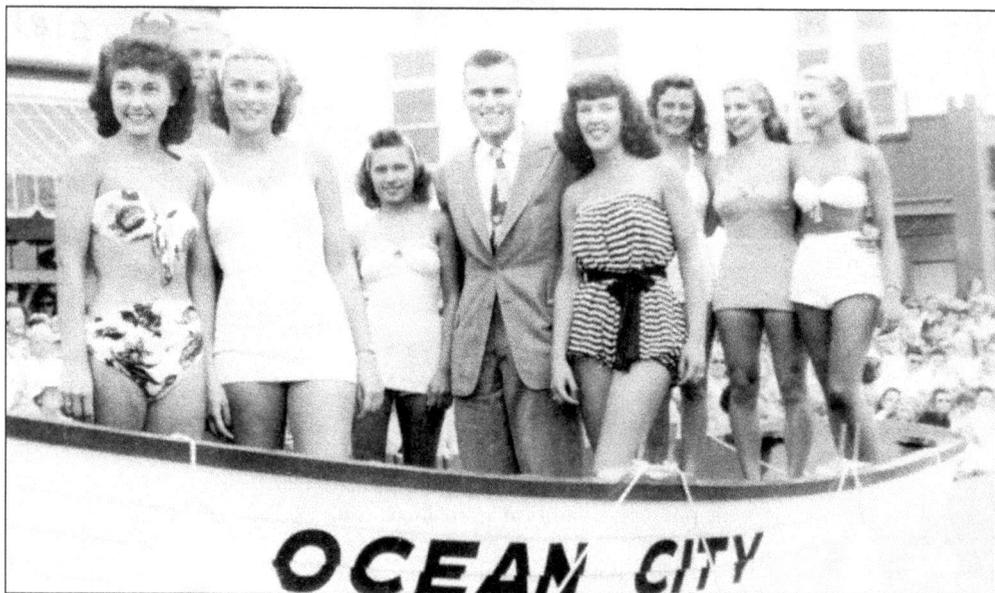

The 38th Ocean City Baby Parade was held on August 14, 1947. Jack Kelly, a former Ocean City Beach Patrol member who had gained fame earlier that summer by winning the Diamond Sculls event of the Royal Henley Regatta in England, was an honored guest. Standing with him in the lifeguard boat is, second from left, his 17-year-old sister, Grace, future Academy Award–winning movie actress who became Princess Grace when she married Prince Rainier of Monaco in 1956. (Courtesy of Ocean City Lifesaving Museum.)

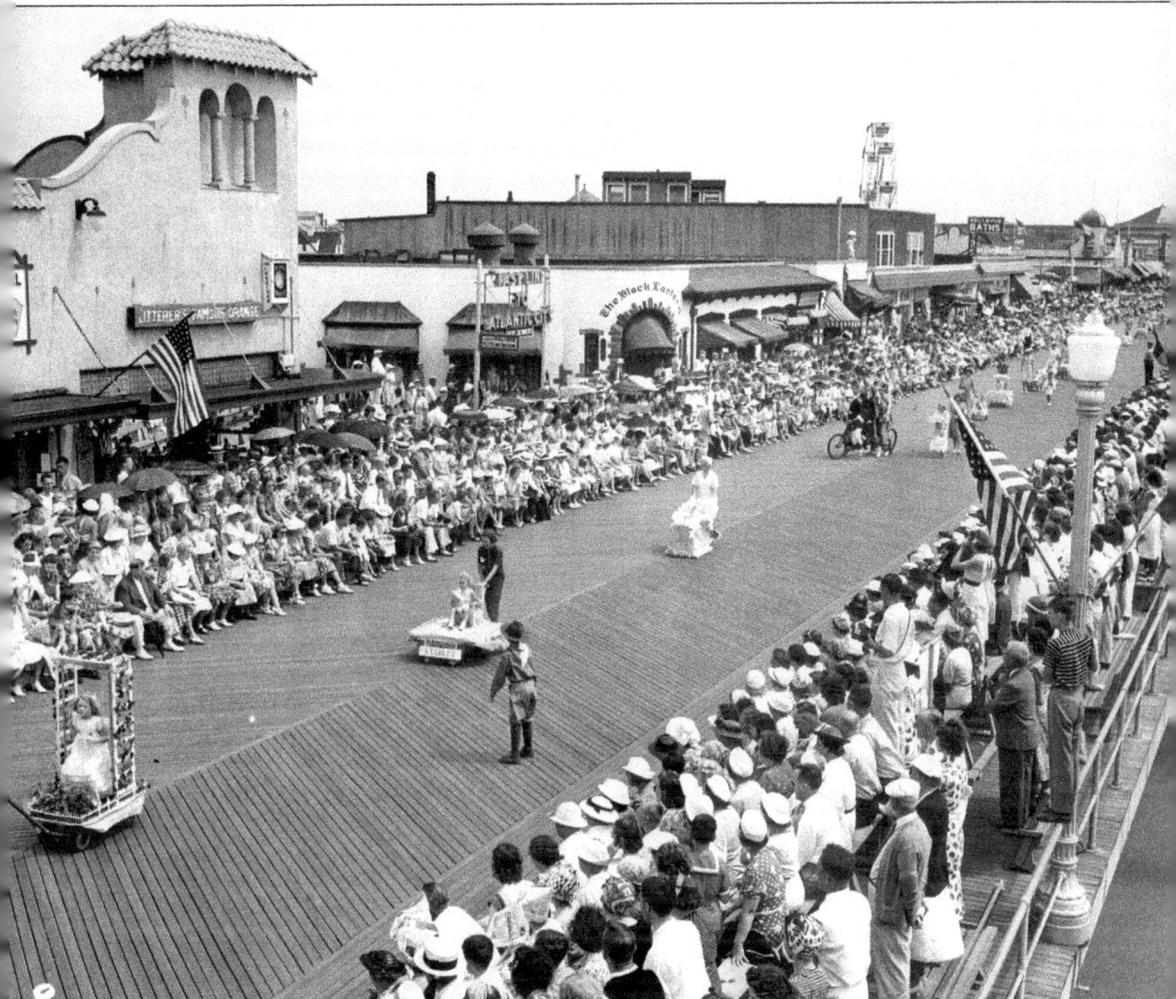

The August 14, 1947, baby parade, with spectators lining the boardwalk, had over 200 entrants. These children are being helped down the boardwalk on their small floats. A month after newspapers coined the phrase *flying saucer*, when an unidentified flying object was sighted in Washington State, Francis P. Kenny won third prize in the comic division dressed in a white outfit and surrounded by paper plates, riding down the boardwalk in a stroller labeled, "the Flying Saucer." Kenny, age 19 months, was also awarded the first-prize trophy as the grand champion baby by a committee of physicians on the basis of health and good looks. (Courtesy of Russell Hanscom.)

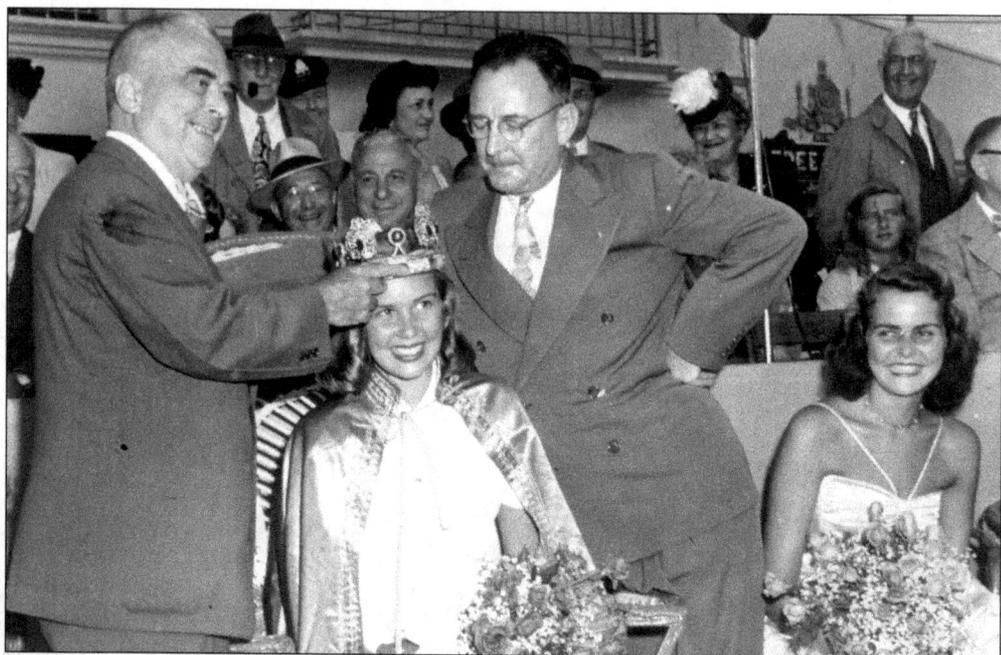

Philadelphia mayor Bernard Samuel (left), seen here as part of the third annual Philadelphia Day, joins Ocean City mayor Clyde W. Struble in crowning Joy Smith as Queen Infanta for the August 12, 1948, baby parade. Helen Newton from Rome, Georgia, one of Queen Infanta's ladies-in-waiting, is on the right. The other ladies-in-waiting were Margie Jones of Philadelphia, Jean Clark of Riverton, and Jinny Hall of York, Pennsylvania. (Courtesy of Doug Longenecker.)

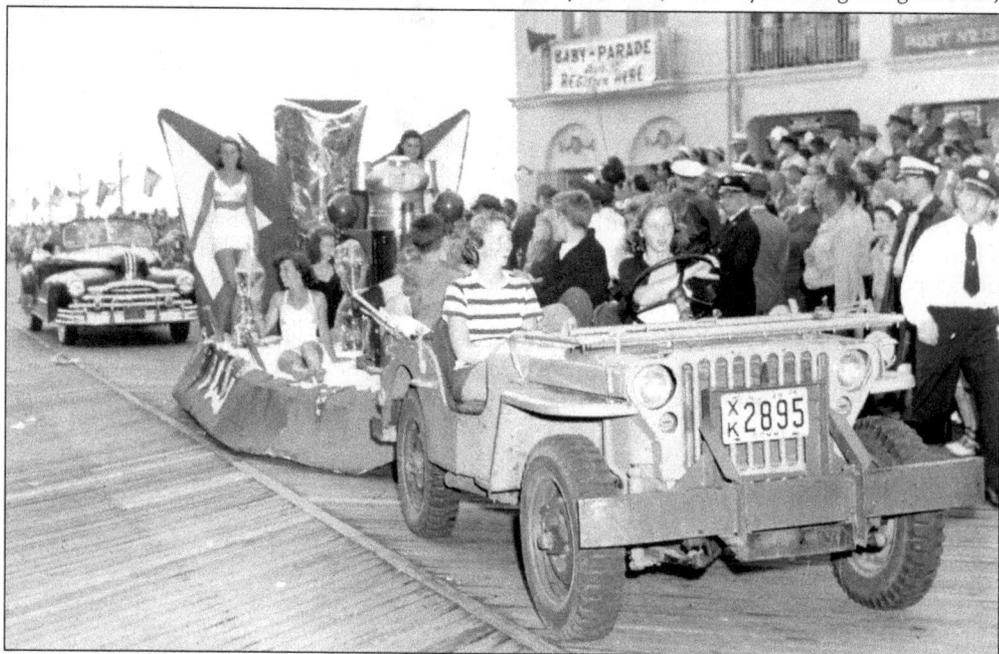

This yacht club float took first place in the commercial float division of the August 12, 1948, baby parade. A jeep pulled the float that held bathing girls, racing trophies, a binnacle, and a cannon. Another yacht club jeep towed sailboats and their skippers. (Courtesy of Doug Longenecker.)

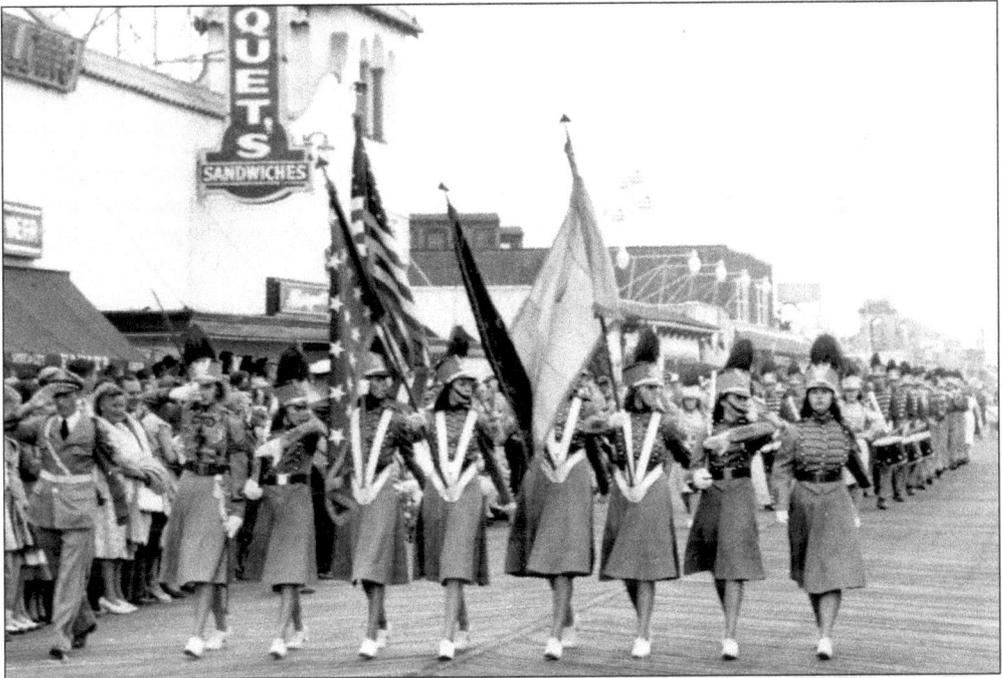

The August 12, 1948, baby parade had to be postponed from the morning until the afternoon because of rain. This color guard and band did not let the overcast sky affect their performance. After the parade, Mayor Clyde W. Struble hosted a formal dinner for Philadelphia Day guests at the Hanscom Hotel. At the end of the evening, there was a fireworks display off the beach between Fifth and Sixth Streets. (Courtesy of Doug Longenecker.)

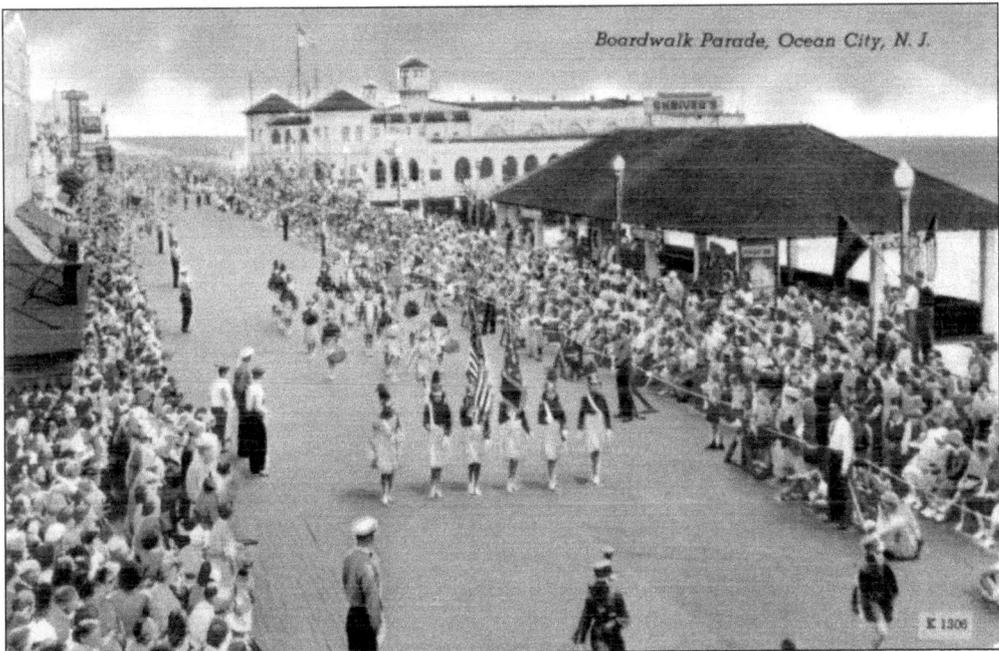

This postcard of a band marching down the boardwalk during the baby parade was one of the most popular sent from Ocean City during 1948.

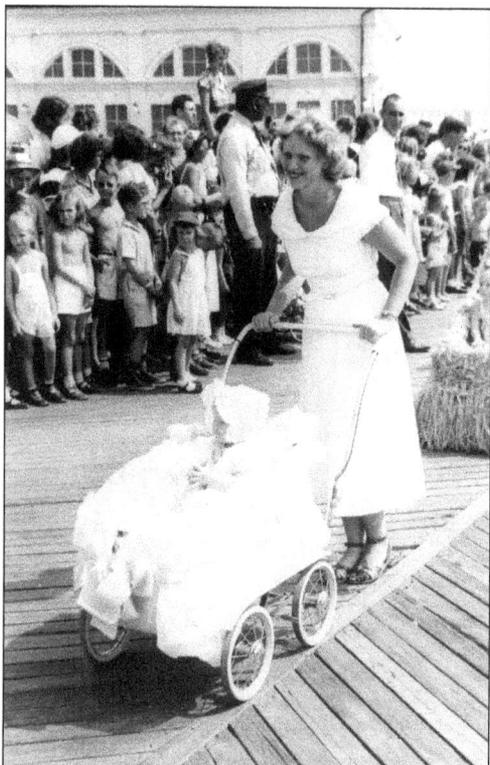

A committee of doctors chose blonde, blue-eyed, nine-month-old Joan Adeline Lentz of Philadelphia as grand champion baby of the August 11, 1949, baby parade. Quadruplets were entered in the parade for the first time. Four-and-a-half-year-old Maureen, Kathleen, Eileen, and Michael Cirminello came from Arlington, Virginia. The family stayed at the Oceanic Hotel.

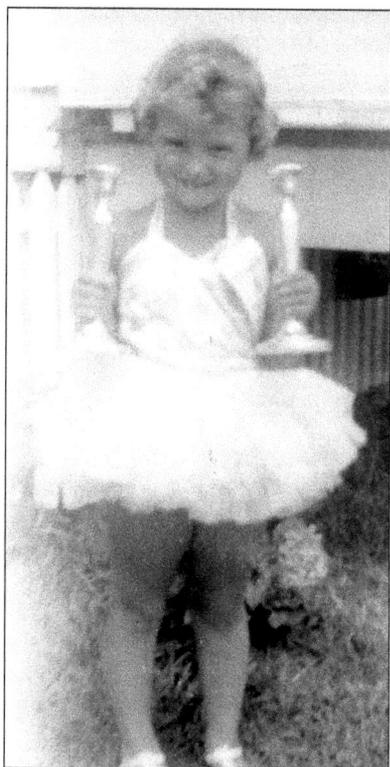

Flossie Crooks holds the silver candlesticks she was awarded during the August 11, 1949, baby parade. Crooks was one of 300 children entered in the parade. Queen Infanta of 1940, Esther Jane Mayer, who was married to William Hooper and living in Philadelphia, entered her youngest child, Gerard Michael, in the parade. (Courtesy of Marion and Ned McCaughey.)

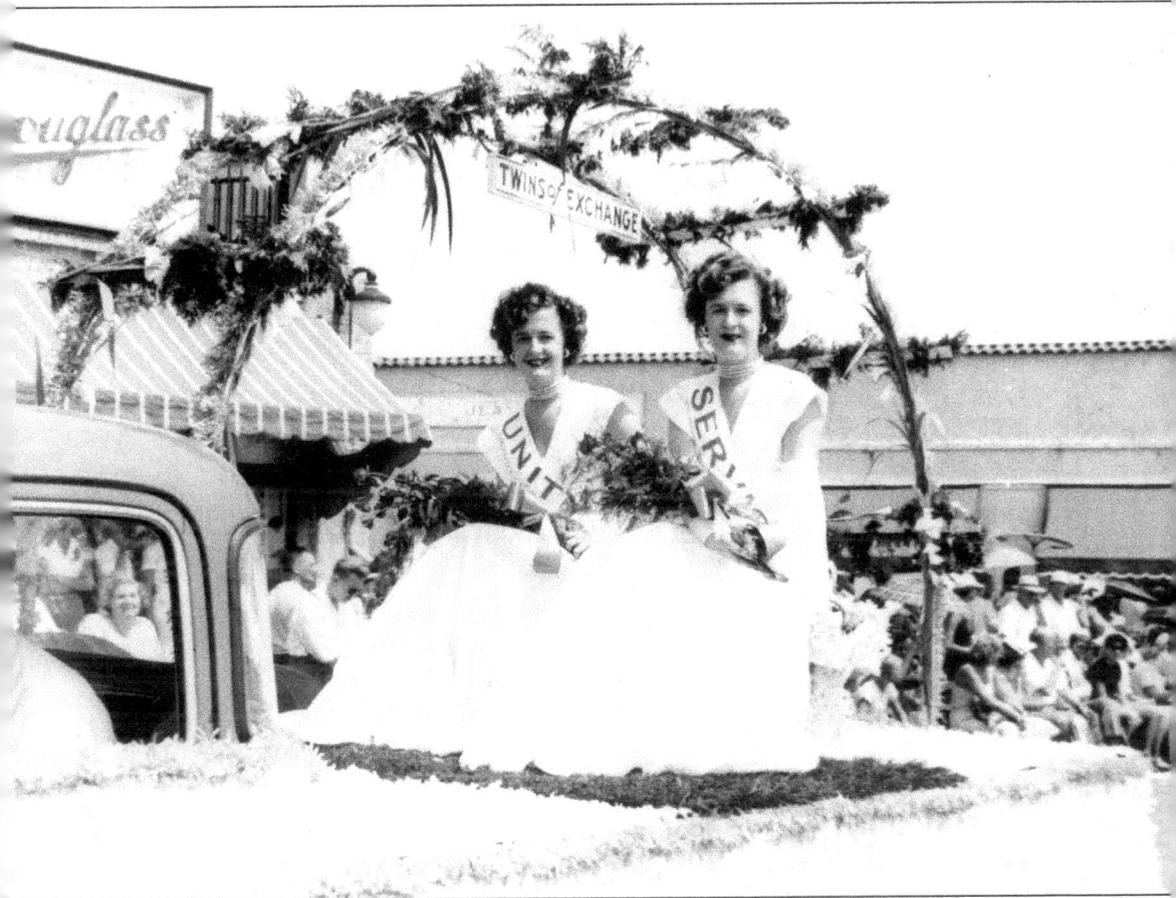

This Exchange Club float was in the August 11, 1949, baby parade. Exchange Club is a national service organization. The float featured Ocean City's Voss twins, Rosemary Margaret and Anneliese Hanna, wearing banners of "Unity" and "Service," the twin mottoes of the Exchange Club. The girls' father was a member of the Exchange Club. About 35,000 spectators watched more than 200 children march in the parade. It was so hot during the day that mothers of several of the children took them out of the parade before they reached the judging stand. (Courtesy of OCHM.)

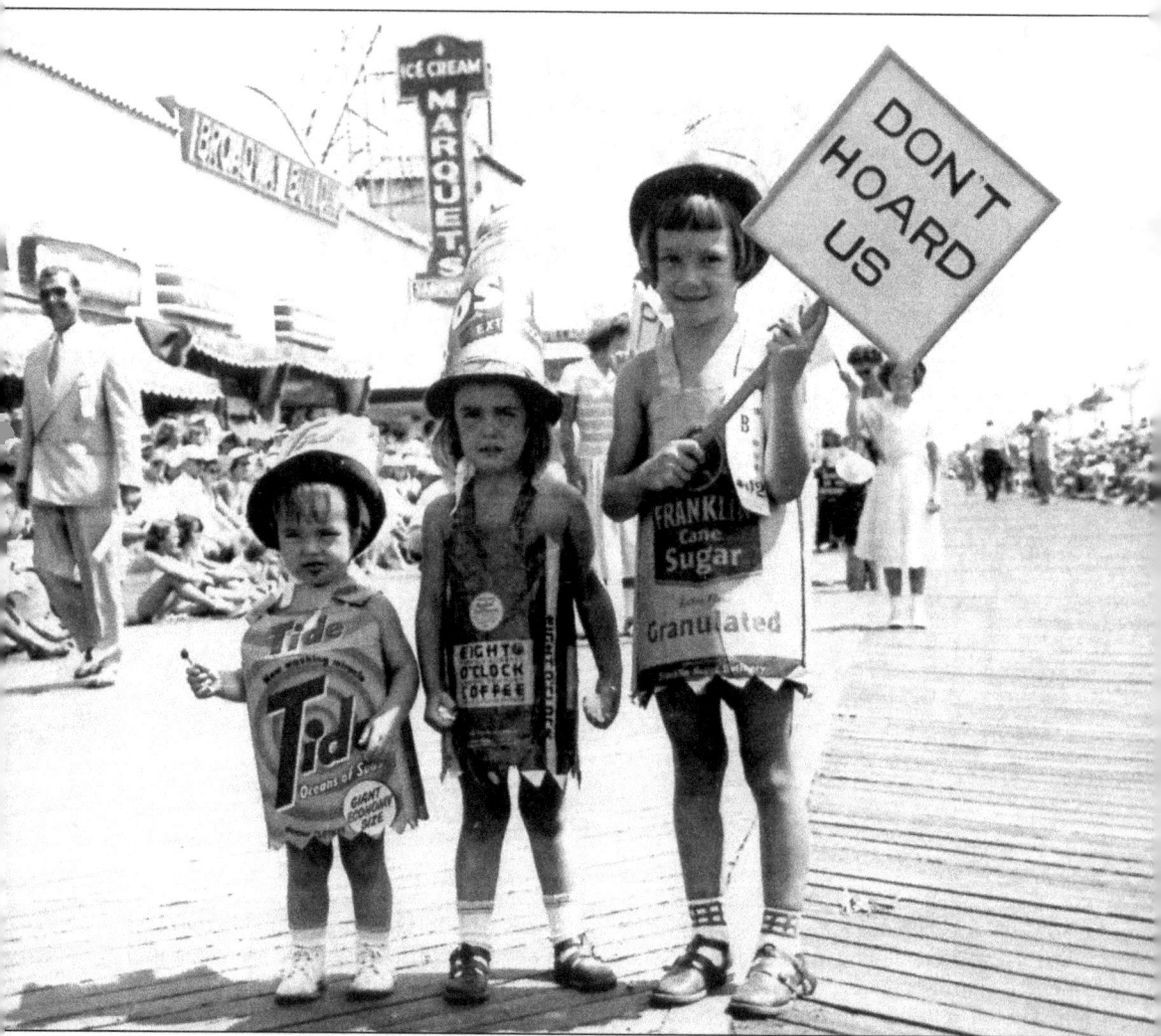

From left to right, sisters Ginny, Joyce, and Carol Haug walk the boardwalk during the August 18, 1950, baby parade. The girls, dressed as a box of Tide detergent, a can of Eight O'Clock coffee, and a bag of Franklin cane sugar, with Carol holding a sign stating, "Don't Hoard Us," won first place in the comic division. There were three other divisions in the parade, including fancy costume, ornate floats, and commercial entries. Ocean City resident Mary Henderson Parker was Queen Infanta. One-year-old Carol and Doris Pamplin were chosen as best twins. As a grand finale to the parade, a calliope, pulled by six ponies, played music for the crowd. (Courtesy of Ginny and Ron Gifford.)

Four-year-old Sandy Morey is hoping to win a prize for her float as she waits in the staging area before the August 9, 1951, baby parade. Prizes were provided by the city, which sponsored the parade in cooperation with businesspeople and a large committee of summer residents who served as judges and marshals. (Courtesy of Sandy Morey McAfee.)

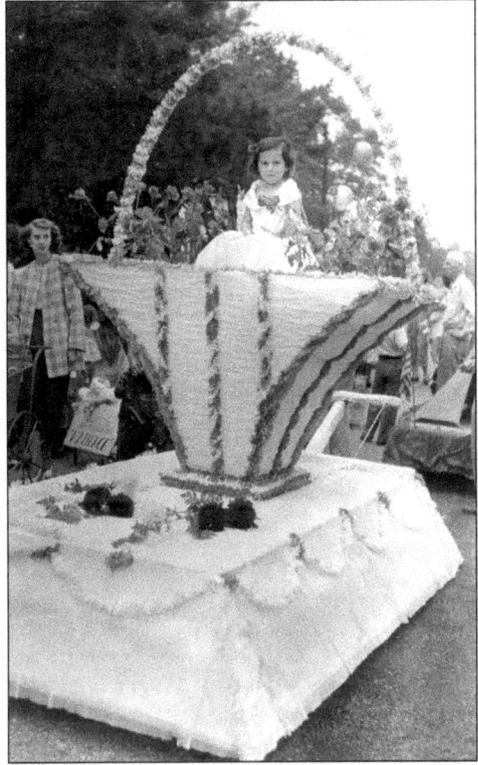

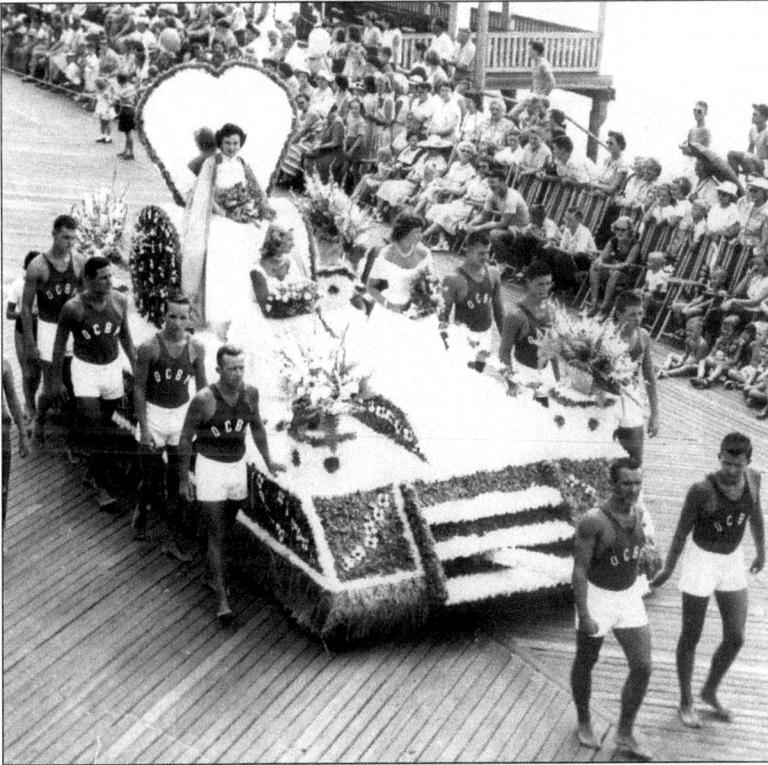

Bernice Massi, Miss New Jersey 1951, reigned as Queen Infanta during the August 9, 1951, baby parade. Jeanne Morris (left) and Carolyn Mears are her ladies-in-waiting, as they ride down the boardwalk on their float. Ten Ocean City lifeguards accompany Queen Infanta's float. (Courtesy of Senior Studios.)

Two-year-old Mary Louise Hayes, dressed as a southern belle, won a prize in the fancy dress division in the August 9, 1951, baby parade. For prizes, the competition was divided into divisions for fancy dress, comic dress, small and large floats, and commercial. (Courtesy of Mary Lou Hayes.)

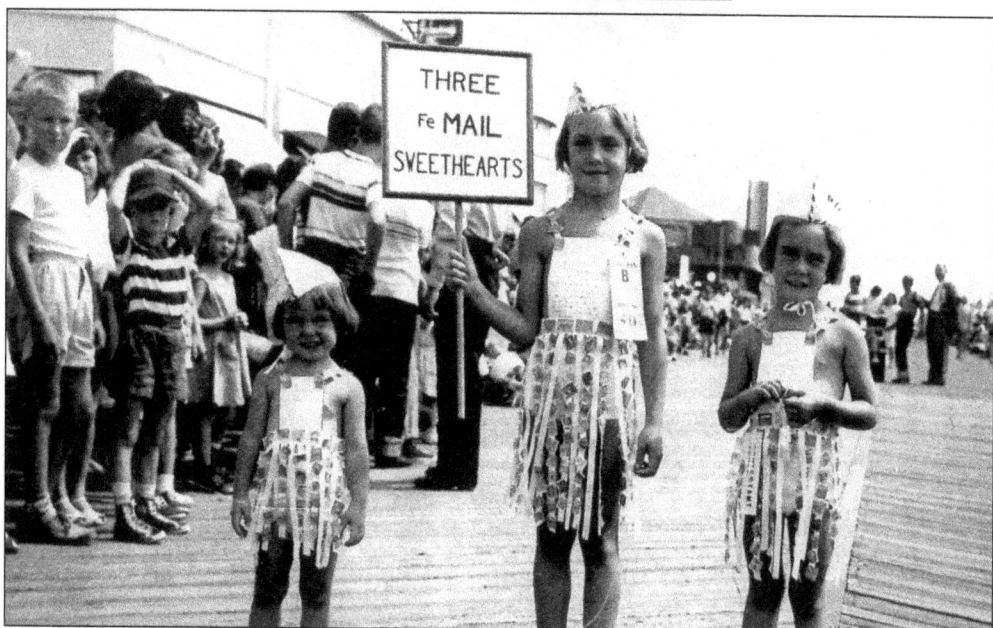

Pictured from left to right, the Haug girls, Ginny (age three), Carol (age seven), and Joyce (age four), are dressed as "Three FeMail Sweethearts" when they walk in the August 9, 1951, baby parade. They won a second-place award in the comic division. More than 20 major prizes were awarded in the various divisions. A special prize was given for twins. (Courtesy of Ginny and Ron Gifford.)

43rd Annual Baby Parade

DATE—THURSDAY, AUGUST 14, 1952

TIME—9:30 A. M. (Formation).

PLACE—On the BOARDWALK at 6th St.

ENTRY FEE—50c.

DIVISIONS

DIV. A—Children in **FANCY** Decorated, Go-Carts, Strollers, Coaches, Kiddie Cars, Express Wagons, Etc., or Walking.

DIV. B—Children in **COMIC** Decorated Go Carts, Strollers, Coaches, Kiddie Cars, Express Wagons, Etc., or Walking.

DIV. C.—FLOATS—All Vehicles, including Express Wagons and Baby Carriages, with tops or sides built or added, measuring more than the over-all size of the Vehicles.

DIV. D—COMMERCIAL FLOATS—Entered by Hotels, Business Concerns, Etc.

SPECIAL AWARD—Entered in Any Division

CHAMPION 1952 BABY—Selected by a committee of doctors from among the babies entered in the parade.

REGISTRATION HEADQUARTERS—Information Bureau at Music Pier, Boardwalk and Moorlyn Terrace.

All participating in parade to be eligible for prizes, must be in line by 9:30 A. M. Parade moves promptly at 10:30 A. M., and all judging will be done at formation of Parade.

FORMATION OF PARADE—All Divisions, except C and D, will form inside of Convention Hall, Sixth and Boardwalk. Division C forms on Boardwalk, between Fifth and Sixth Sts. Division D forms on Boardwalk, between Fourth and Fifth Streets.

ROUTE OF PARADE—Sixth to Twelfth Street on Boardwalk.

REVIEWING STAND at Music Pier.

In the event of rain, the parade will be postponed at the discretion of the committee.

(RETAIN THIS SHEET FOR YOUR INFORMATION)

Thursday, August 14, was the day of the much-anticipated 1952 baby parade. Flyers were handed out with information on entering to anyone showing the slightest interest. Rules of the parade were listed on the back. The first rule read, "In all contests, the decoration subject, theme and costumes worn by those taking part are to be considered by the judges." "Any child under twelve years of age may compete, but the Director of the Pageant reserves the right to refuse any entry" was another rule. "To prevent late comers from disorganizing the work, any contestant may be declared ineligible who is not at the Convention Hall, Sixth Street and Boardwalk, 30 minutes before starting time," read another. While anyone could enter the parade, fairly strict rules had to be adhered to so that order could be kept with so many young entrants.

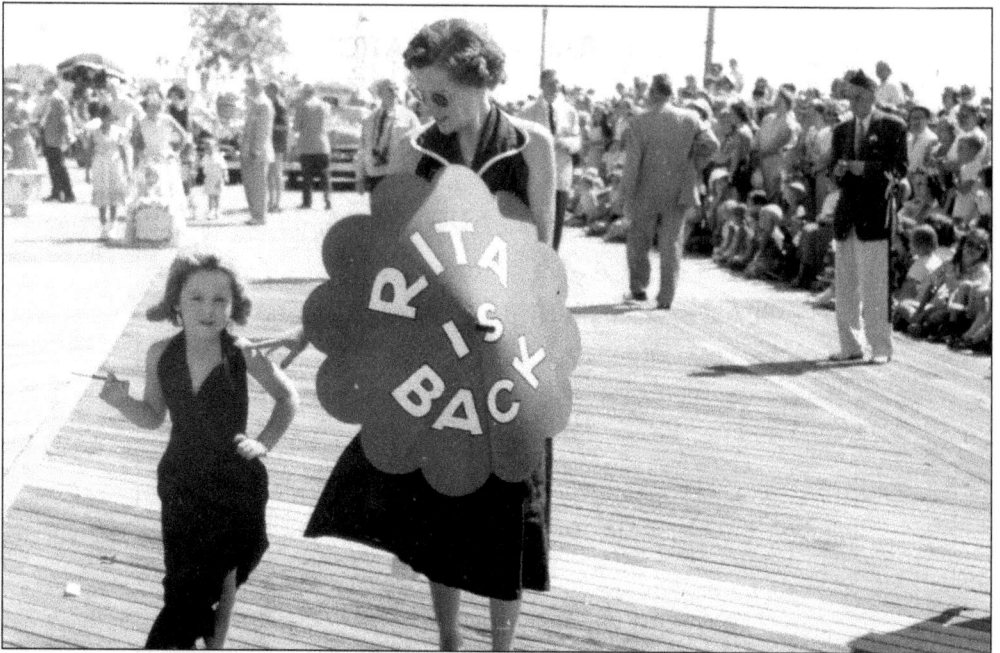

Five-year-old Sandy Morey is accompanied down the boardwalk by her mother, Bette Morey, during the Friday, August 14, 1952, baby parade. Sandy is dressed as Rita Hayworth, complete with cigarette holder, in "Rita Is Back!" The 1952 parade was organized and conducted by the chamber of commerce instead of the city. (Courtesy of Sandy Morey McAfee.)

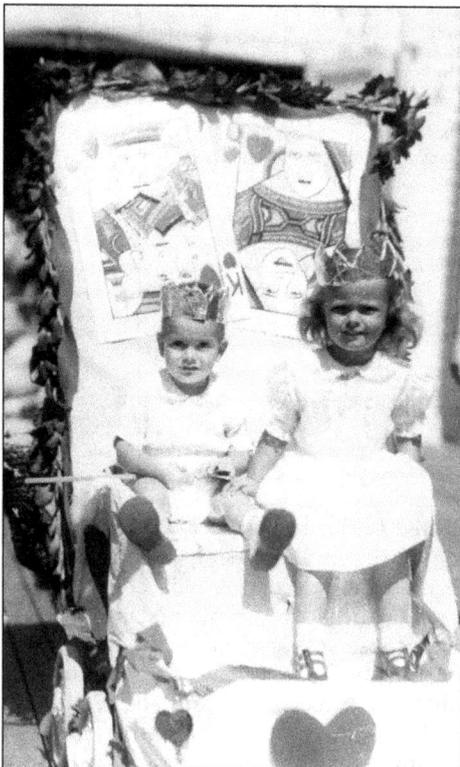

I. Scott Johnson III and his sister Cathy are "King and Queen of Hearts" during the August 14, 1952, parade. Their father, I. Scott Johnson Jr., was in the parade when he was a youngster. In 1924, he was "King of Hearts." (Courtesy of Mrs. I. Scott Johnson Jr.)

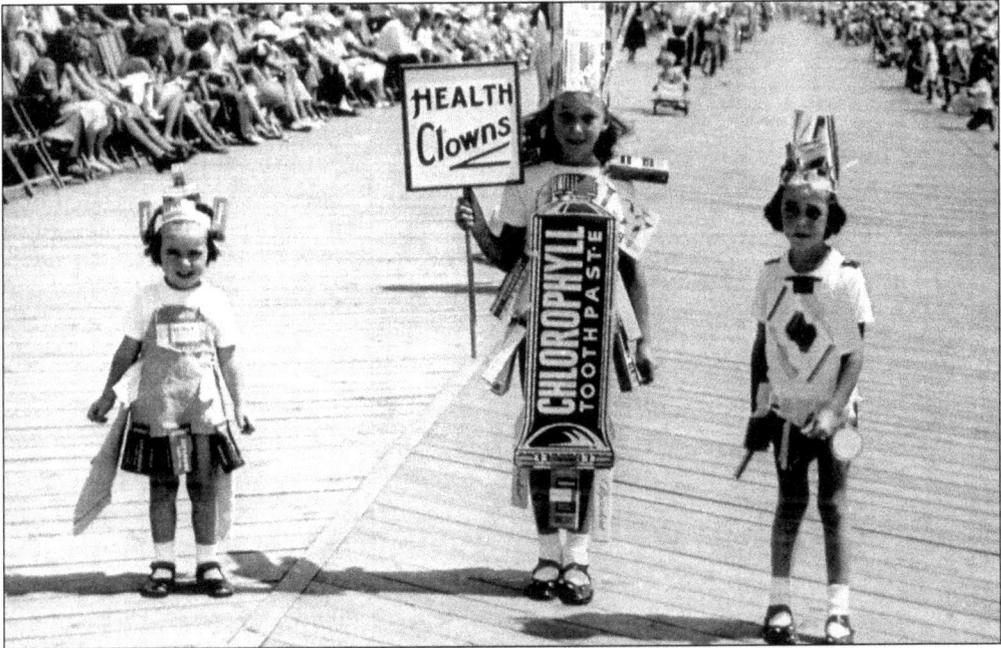

Sisters Ginny, Carol, and Joyce Haug, shown from left to right, won a second-place award in the comic division during the August 14, 1952, baby parade. The girls were "health clowns." Eight-year-old Carol is dressed as a tube of chlorophyll toothpaste, while her sisters show off other good grooming and health aids. (Courtesy of Ginny and Ron Gifford.)

Jeanne Morris was Queen Infanta in the August 13, 1953, baby parade, sponsored by the Commuters Club. The members of her court were Joan Bertolet and Diane Stoney. Russell Hanscom and William Bishop served jointly as grand marshals.

One-year-old Tom Shaw and his three-year-old sister Kathy of Ocean City wait for the August 13, 1953, baby parade to start. Howard Mathunes of Vienna, Austria, was given the award for greatest distance traveled. (Courtesy of Hope Shaw.)

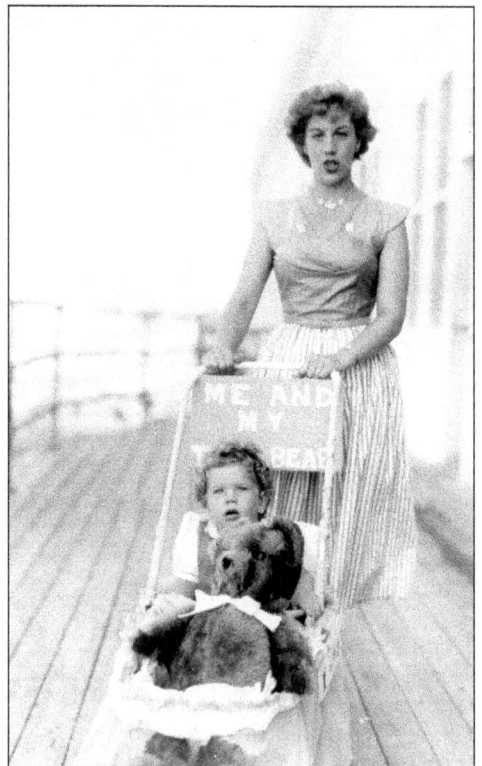

Ready for the August 13, 1953, baby parade, Florence Dungan stands with her son Benjamin Dungan Jr. Benjamin's entry is titled "Me and My Teddy Bear." Mary Beth Thomas was chosen as grand champion baby. A special award was given to Kathleen Ann Escher for "displaying the most personality during the course of the parade." (Courtesy of Bonnie and Pete Ault.)

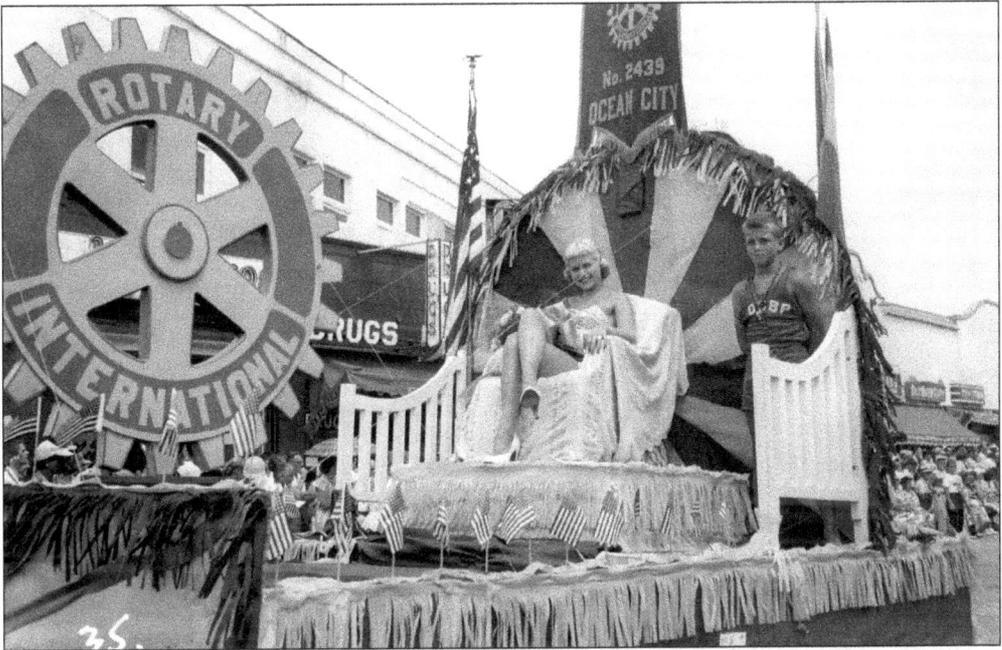

Miss Ocean City Carol Young rides on the Rotary International float during the August 13, 1953, baby parade. With her on the float is Ocean City Beach Patrol mascot John Stull. Rotary International was a service organization whose members were very active in the city. (Courtesy of Carol Frisby.)

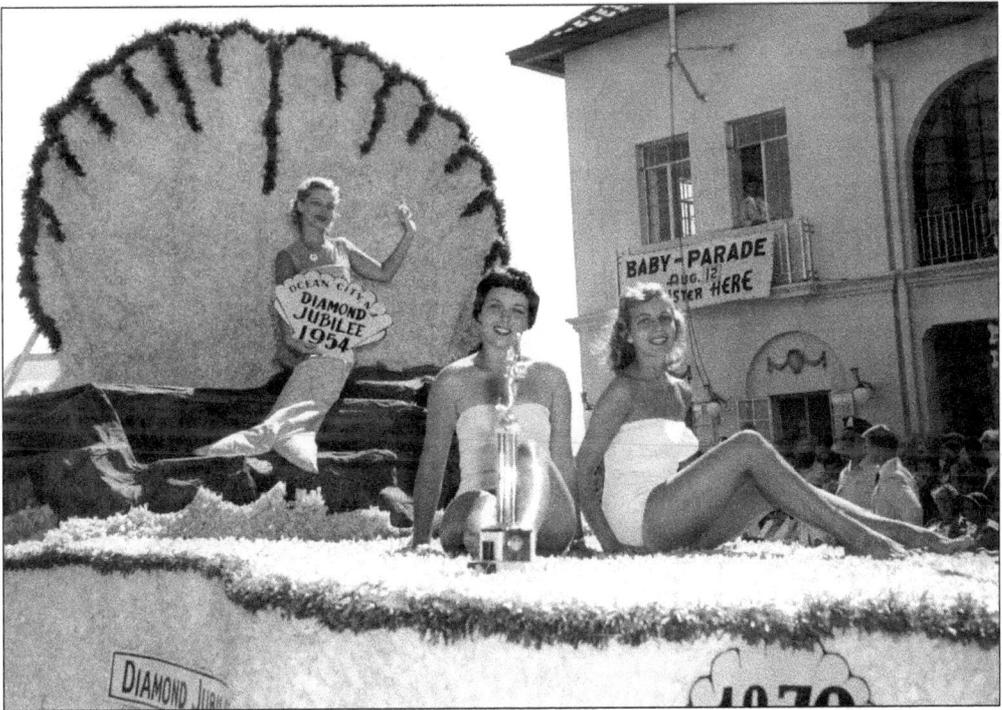

Carolyn Kilpatrick-Richter poses as a mermaid holding a scallop shell and diamond, the symbol of the diamond jubilee, on the diamond jubilee float in the August 12, 1954, baby parade.

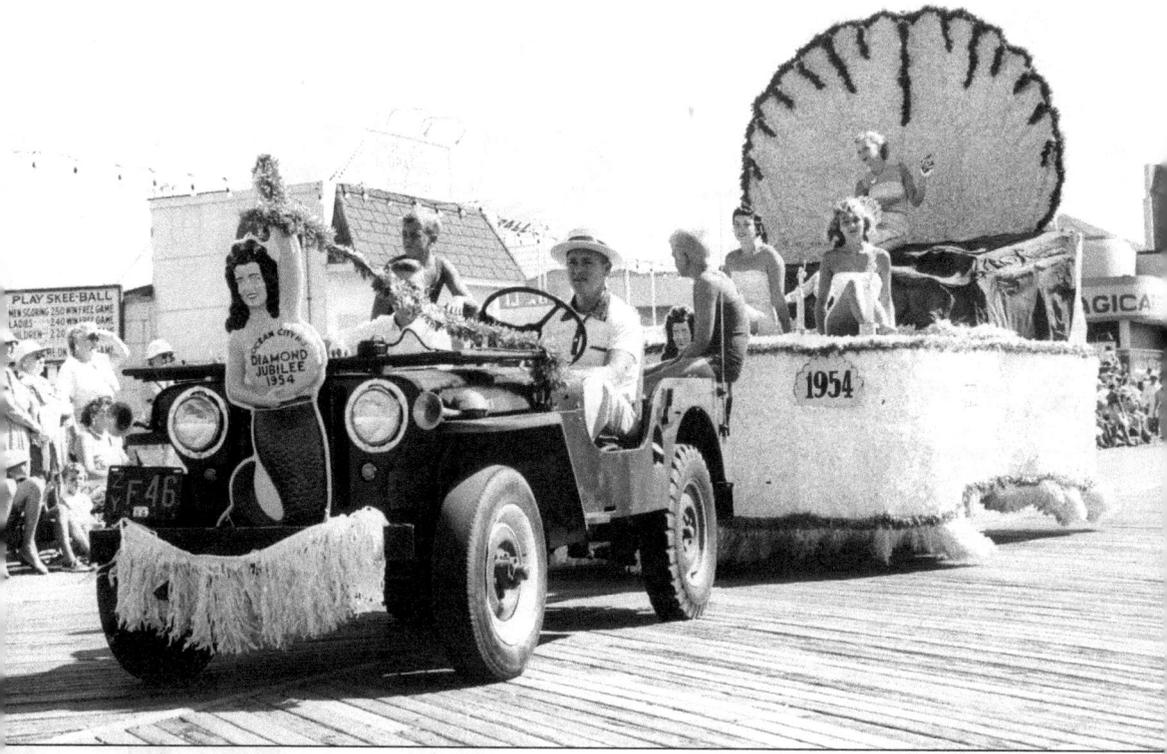

The year 1954 was Ocean City's diamond jubilee, the 75th anniversary of the founding of the city. The baby parade, held on August 12, was part of the yearlong celebration. The city used a mermaid holding a scallop shell and a diamond as a symbol of the diamond jubilee. This was the diamond jubilee float. Besides the baby parade, special attractions were planned throughout the year to highlight three-quarters of a century of progress. Souvenirs of all kinds were made. All of them had the mermaid, scallop shell, and diamond on them, and they were imprinted with "Ocean City Diamond Jubilee."

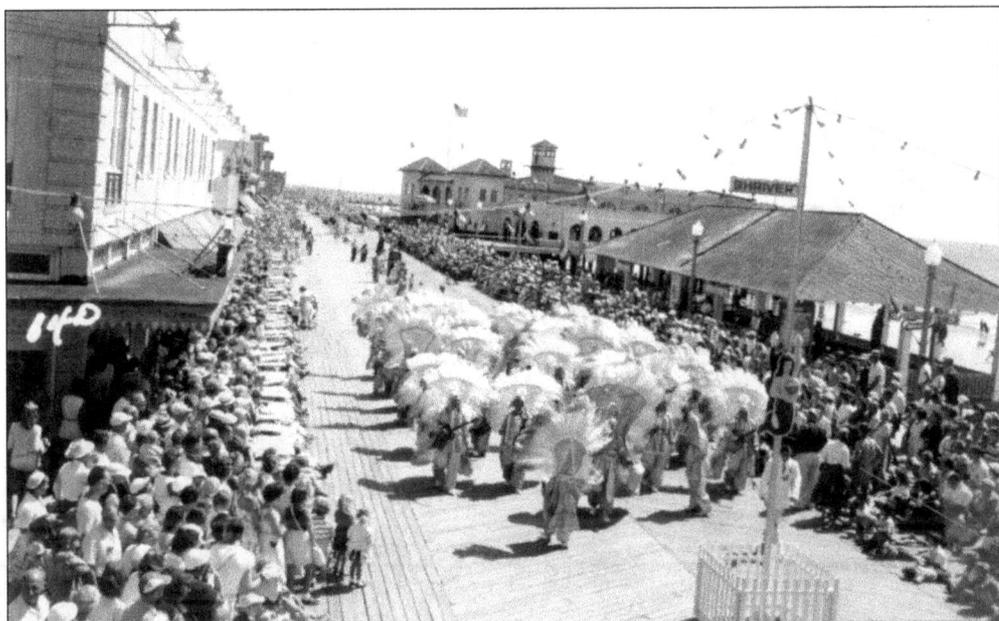

Harrowgate String Band of Philadelphia was judged the best string band in the August 12, 1954, parade. It played several songs, including "I'm Looking Over a Four Leaf Clover" and "Happy Days Are Here Again." The Belmar All-Girl Scotch Kilties, also of Philadelphia, won first prize over four other cadet corps. (Courtesy of OCHM.)

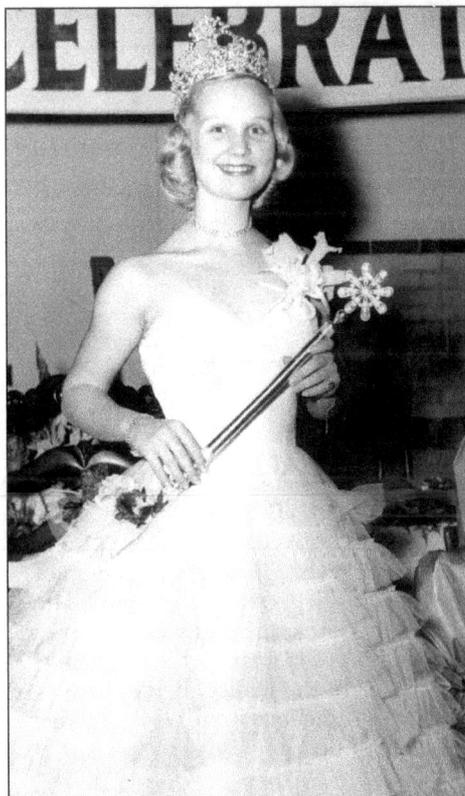

Marla Adams, an Ocean City native and descendant of the Lake family who founded Ocean City, was Queen Infanta of the August 12, 1954, baby parade. Adams was also crowned queen of the diamond jubilee. She graduated from the American Academy of Dramatic Arts in New York City and performed on Broadway and in the movie *Splendor in the Grass*. She also had a leading role in the daytime television show *The Secret Storm*. (Courtesy of OCHM.)

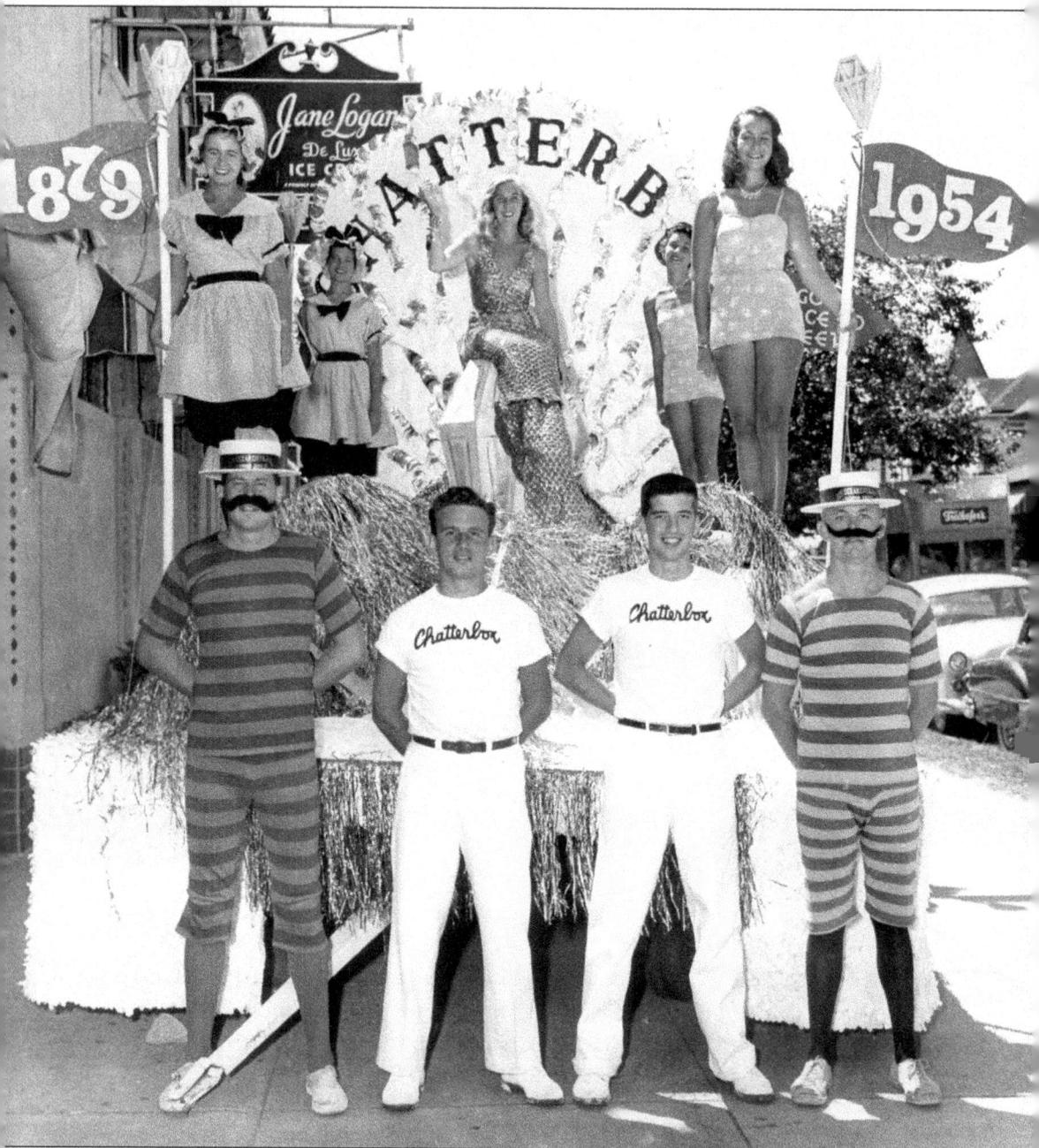

This float by the Chatterbox Restaurant won first place in the commercial float division of the August 12, 1954, baby parade. The float helped commemorate Ocean City's diamond jubilee, the 75th anniversary of the city's founding. Sally Watson (left) and Irmagard Hagedorn (second from left) wear bathing suits in the style of 1879. Ellie Davis is the mermaid, depicting the symbol of the jubilee. Betty Martin (second from right) and Francie Williams (right) are wearing bathing suits from 1954. The young men standing in front are not identified. (Courtesy of Elizabeth Booth.)

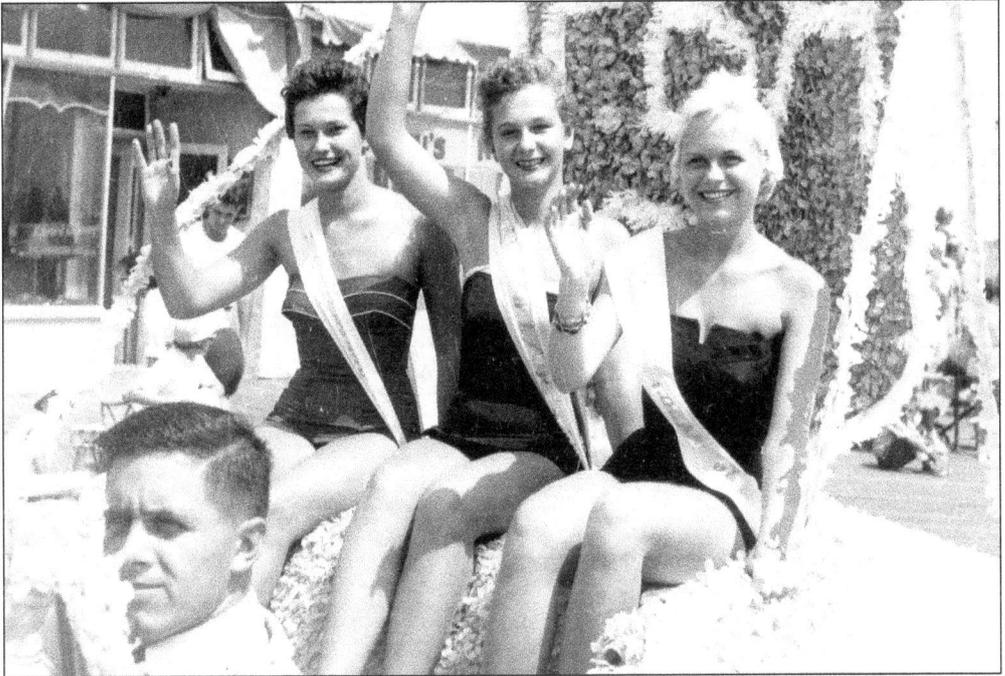

Ocean City's Police Benevolent Association had this float in the August 12, 1954, baby parade. The young women are, from left to right, Anne Locke, Julie Smith, and Carol Young. (Courtesy of Carol Frisby.)

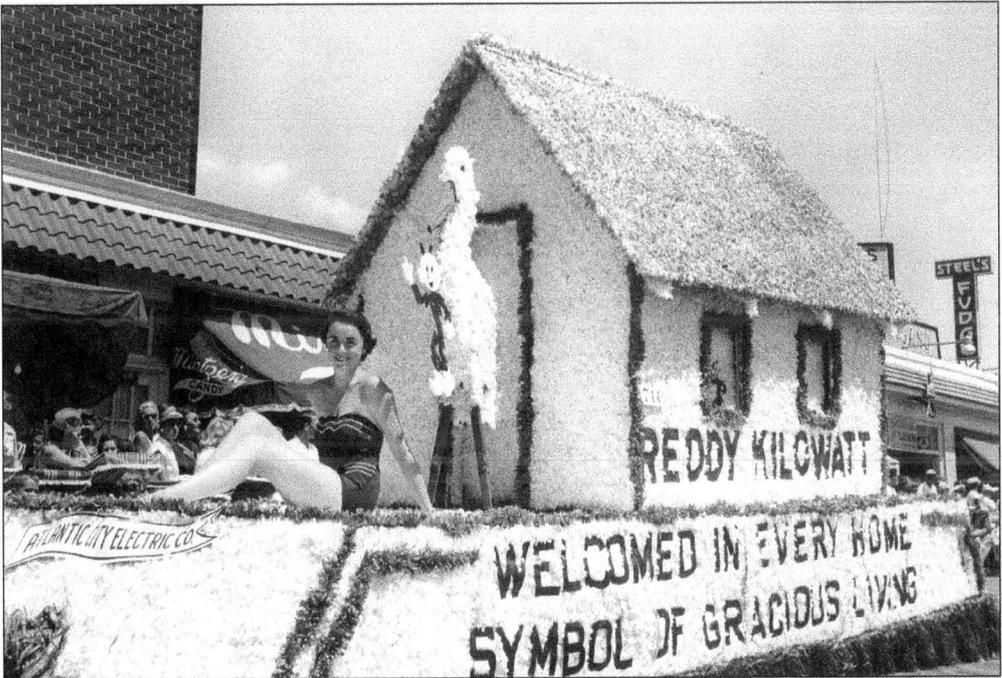

Joan McDermott poses on the Atlantic City Electric Company float during the August 12, 1954, diamond jubilee baby parade. The float states, "Reddy Kilowatt / Welcomed in Every Home / Symbol of Gracious Living."

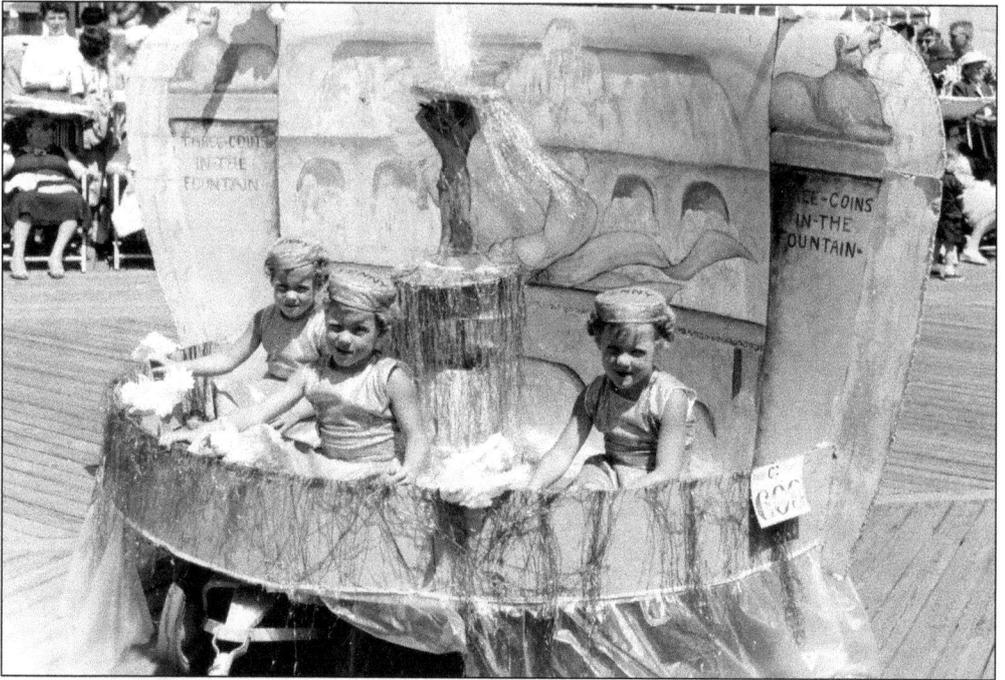

Five-year-old Annette, Marion, and Rita Kane of North Wildwood received a special prize for being the only triplets in the August 12, 1954, baby parade. Their float, "Three-Coins-in-the-Fountain," was a big hit. (Courtesy of OCHM.)

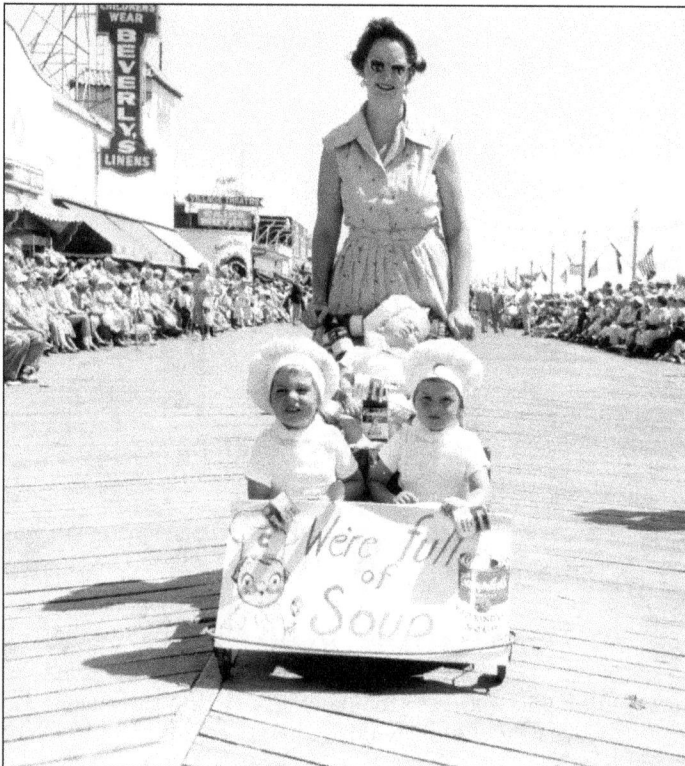

This entry, "We're Full of Soup," won first prize in the comic division in the August 12, 1954, baby parade. Their mother pushes a stroller carrying Marylee (age three), Joann (age two), and Johnny Siano (age 11 months) down the boardwalk. Johnny appears to have slept peacefully through most of the parade. (Courtesy of OCHM.)

Members of the Ocean City Beach Patrol, from left to right, Bill Patterson, Lee Spampinetto, Garry Powel, and Tom Oves accompany Queen Infanta's float down the boardwalk during the August 18, 1955, baby parade. Mary Edith Wheaton, sitting at right on the float, was Queen Infanta. The queen's ladies-in-waiting were Mabel McKenna and Meredith Rapp. The parade was scheduled for August 11, but because of the threat of Hurricane Connie, it was postponed a week. (Courtesy of Ocean City Lifesaving Museum.)

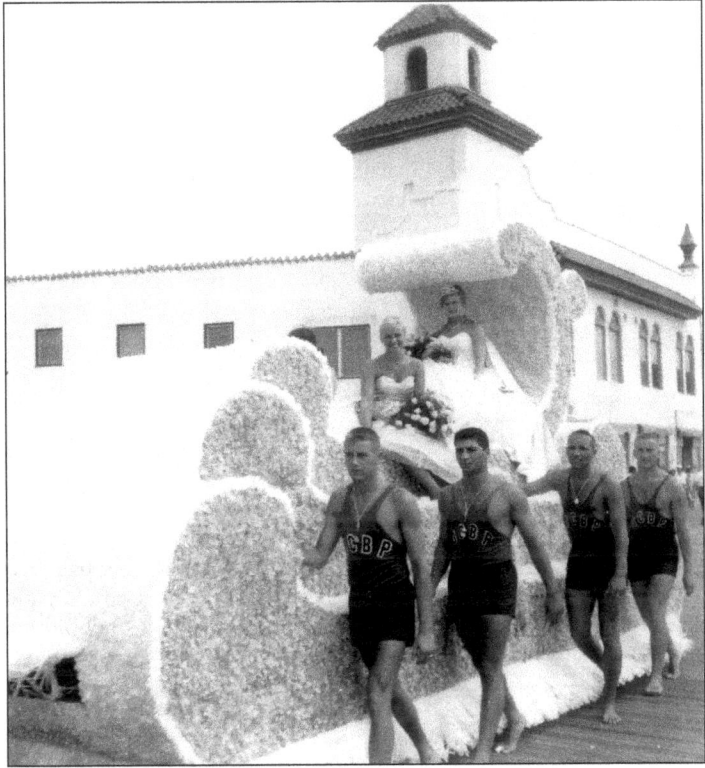

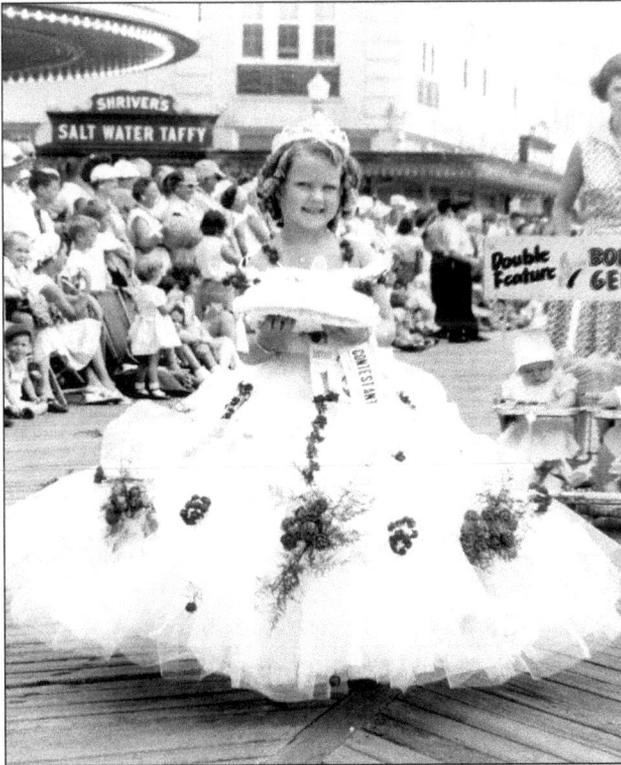

Mary Louise Hayes's Cinderella costume, inspired by the movie *Glass Slipper*, won first place in the fancy dress division of the August 18, 1955, baby parade. Her picture was on the front page of the *Ocean City Sentinel-Ledger*. (Courtesy of Mary Lou Hayes.)

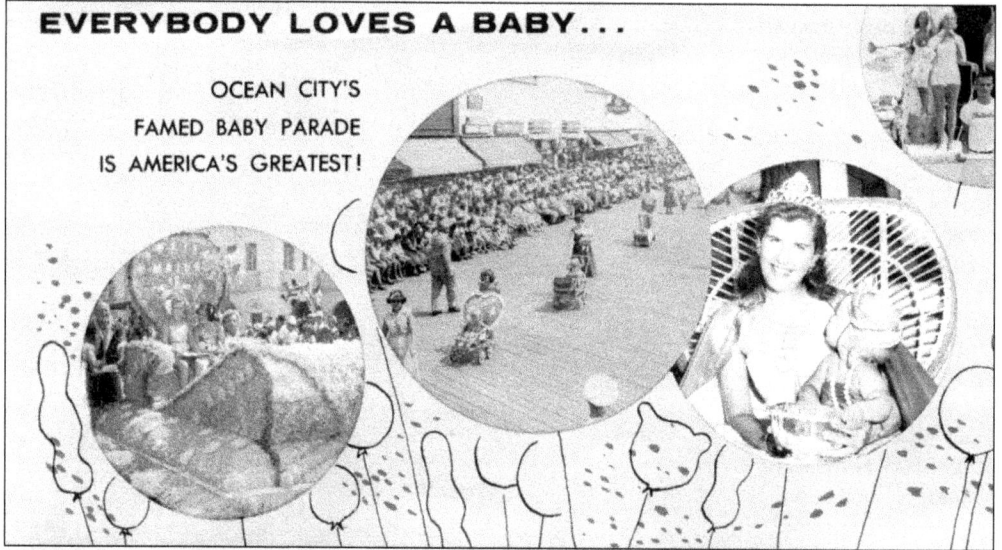

EVERYBODY LOVES A BABY...

OCEAN CITY'S
FAMED BABY PARADE
IS AMERICA'S GREATEST!

The cover of this 1957 tourist brochure shows scenes from past baby parades. "Everybody Loves a Baby . . . Ocean City's Famed Baby Parade Is America's Greatest!" In the various divisions, 25 major prizes were awarded, including a $100 savings bond offered by the Ocean City Hotel and Restaurant Association for the most outstanding noncommercial entry in the 1957 parade.

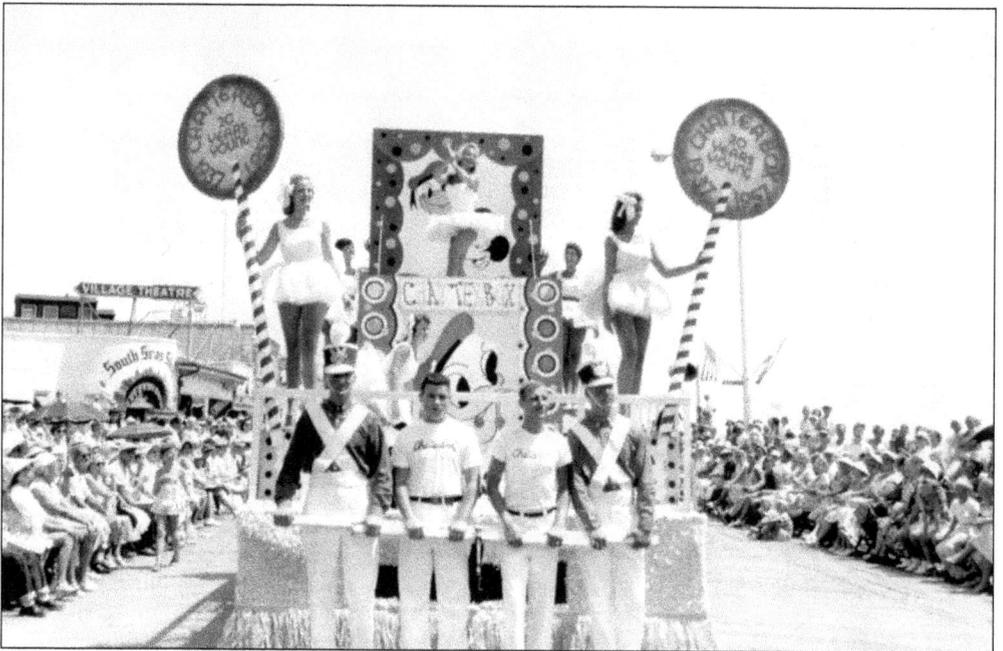

The Chatterbox Restaurant, located at Ninth Street and Central Avenue, presented this float in the 1957 baby parade held on August 8. The float won the top prize for the commercial float division. The Chatterbox Restaurant was celebrating its 20th anniversary that year. (Courtesy of Aimee Repici.)

74

Bess Myerson was an honored guest during the August 7, 1958, baby parade. Myerson, Miss America 1948, was one of the best-known former Miss Americas. She was a stage and television actress and starred in *Tea and Sympathy* at the local Gateway Playhouse.

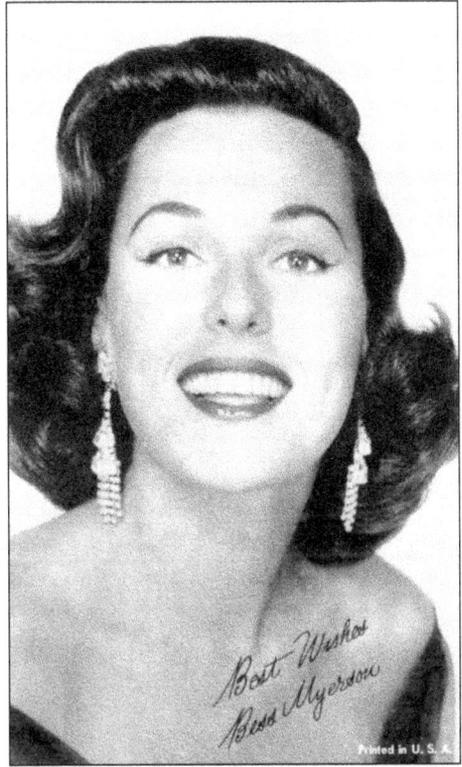

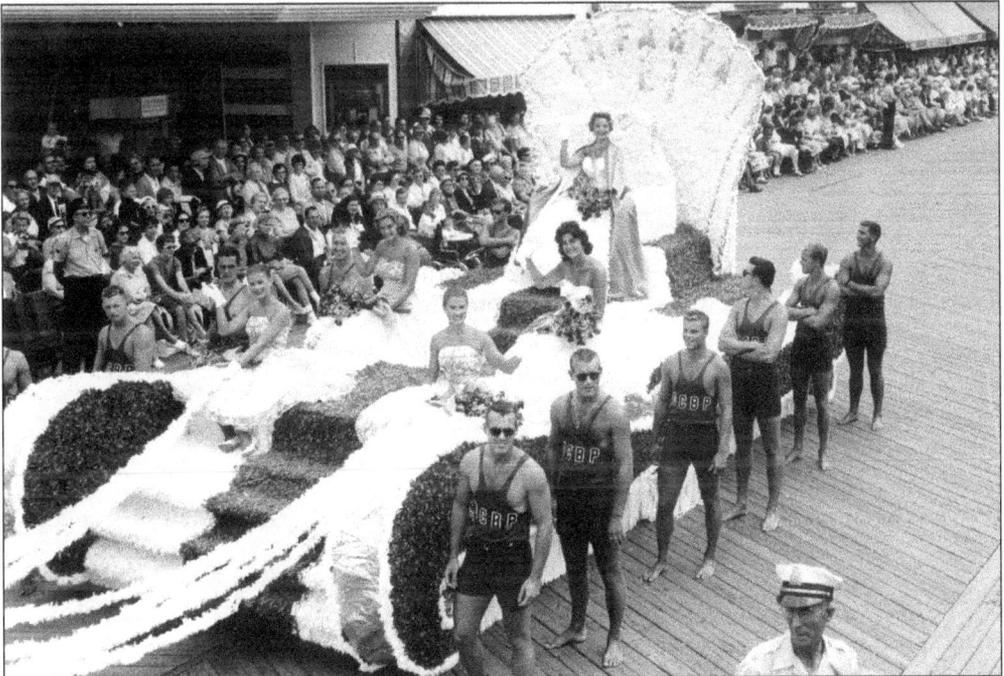

Nancy Deininger reigns as Queen Infanta in the August 6, 1959, golden anniversary baby parade. Members of the Ocean City Beach Patrol accompany the Queen Infanta float. (Courtesy of OCHM.)

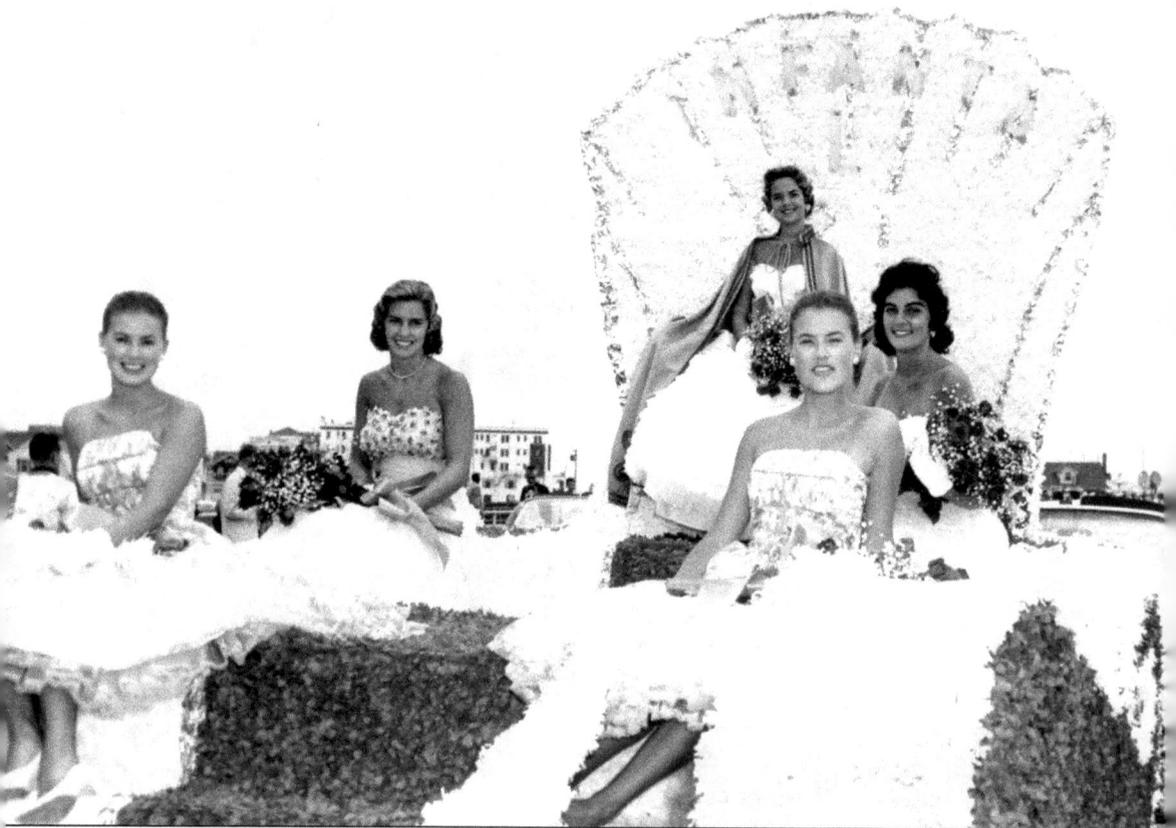

Queen Infanta and her ladies-in-waiting are, from left to right, Marilyn Rink, Nancy Wheaton, Nancy Deininger on her throne, Evelyn Rink, and Barbara Nugent. Their float is waiting to move down the boardwalk as part of the August 6, 1959, baby parade. The queen was usually picked from the previous year's ladies-in-waiting. The coronation for the queen and her royal court took place Wednesday evening before the parade during the intermission of a concert at the Music Pier. At age 91, Leo Bamberger, founder of the baby parade, was grand marshal of the golden anniversary parade. (Courtesy of Senior Studios.)

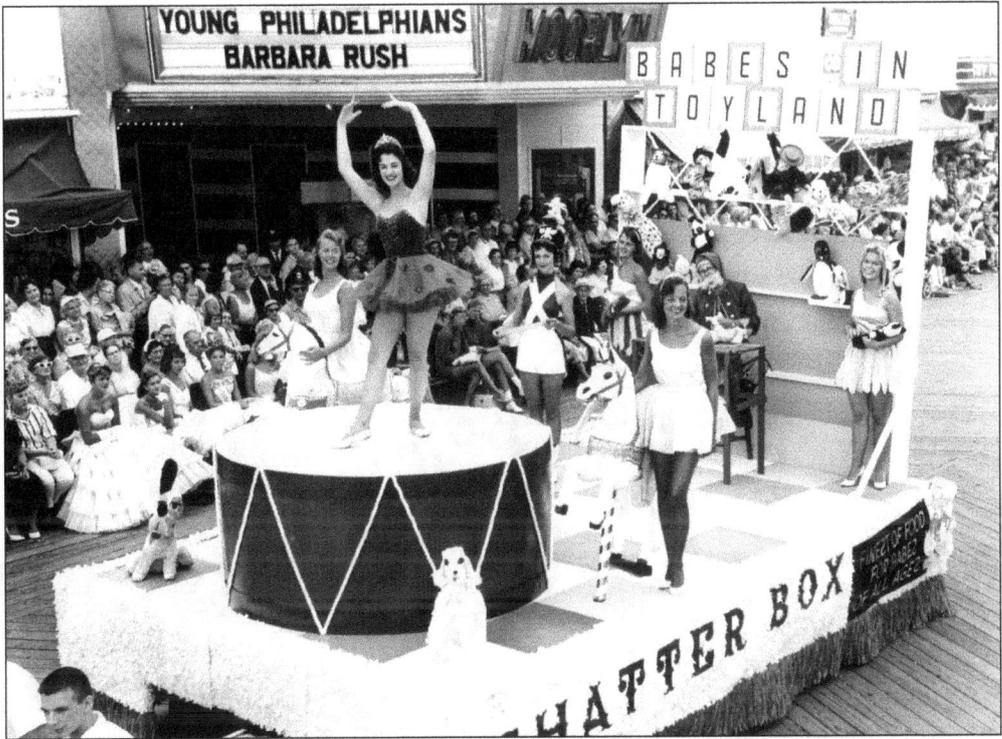

This Chatterbox Restaurant float took first place in the commercial float division for its "Babes in Toyland" theme in the August 6, 1959, baby parade. The float features ballerina Carol Konschak dancing atop the giant drum. (Courtesy of Elizabeth Booth.)

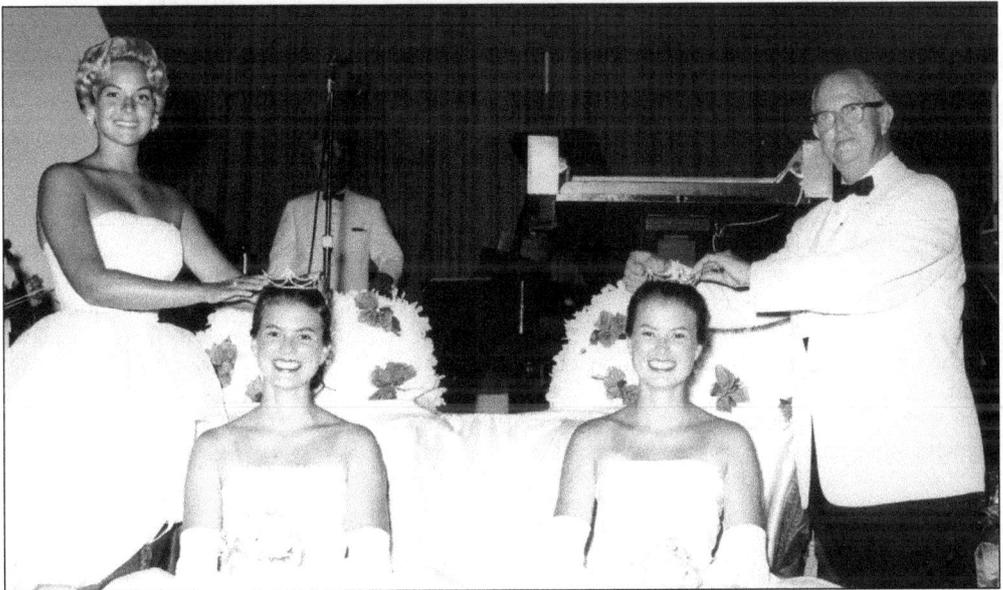

Nancy Deininger, Queen Infanta 1959, crowns Evelyn Rink, while Mayor Nathaniel C. Smith crowns Marilyn Rink as Queen Infantas 1960. The coronation of the identical twins took place at the Music Pier on August 10, 1960, the evening before the baby parade. It was the first time there were two Queen Infantas. (Courtesy of Senior Studios.)

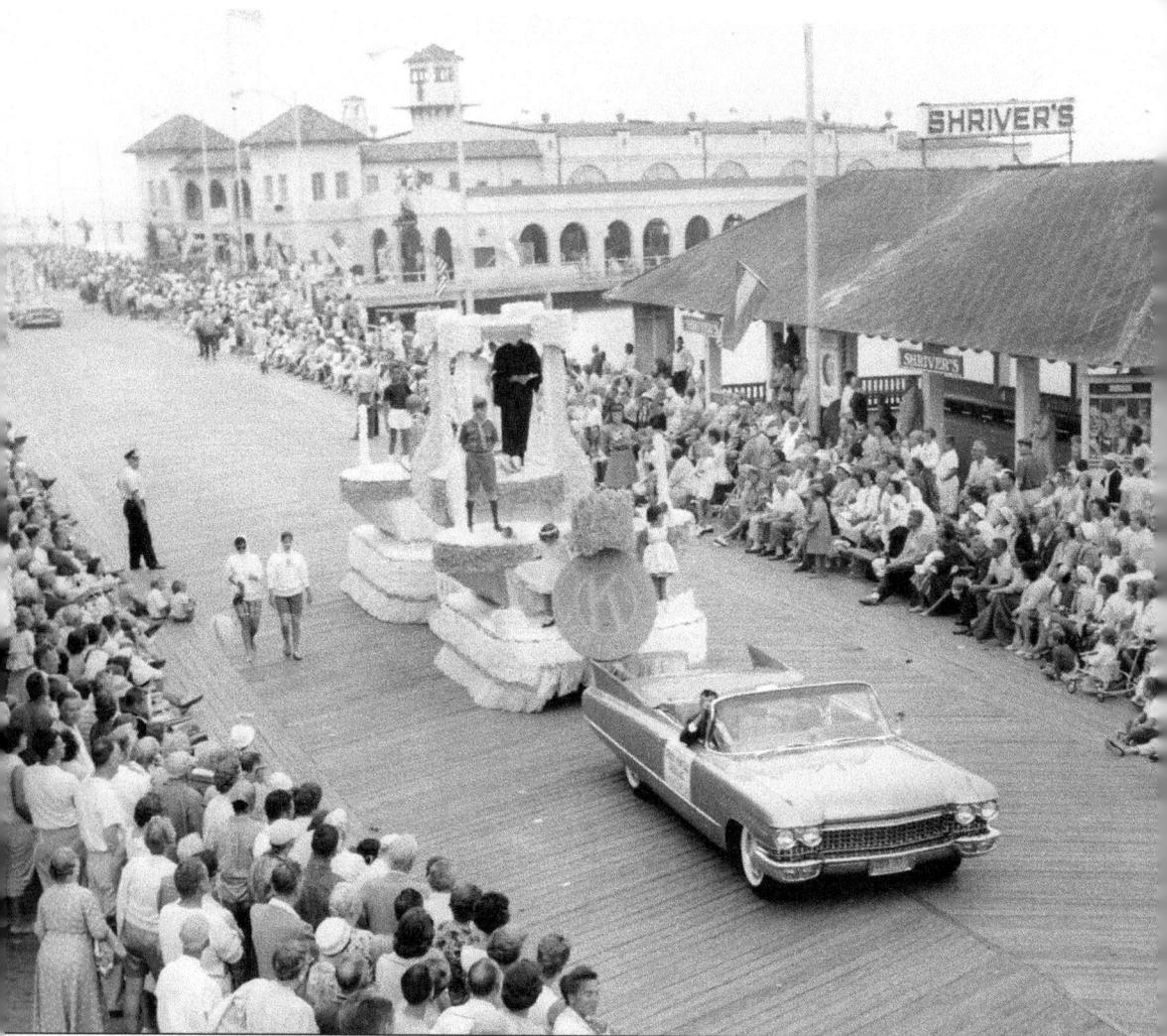

This Kiwanis Club float was in the August 11, 1960, baby parade. The Kiwanis Club is a national service organization with a focus on youth in the community. Riding on the float are Nicholas Trofa, Francis Trofa, Linda Hunter, Everett Beard, Thomas DeBaufre, Barbara Collingwood, Linda Druck, and Patty Hunter. Druck Pontiac-Cadillac of 1158 Asbury Avenue loaned the car for the parade. There were several noncommercial floats that year. In addition to the Kiwanis Club, the Exchange Club, the Ocean City Hotel and Restaurant Association, and the Ocean City Yacht Club had floats entered in that division. (Photograph by Senior Studios, courtesy of Russell Hanscom.)

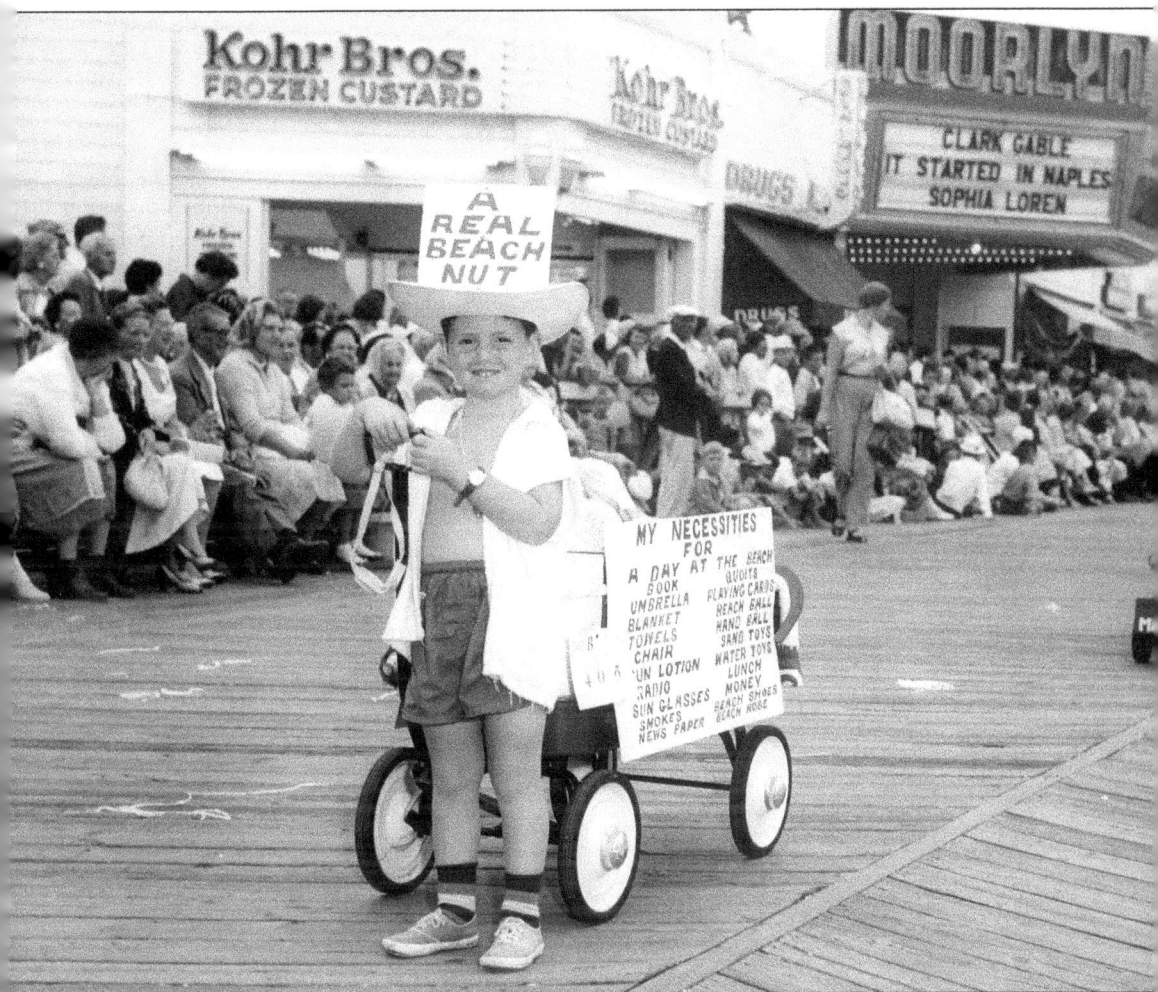

In Ocean City's August 11, 1960, baby parade, this young boy, "A Real Beach Nut," was surely a winner. His list of "necessities for a day at the beach" includes a book, playing cards, umbrella, sun lotion, beach robe, smokes, radio, lunch, money, sand toys, and quoits. The prize for youngest entrant went to Nelson Clark Alexander Dice of Philadelphia. He was only two months old. Jo-Ann Elaine Pike from Miami, Florida, won for greatest distance in North America, while Paula Michelle Weiser, Mark Kevin Weiser, and Scott Keith Weiser won for greatest distance outside of North America. They came from Kermanshah, Iran.

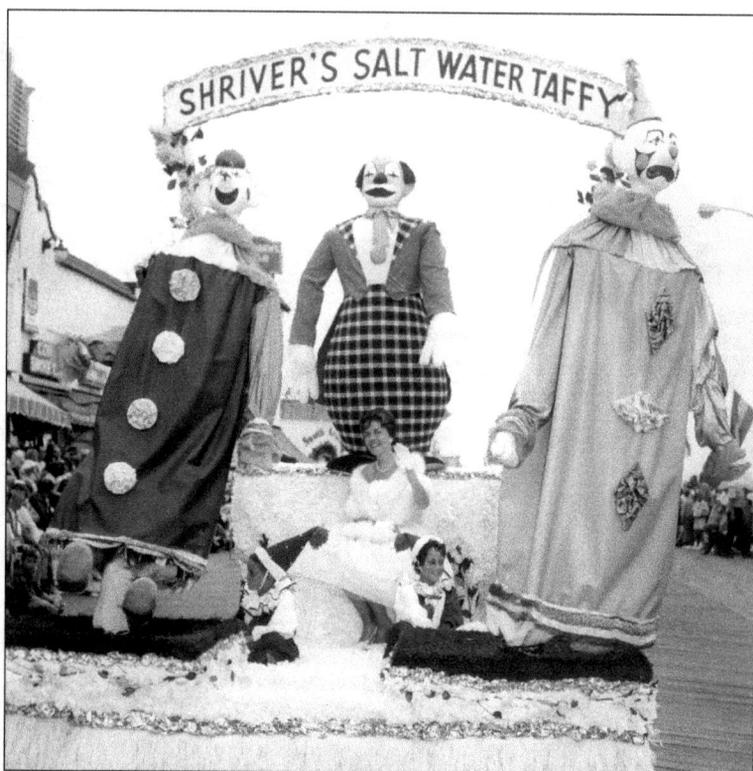

Stephen Gretz (left), Kathy McFeeley, and Susan Gretz are almost lost among the clown buffoons on the Shriver's Salt Water Taffy float during the August 11, 1960, baby parade. There were over 400 entries in this year's parade, and 50,000 spectators lined the boardwalk. (Courtesy of Russell Hanscom.)

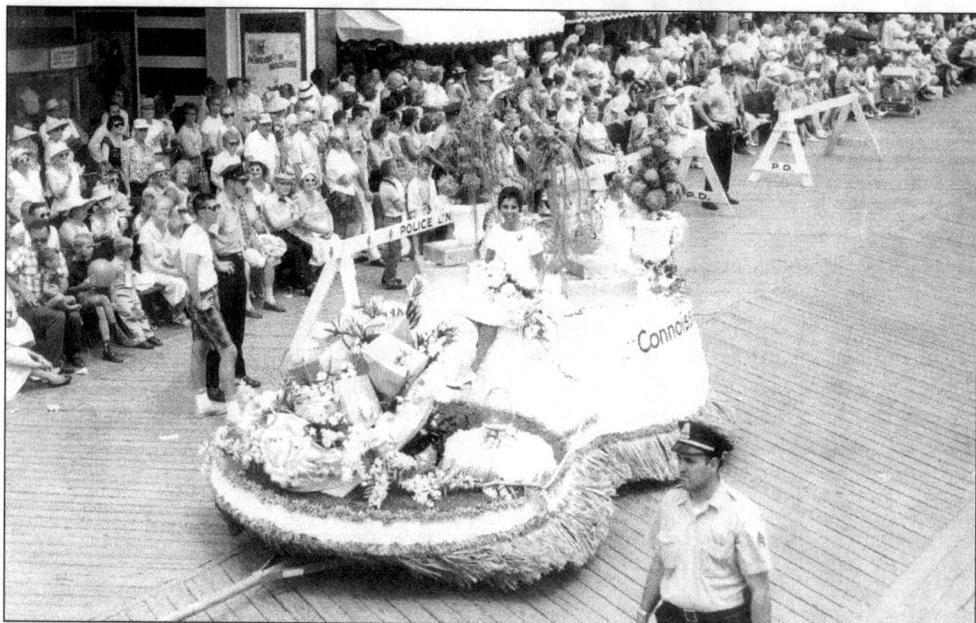

Jim Penland won second place in the commercial float division for this float advertising his shop in the August 10, 1961, baby parade. He opened the Connoisseur Shop at 1112 Boardwalk in 1956. This year, the first Bamberger award, named for parade founder Leo Bamberger who had died in February, was presented to Lynn and Howard Reif. The award, for best personality, was to be given yearly. (Courtesy of Senior Studios.)

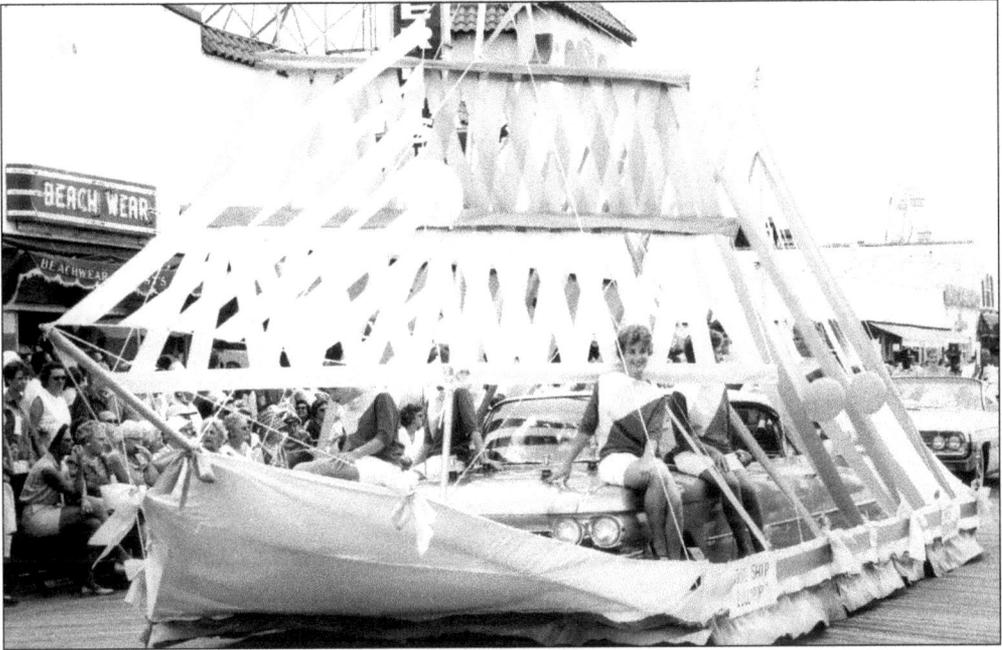

This "boat," the "Good Ship Lollipop," was an entry from Chris' Restaurant in the August 10, 1961, baby parade. The restaurant, at Ninth Street and the bay, also offered sightseeing tours on owner Chris Montagna's boats. The women sitting on the Cadillac were waitresses at the restaurant. (Courtesy of Russell Hanscom.)

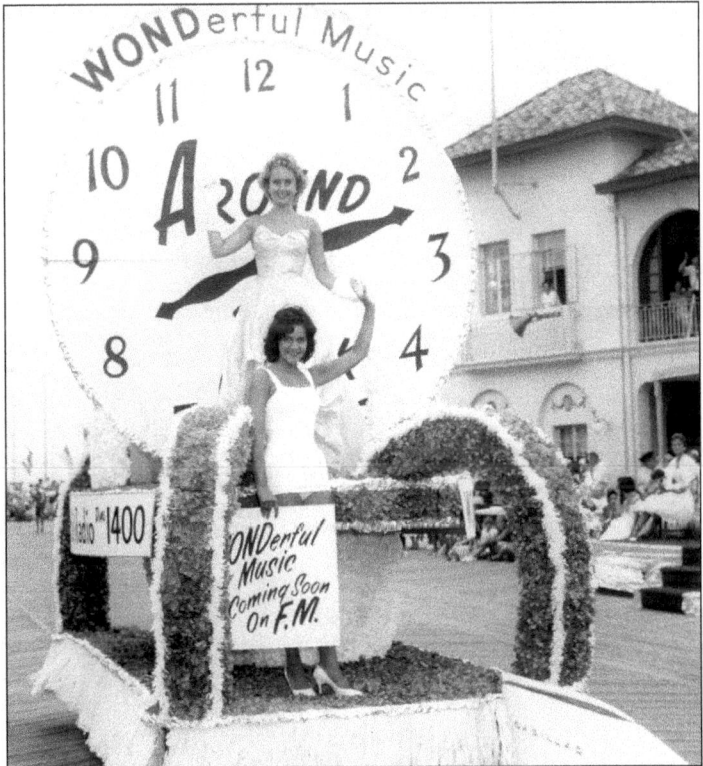

This float for WOND radio was in the August 10, 1961, baby parade. WOND was a top-40 AM station broadcasting out of Pleasantville, about 10 miles from Ocean City. Deejays played the top-40 music hits of the day. These women worked at the station. (Courtesy of Russell Hanscom.)

Queen Infanta Judy Jones (center) and her court are sitting in front of the judges reviewing stand during the August 9, 1962, baby parade. The ladies-in-waiting are, from left to right, Edith Yeager, Linda Hipp, Lynn Clarkson, and Marcy Zin. The court's coronation ball was held at the Music Pier the Saturday before the parade. Clarence Fuhrman and his Rythmaires provided the music. (Courtesy of Russell Hanscom.)

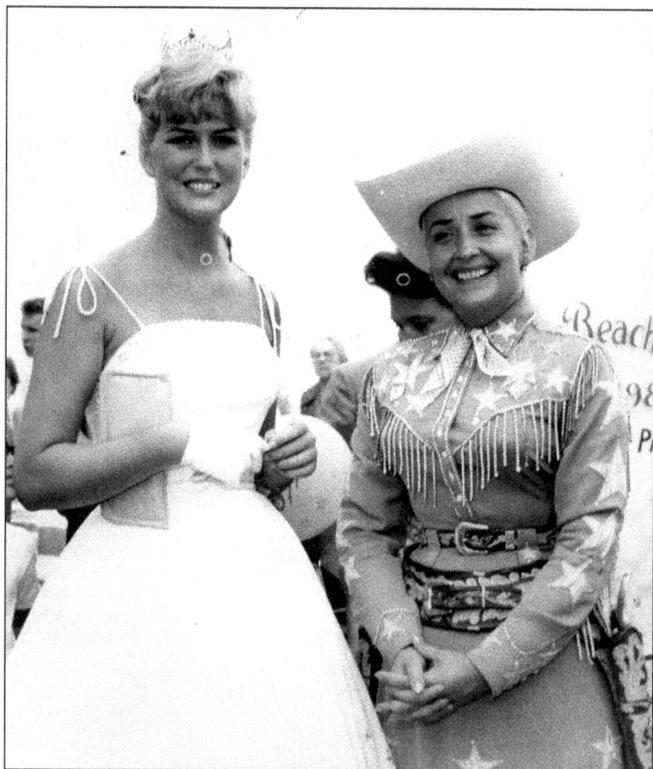

Sally Starr, television's "Queen of the West," was a special guest at the August 9, 1962, baby parade. Nancy Wheaton, Queen Infanta 1961, joined Starr after the parade. Starr was in town for a show with her Bang-Bang-Up Revue sponsored by the Kiwanis Club for its charity fund. (Courtesy of Russell Hanscom.)

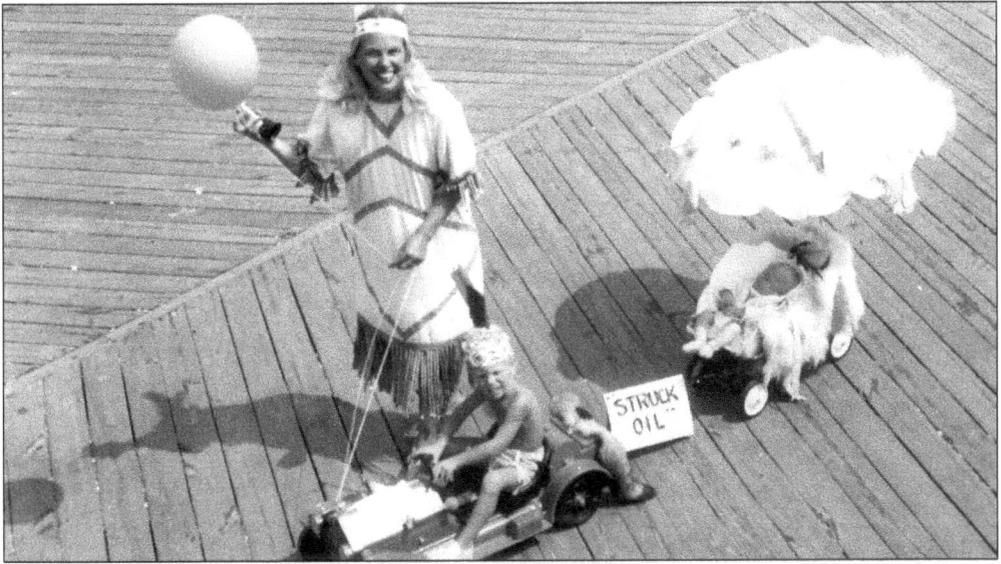

Mrs. Russell Hanscom Jr. walks with her children, three-and-a-half-year-old Russell III and 10-week-old Mabel during the August 9, 1962, baby parade. Young Russell and his sister were the grandchildren of Evelyn and Russell Hanscom, parade organizers. The Hanscoms had 25 commercial and noncommercial large floats scheduled for the parade. (Courtesy of Russell Hanscom.)

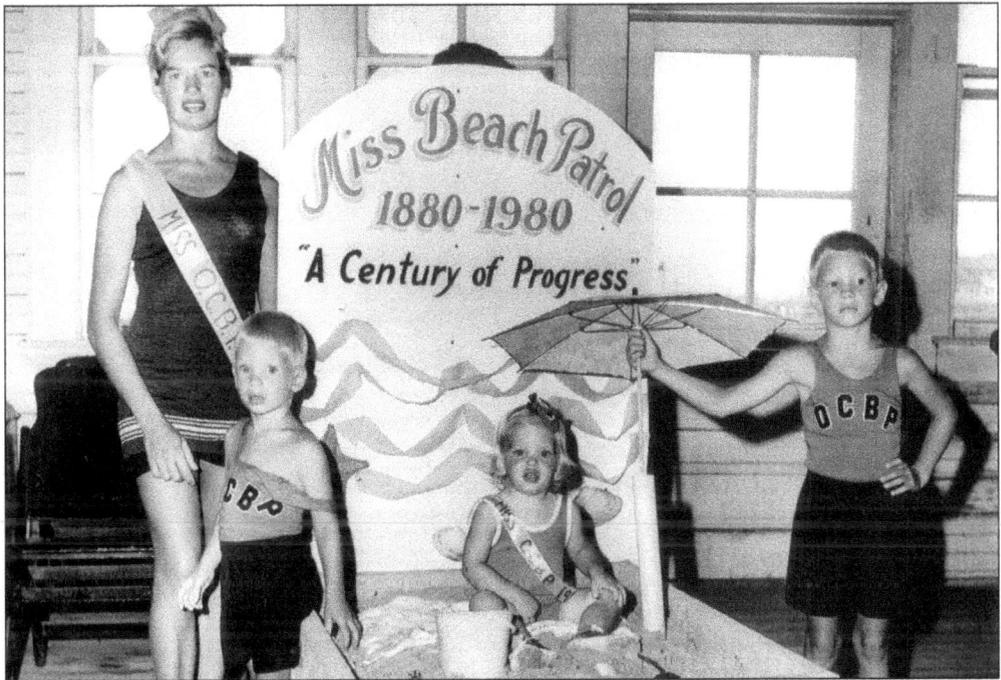

The 1962 baby parade was held on August 9. The Raab family took a peek into the future and won a prize for its float, "Miss Beach Patrol, 1880–1980, a Century of Progress." From left to right are Ocean City residents Dottie, Gary, Diane, and Jerry Raab. Interspersed between the children's divisions were nine bands, including the Musicians Protective Association of Atlantic City, the Onized Band of Bridgeton, and the Ocean City High School band.

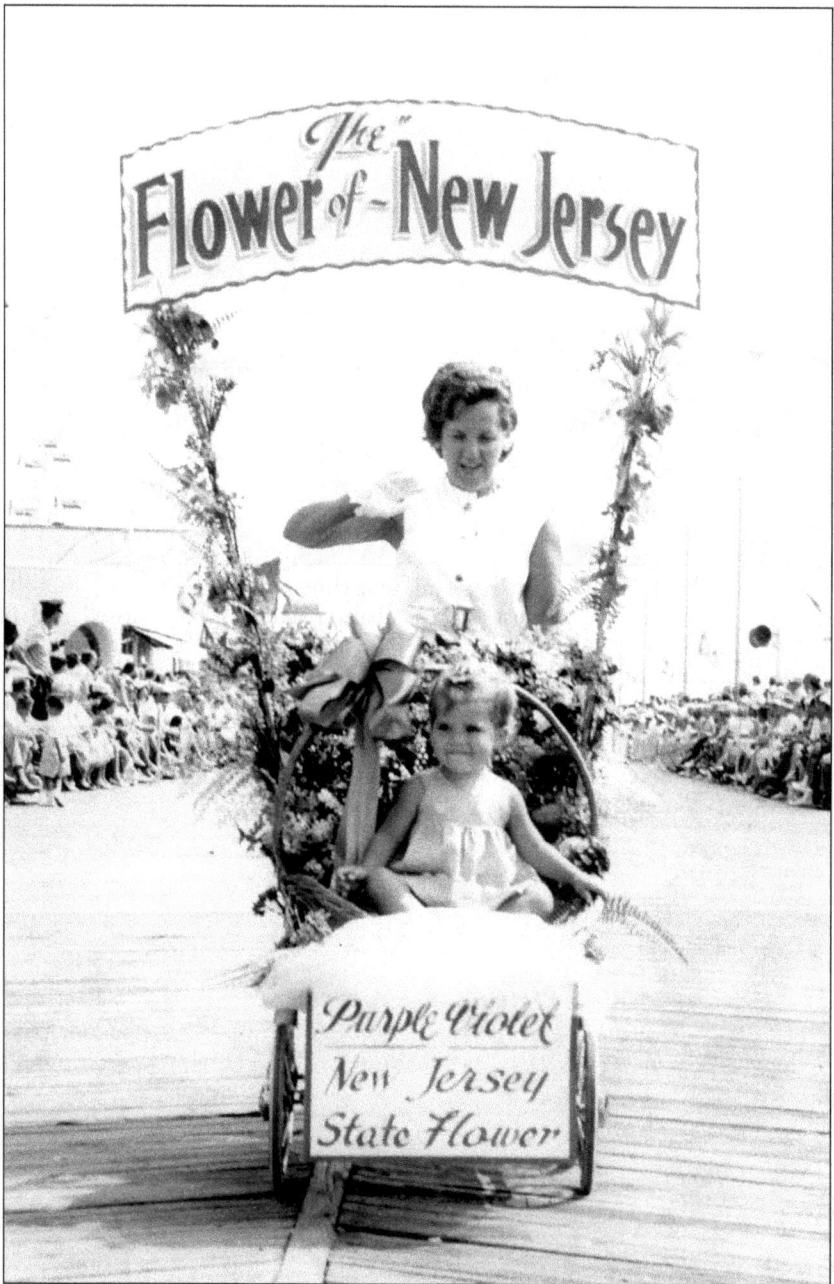

Kimberly Ann Hillanbrand won first prize in her division in the August 9, 1962, parade as "the Flower of New Jersey," despite the fact that she was from Philadelphia. Ocean City resident 20-month-old Kevin Blevin won the second annual Bamberger award for best personality. Sauntering along barefoot and wearing only a bathing suit over his diaper with "I'm the Boss" emblazoned on the back, Blevin won the crowd as he waved to everyone. The Bamberger award, presented by Mrs. Leo Bamberger, supplanted the champion baby award previously given. A committee of doctors who observed the children before the parade chose the champion baby. Because their choice was so often questioned by parents of other children, it was decided it would be in the best interest of all to discontinue that category. (Courtesy of Russell Hanscom.)

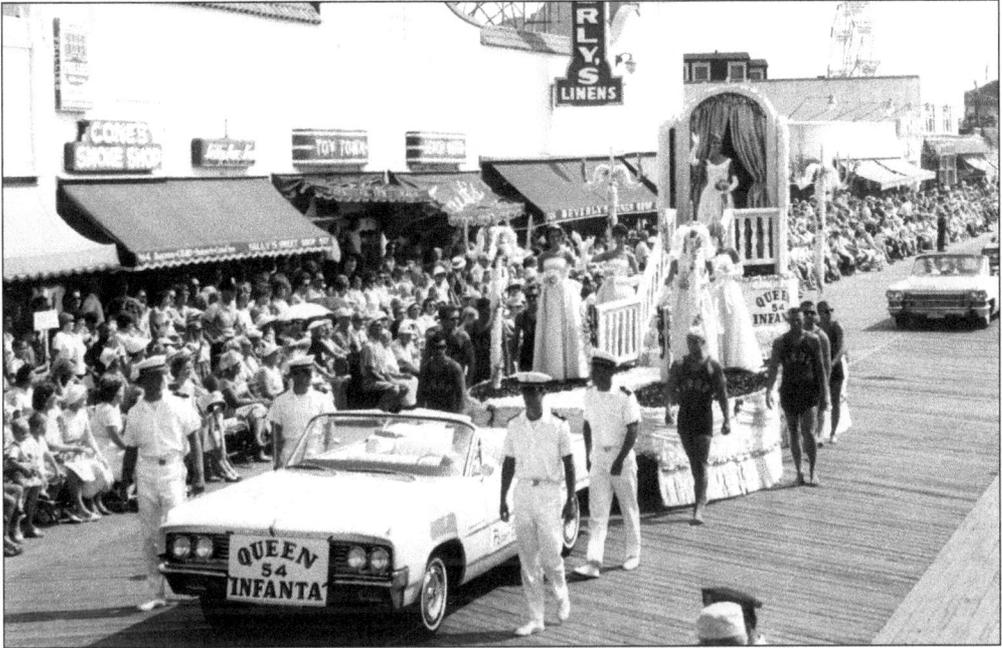

Marcy Zin reigned as Queen Infanta of the August 8, 1963, baby parade. She stands above her court on the Queen Infanta float, which is accompanied by members of the Ocean City Beach Patrol. Members of the queen's court are, from left to right, Sandra Green, Carolyn Blough, Deborah Nicols, and Dorothea Lewis. (Courtesy of Russell Hanscom.)

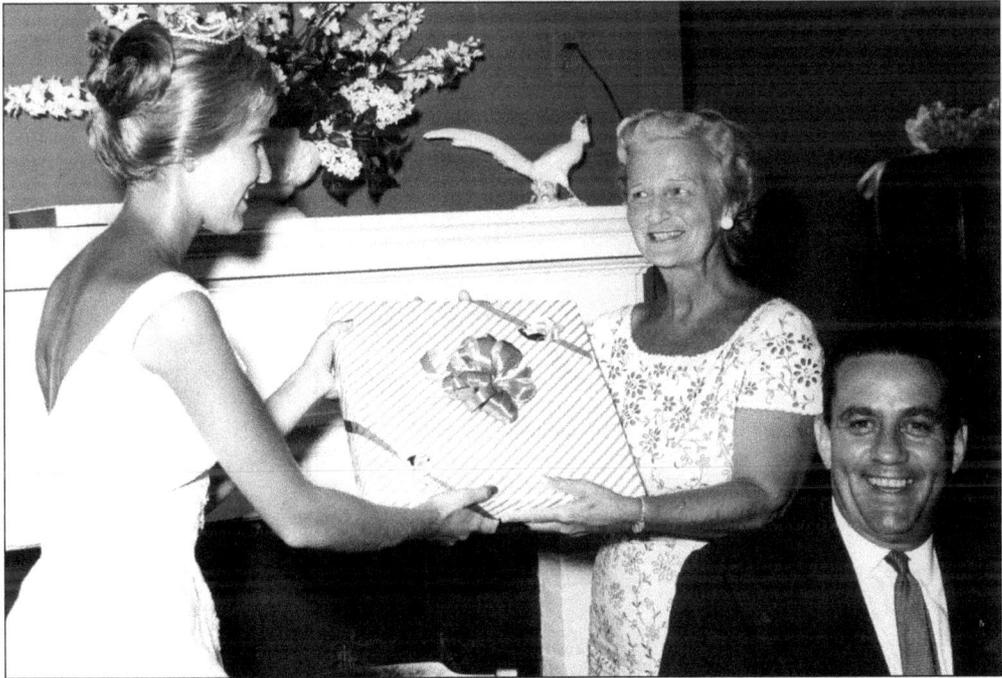

At a luncheon after the August 8, 1963, baby parade, Queen Infanta Marcy Zin (left) presents parade organizer Evelyn Hanscom a gift from herself and her ladies-in-waiting in appreciation of Hanscom's efforts. On the right is Mayor B. Thomas Waldman. (Courtesy of Russell Hanscom.)

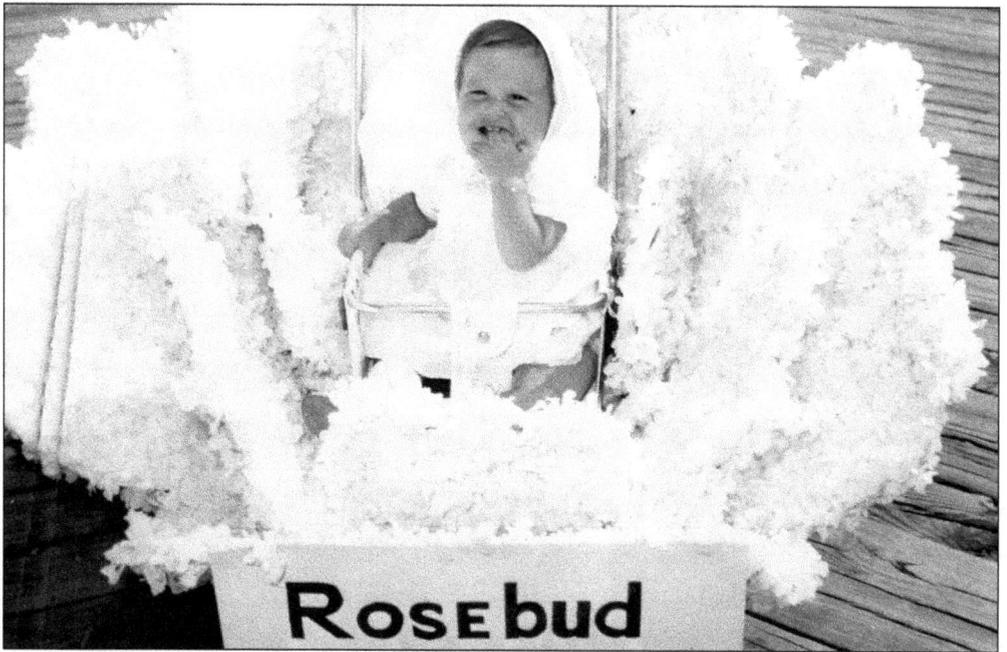

One-year-old Allison Beth Abouchar of New York City won first place in her division as "Rosebud" in the August 8, 1963, baby parade. Her carriage was completely covered in pink crepe paper rose petals. Each child entered received an engraved sterling silver bracelet. (Photograph by Senior Studios, courtesy of Lew Shupe.)

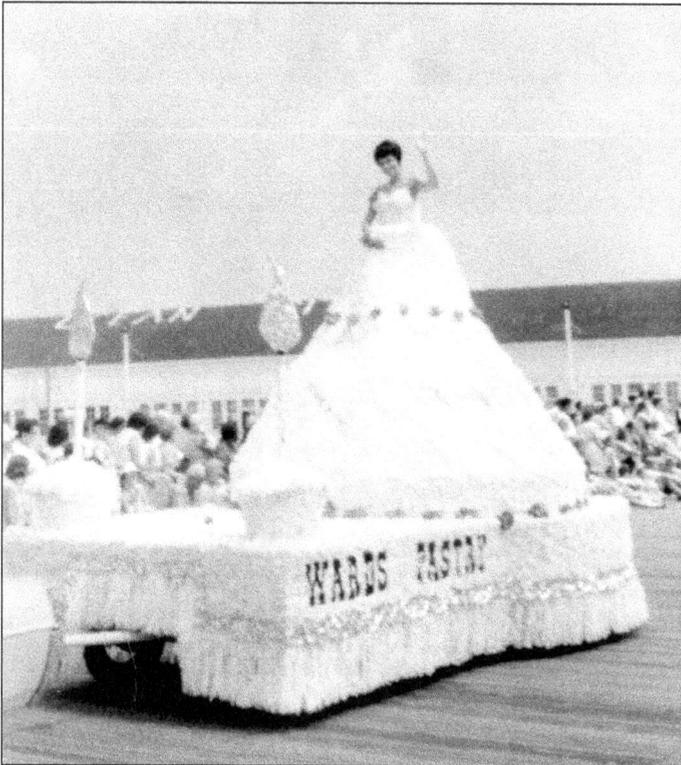

Wards Pastry took third prize in the commercial float division in the August 6, 1964, baby parade. The skirt of the young woman on the float was made to resemble cake icing. Wards Pastry has been on Asbury Avenue since the 1930s. (Courtesy of Walt Hohman.)

The College Grill, on the boardwalk near Fourteenth Street, was a favorite hangout. This float, entered in the August 6, 1964, baby parade, shows the youthful exuberance that was part of the attraction of the restaurant. The float also carried a piglet, one of only three animals in that year's parade. The other two animals were a baby deer on the Storybook Land float and a donkey with one of the children's entries.

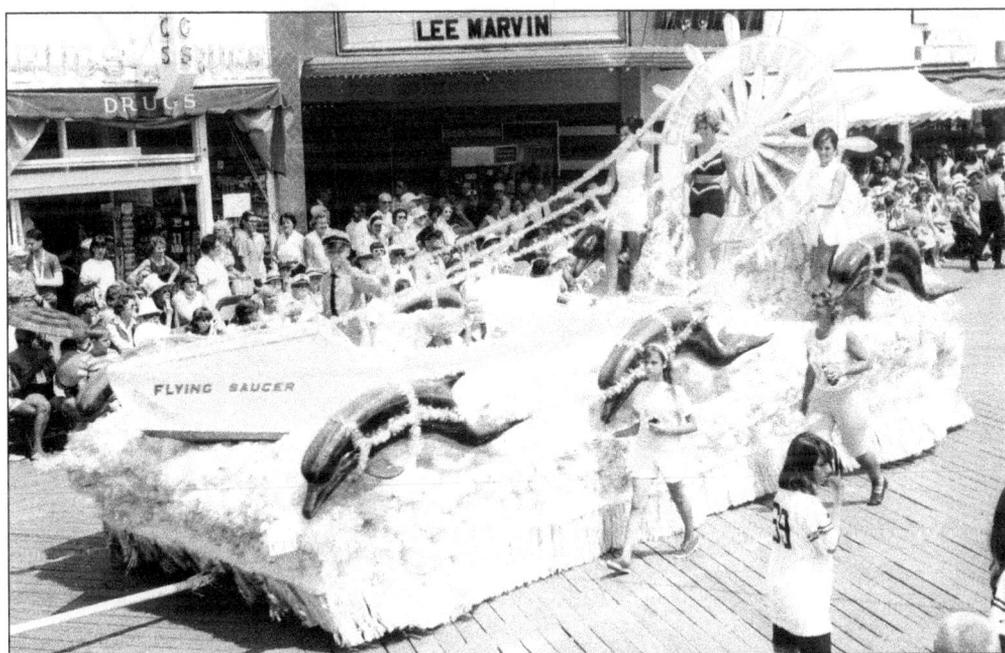

Chris' Restaurant, at Ninth Street on the Great Egg Harbor Bay, had this float in the August 12, 1965, baby parade. Chris Montagna, owner of the restaurant, also owned a fleet of fishing boats and speedboats. Sightseeing tours were given on the speedboats, usually with Montagna at the helm. The *Flying Saucer* was the most famous of the speedboats. (Courtesy of OCHM.)

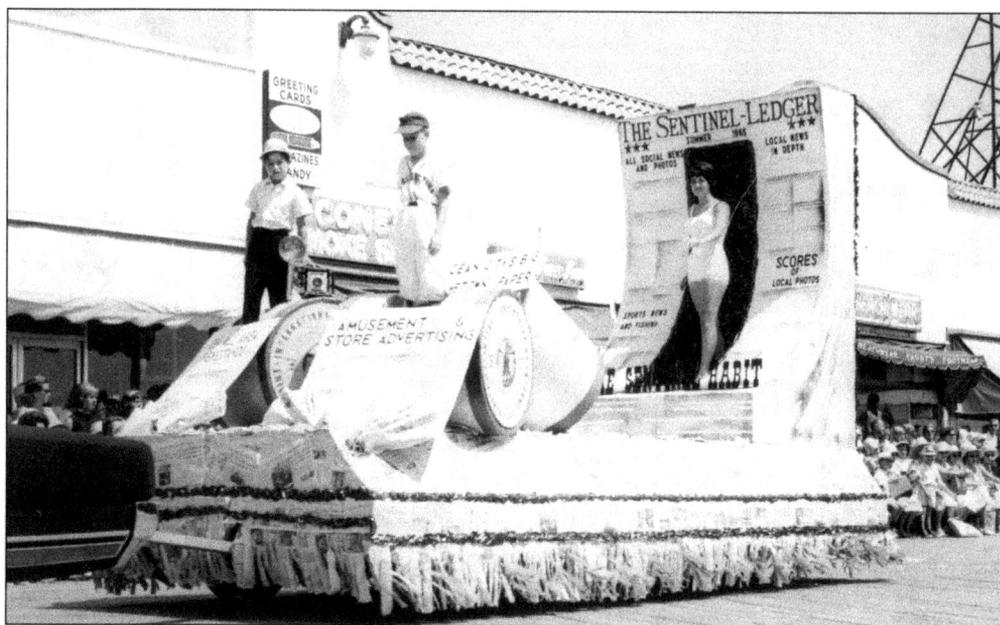

On Thursday, August 12, 1965, this float from the *Ocean City Sentinel-Ledger* newspaper was one of the entrants in the baby parade. Breaking through the front page is Madaline Allegretto, the news photographer is John G. Manni, and the ballplayer representing the newspaper's sports coverage is James Nickles. A special guest at the parade was retired Marine Corps major Richard W. Sooy, who won as cutest baby in the 1901 baby show.

"Two Frontier Ladies" is the title of this entry in the August 12, 1965, baby parade. Patti Jo Haines (left) and Susan Godfrey ride in an old-fashioned carriage pulled by a real horse. Susan was the daughter of Herbert and Teresa Godfrey, owners of Godfrey Funeral Home on Central Avenue. (Courtesy of Val and Herb Godfrey.)

Susan Yoder was two years old when she was entered in the August 12, 1965, baby parade. She is sitting in a cup of Kohr Brothers frozen custard. Her father and mother managed the custard stand during the summer. Kohr Brothers custard has been a staple on the Ocean City Boardwalk for many years. (Photograph by Senior Studios, courtesy of Jean Yoder.)

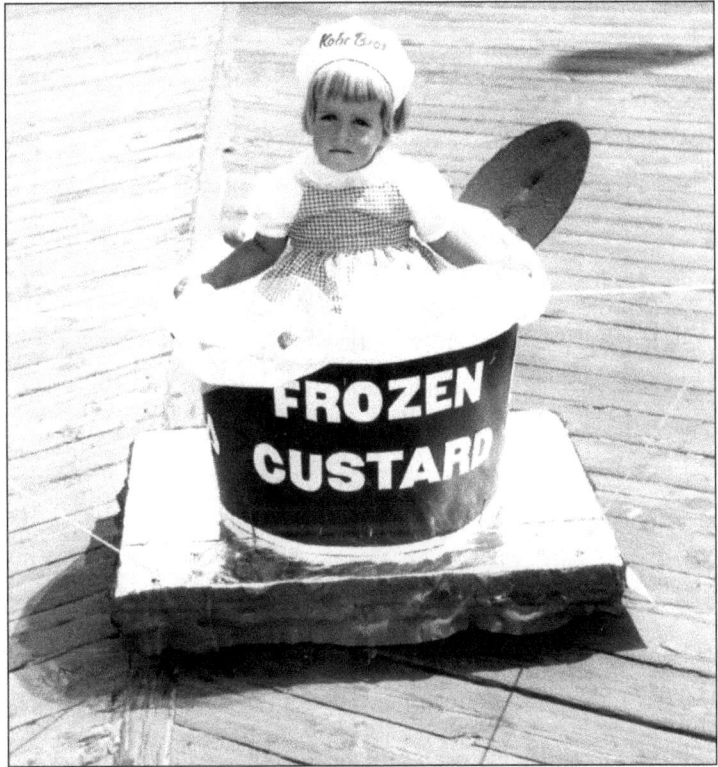

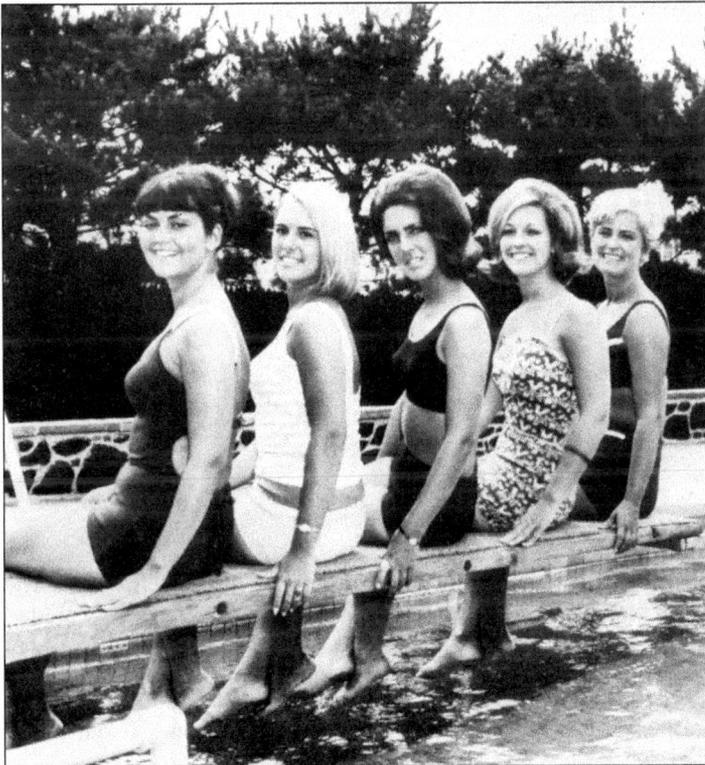

The 1966 baby parade was held on Thursday, August 11. Queen Infanta and her court are shown in this picture from the cover of the *Weekly Guide of Ocean City*. From left to right are Kathi Cini, Donna Proud, Queen Infanta Grace Hendershott, Andra McElroy, and Linda Diehl.

Herbert and Teresa Godfrey entered their three children in the August 11, 1966, baby parade. The children, from left to right, Susan, Herb, and Sallie, ride on a small flower-decorated float called "Three's a Crowd." They won third prize in the small floats division. Eleven bands and marching groups and 14 commercial floats also participated. (Courtesy of Val and Herb Godfrey.)

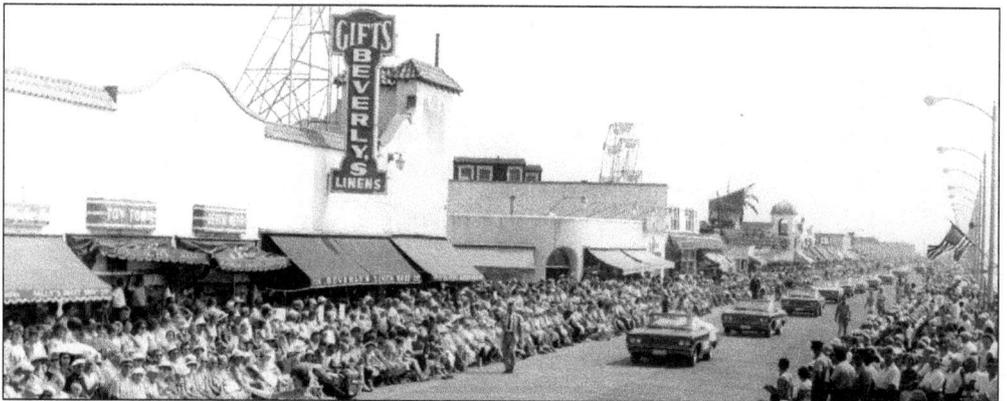

Every year, Palmer Chevrolet-Oldsmobile received 50 Oldsmobile convertibles from the manufacturer for use in the baby parade. The license plates read, "Official O.C. Baby Parade." Miss Ocean City, Miss Cape May County, Miss Somers Point, and various other misses were driven down the boardwalk during the parade. The cars were then used for the Miss America pageant parade in Atlantic City the week after Labor Day. After the parades, New Jersey car dealers from all over the state picked up the cars to sell from their showrooms. (Courtesy of Cathy and John Flood.)

The *Weekly Guide of Ocean City* had this picture of Queen Infanta and the ladies of her court on the cover the week of the August 8, 1968, baby parade. In the picture, Queen Infanta Susan Cornwell is at the top. Shown from left to right are the members of her court, including Carol Benzon, Kathleen Felmey, Marcia Nuss, and Mary Verdiani.

This gaily decorated float won first prize in the commercial float division for the Chatterbox Restaurant in the August 8, 1968, baby parade. The float had a patriotic theme with red, white, and blue colors. In this election year, the "demonstrators" on the float waved banners with the slogan "For a Party That Beats All Parties—Go to the Chatterbox." (Courtesy of Elizabeth Booth.)

The Madera family of Pittsburgh won first place for this float in the August 8, 1968, baby parade. From left to right are Bruce, Linda, Diane, Laura, and mother Carol Madera. Jimmy Madera is peeking from the chimney. They represented the "Old Lady Who Lived in a Shoe, She Had So Many Children She Didn't Know What to Do!" (Courtesy of Carol Madera.)

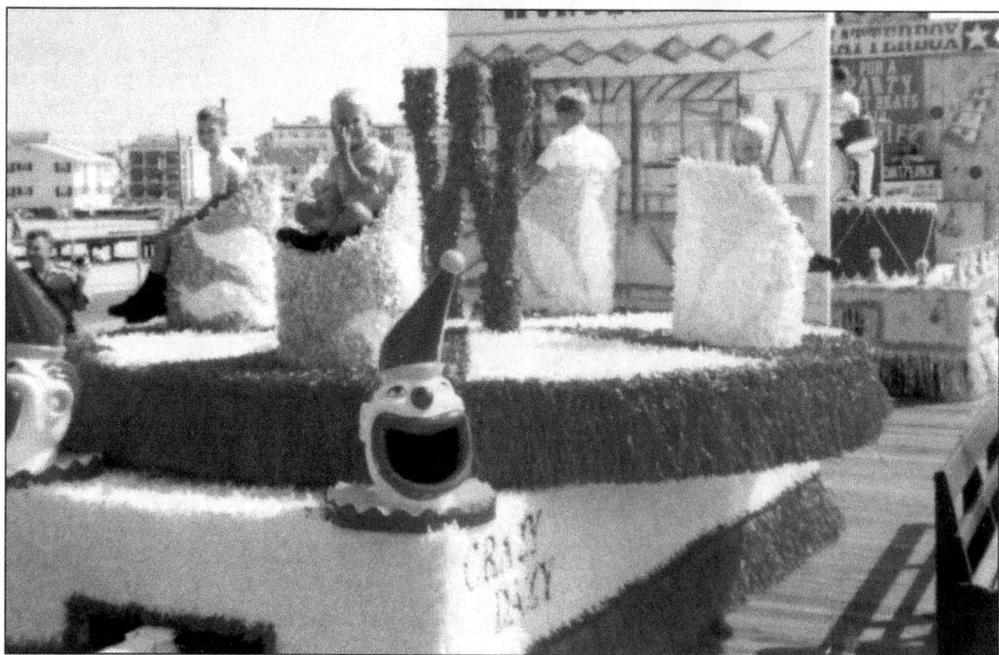

Roy Gillian, owner of Wonderland Pier at Sixth Street and the boardwalk, had this float in the August 8, 1968, baby parade. His four sons ride on the "Crazy Dazy." From left to right are Steve on a green chair, John on a pink chair, Jim on a blue chair, and Jay on a yellow chair. (Courtesy of Michele and Jay Gillian.)

Nancy Gunther, Queen Infanta 1970, helps Mayor B. Thomas Waldman crown Deborah Joy Neall Queen Infanta 1971. Neall's coronation took place at a gala party at the Music Pier on Saturday, August 7, 1971. Her mother, Joy Smith Neall, had been Queen Infanta in 1948. This was the first time a mother and daughter had both been Queen Infanta. (Courtesy of Debbie Jewell.)

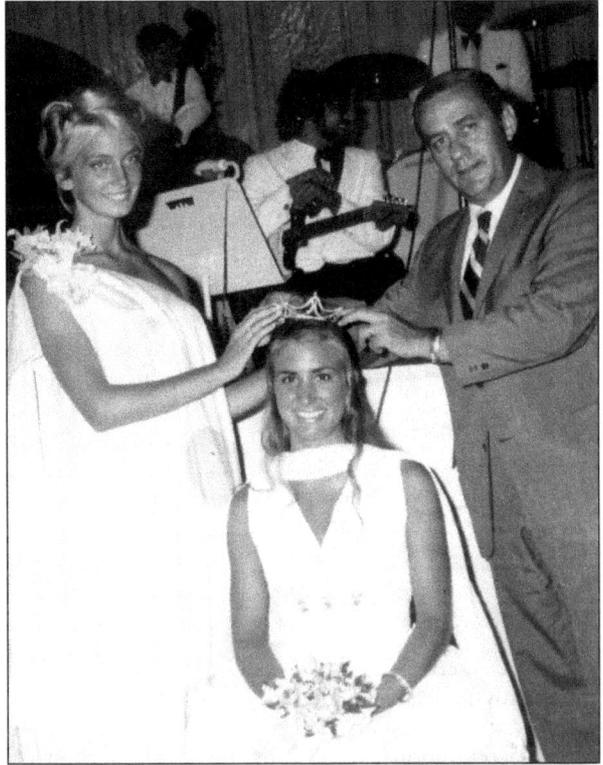

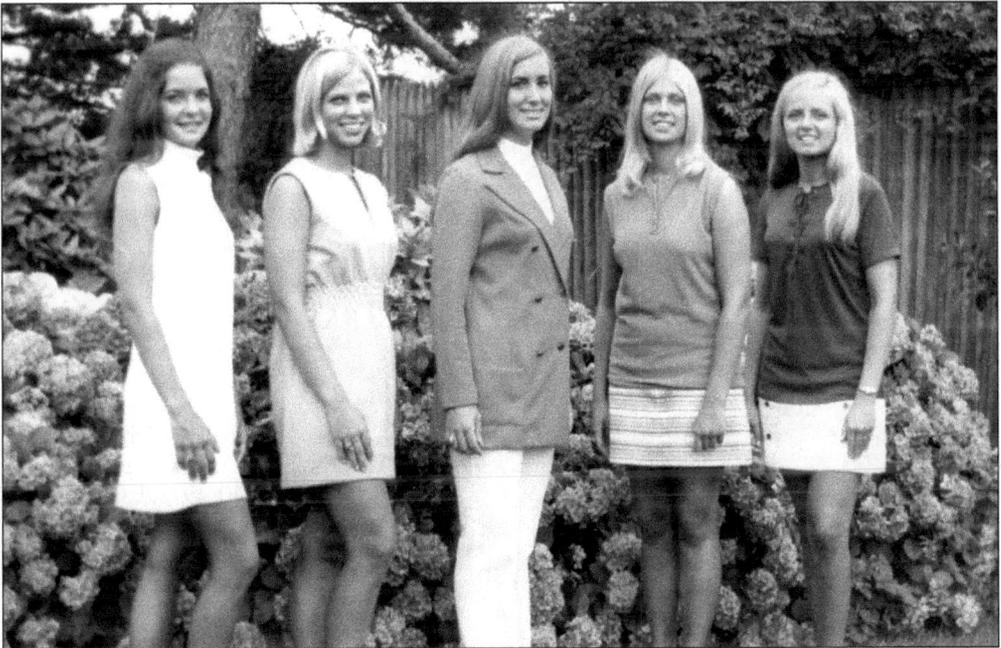

Queen Infanta 1971 and her ladies-in-waiting pose for this picture on the grounds of the Kimble Estate in the Gardens section of Ocean City. The women are, from left to right, Patricia Ann (Patti) Hunter, Kathy Lamb, Queen Infanta Deborah Joy Neall, Frieda Toews, and Claudia Ann Rommel. (Courtesy of Debbie Jewell.)

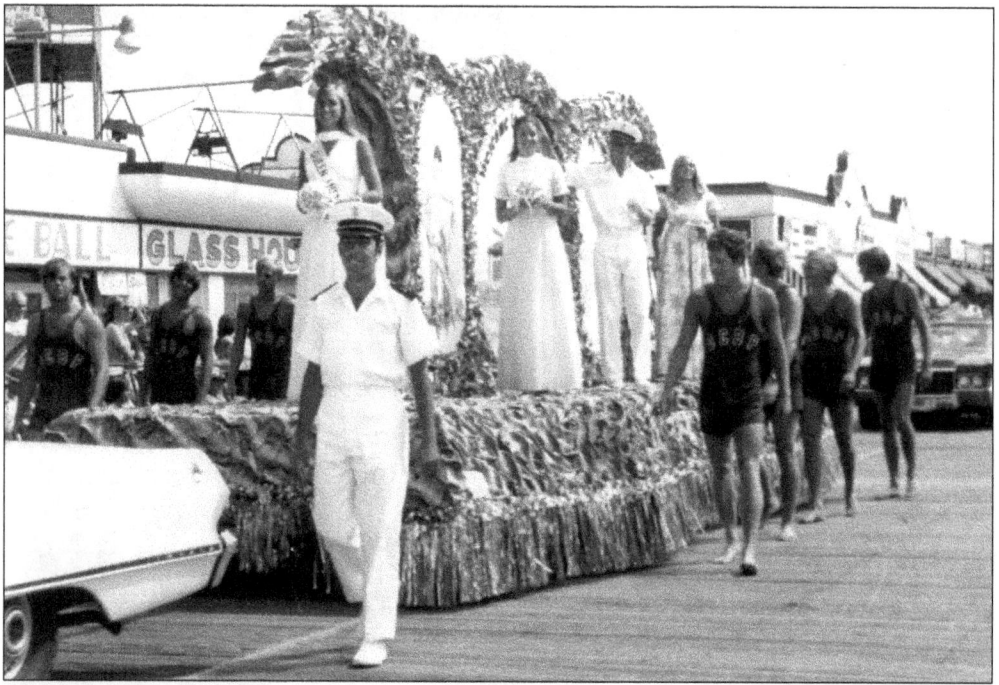

Queen Infanta Deborah Joy Neall and her royal court ride on their float in the August 12, 1971, baby parade. Ocean City Beach Patrol members, some in their white dress uniforms and some in their beach uniforms, accompany the float. (Courtesy of Debbie Jewell.)

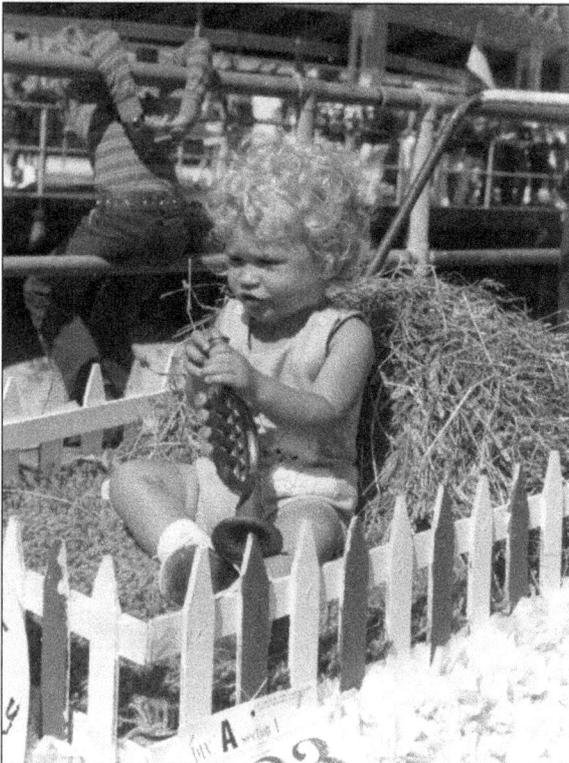

Thirteen-month-old Michael Allegretto was "Our Little Boy Blue" in the August 10, 1972, baby parade. He won the Tuckahoe Inn Award for this entry. The youngest child in the parade was 11 weeks old. For several years, there was an award for the youngest entrant in the parade, but after a child only several days old was entered, this category was discontinued. (Courtesy of Kathy and Mike Allegretto.)

Patti Hunter of Ocean City was Queen Infanta for the August 9, 1973, baby parade. Hunter had been in the 1972 parade when she was crowned Miss Night in Venice. Queen Infanta's ladies-in-waiting were Nancy Nelms of Medford Lakes, Stacie Wilgus of Ashton, Pennsylvania, Robin Bowman of Lafayette Hills, Pennsylvania, and Christine Wotell of Delran.

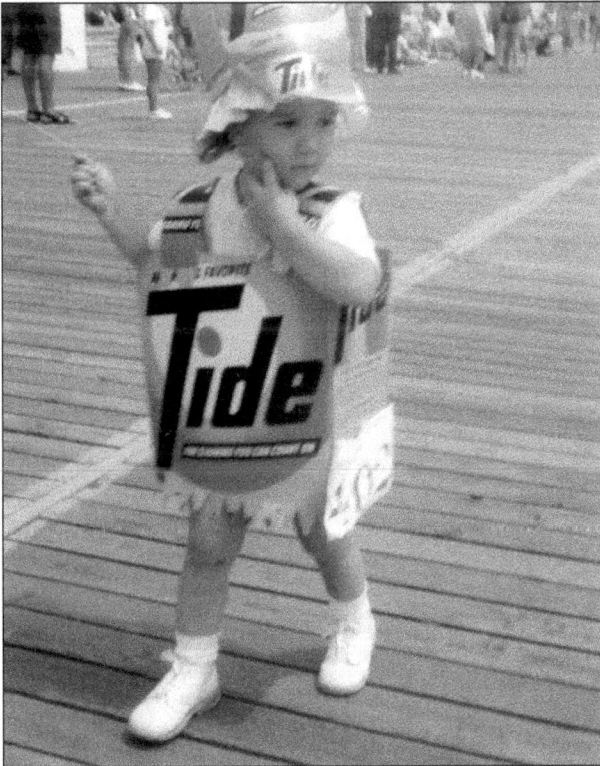

"Don't Hoard Me in '73" was the title for this entry in the August 9, 1973, baby parade. Heather Cramer wore almost the same costume that her mother, Ginny, wore during the 1950 parade. (Courtesy of Ginny and Ron Gifford.)

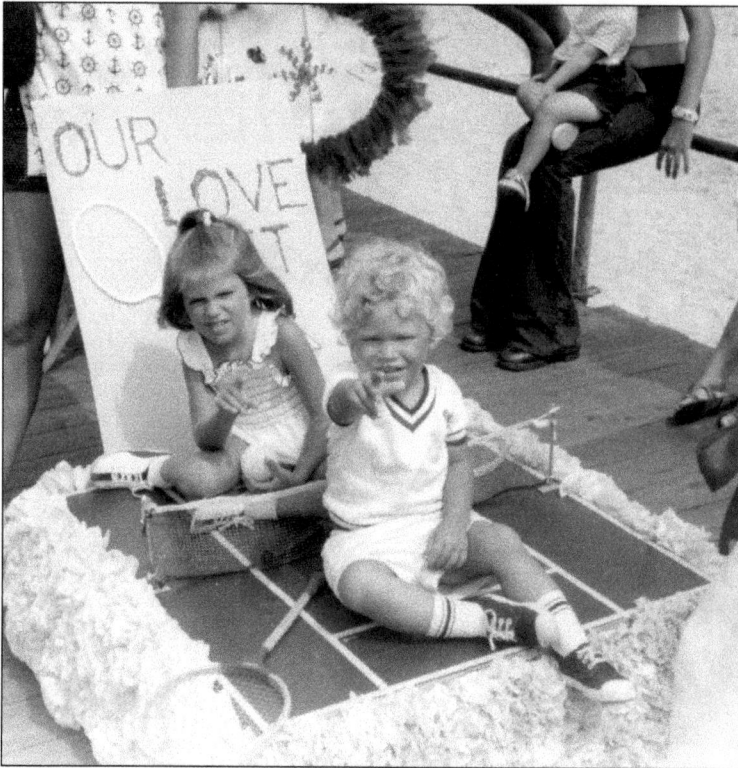

Ocean City residents Kristi Allegretto, age three, and her brother Michael, age two, ride on their "Love Set" float during the August 9, 1973, baby parade. The Allegrettos did not have far to travel to be in the parade, but one entrant came from Venezuela in South America. (Courtesy of Kathy and Mike Allegretto.)

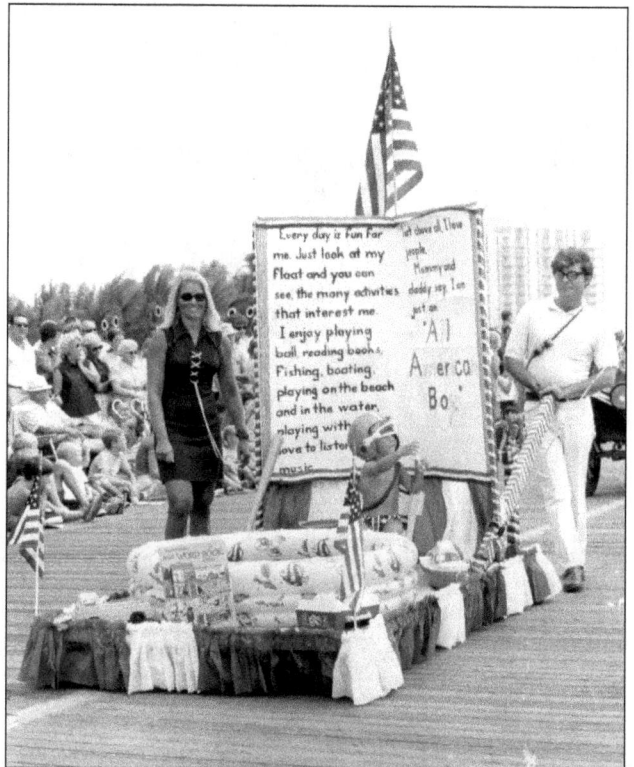

Parents Joan and Dave Wilson push three-year-old Christopher Wilson on his float during the August 9, 1973, baby parade. His entry, "All American Boy," listed all the things he liked to do: "playing ball, reading books, fishing, boating, playing on the beach and in the water . . . listening to music." (Courtesy of Joan and Dave Wilson.)

Six-month-old Ocean City resident D. J. Jessel's parents took this picture of her after the August 8, 1974, baby parade. She was No. 120 in her division. Children from 15 states, including Hawaii, were entered in that year's parade. (Courtesy of Denise and Gary Jessel.)

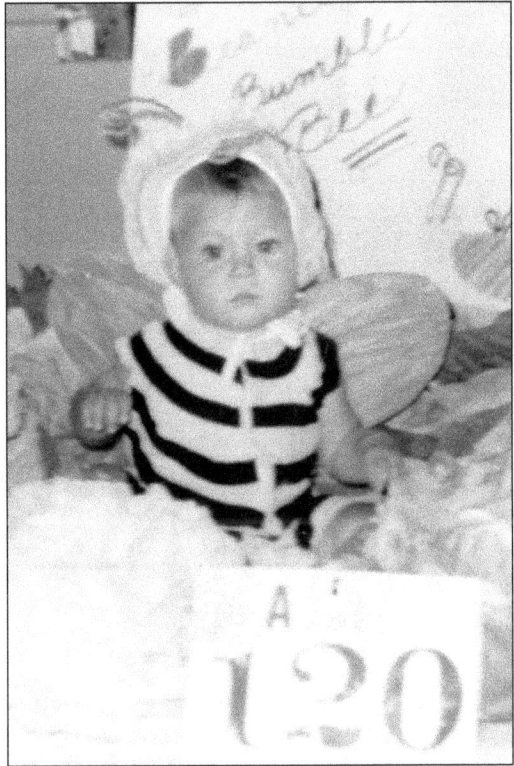

Marion Crooks pulls the float of her nephew 23-month-old Fred Tinney, "Crown Prince Frederick," during the August 14, 1975, baby parade. Almost 500 children as more than 300 entries were in that year's parade. (Courtesy of Marion and Ned McCaughey.)

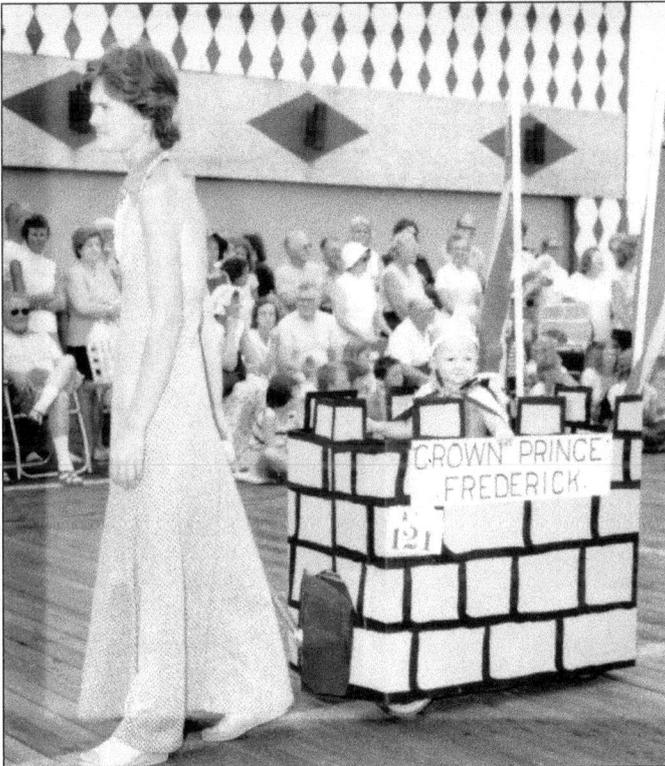

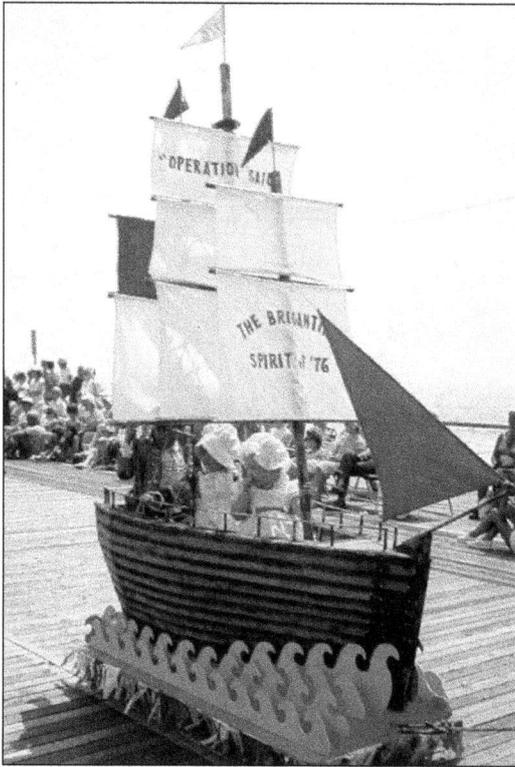

Tommy, Cher, and Lonnie Callowhill of Brigantine won second place in their division with "Operation Sail." They rode in the "Brigantine Spirit of '76." The back of their float held the note "Made by Pop Pop." Many of the entrants in the August 12, 1976, baby parade had themes recognizing America's bicentennial celebration.

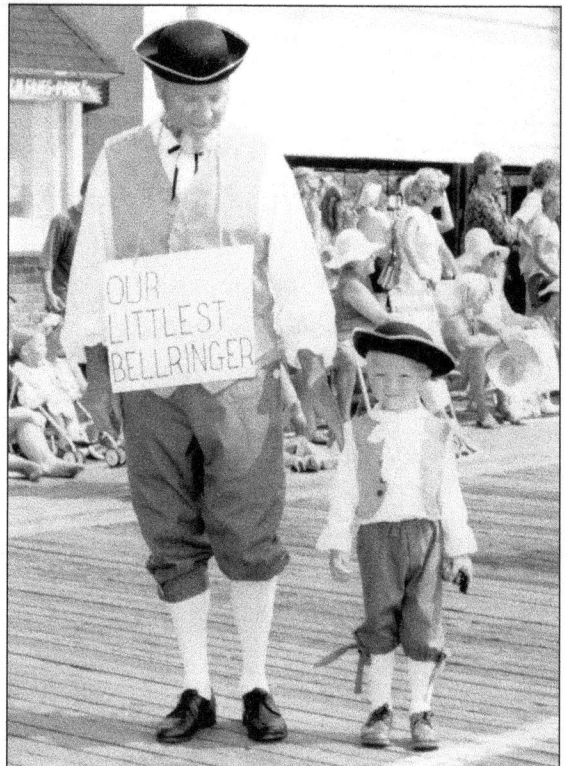

Harry A. Crooks walks his grandson Fred Tinney, "Our Littlest Bellringer," down the boardwalk during the August 12, 1976, baby parade. This entrant, like many of the others, is paying tribute to America's bicentennial. (Courtesy of Marion and Ned McCaughey.)

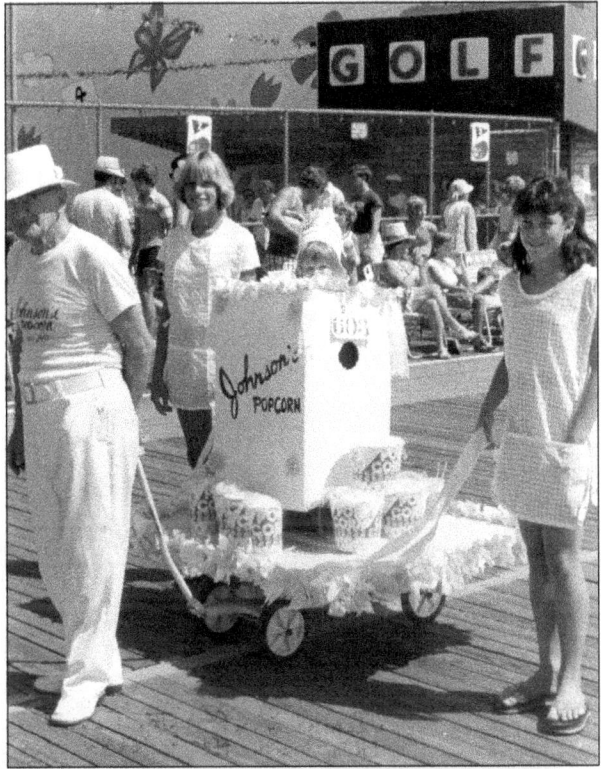

Walter E. Stauffer pulls a box of Johnson's Popcorn down the boardwalk as Cherie Stauffer peeks out. They are accompanied by Dana Santini (left) and Sherry Wallace during the August 12, 1976, baby parade. Johnson's Popcorn had been a boardwalk favorite for many years. (Photograph by Senior Studios, courtesy of Rita and John Stauffer.)

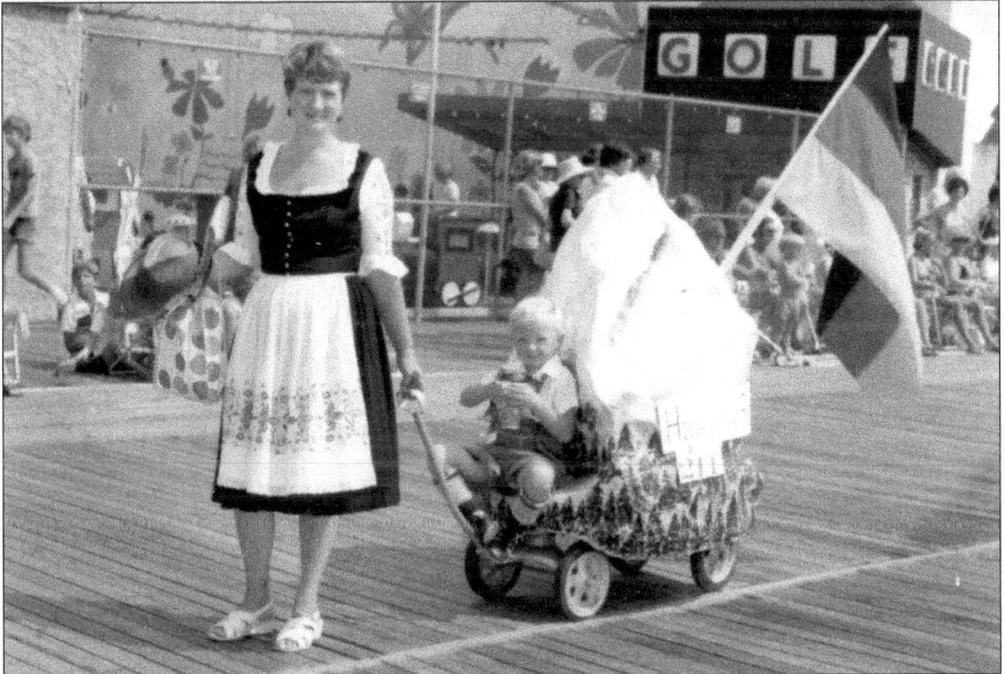

Fred Tinney is pulled down the boardwalk by his mother, Florence Tinney, during the August 11, 1977, baby parade. He won a silver bowl as the third-place prize for his entry, "High in the Alps." (Courtesy of Marion and Ned McCaughey.)

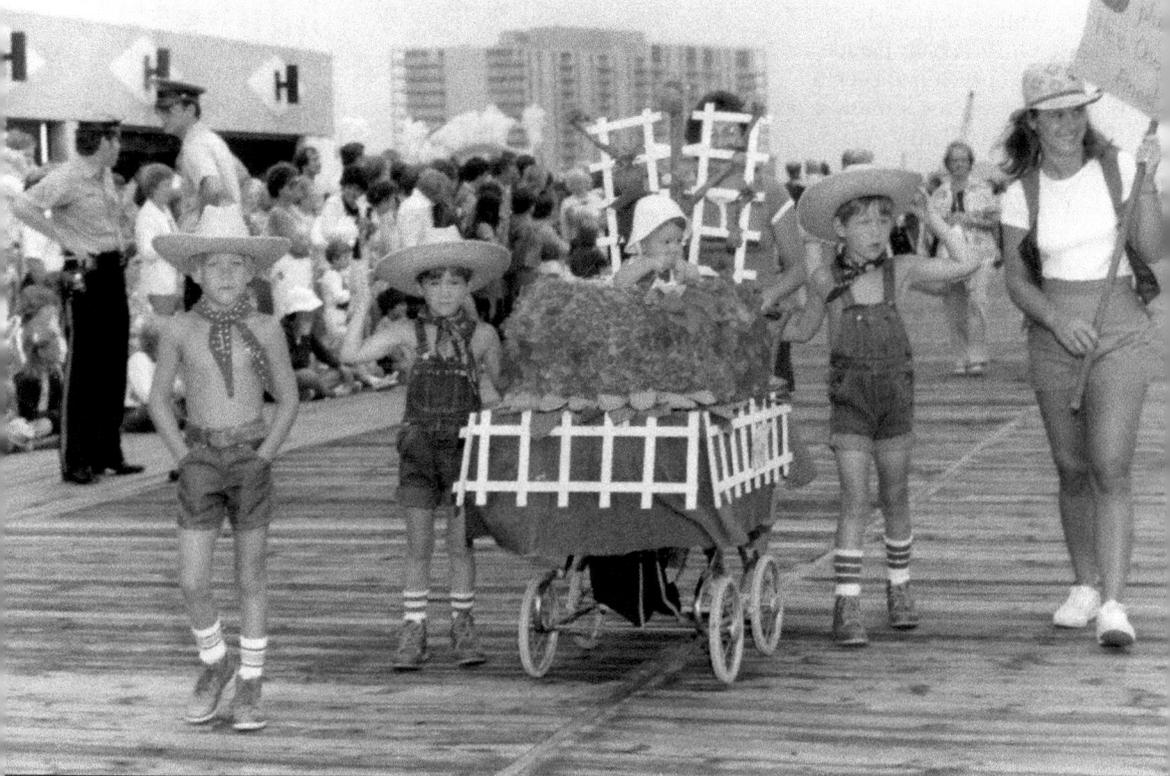

This group of farmers and their plump tomato won a silver bowl in the August 10, 1978, baby parade. Their entry was called, "Farmers and Their Tomato." From left to right, the farmers are Eddie Huff, Jimmy McAfee, and Joe McAfee. Aunt Jill McAfee, accompanying the farmers, is holding a sign reading, "The farmer says: 'This tomato is plump and sweet, He's Ocean City's finest treat!'" The farmers walk the parade route while baby Jeffrey McAfee, the "tomato," is seated in the center of a large, red paper tomato and is pushed by his mom, Sandy McAfee. (Courtesy of Sally Huff.)

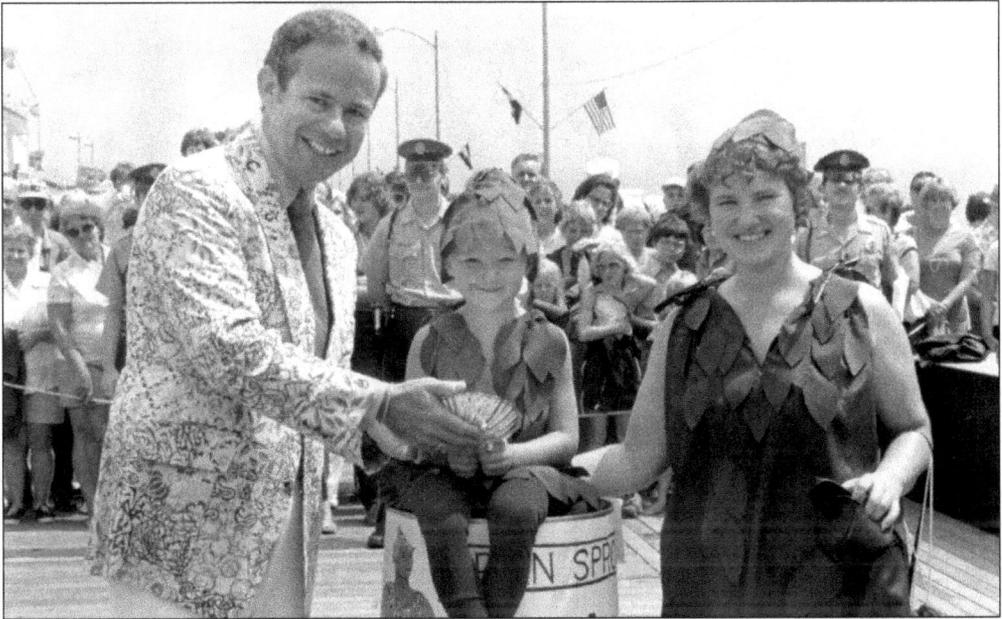

William H. Woods, city council president, presents the second-place award in the fancy dress division to Fred Tinney and his mother, Florence Tinney, after the August 10, 1978, baby parade. Fred's entry was "the Little Green Sprout." (Courtesy of Marion and Ned McCaughey.)

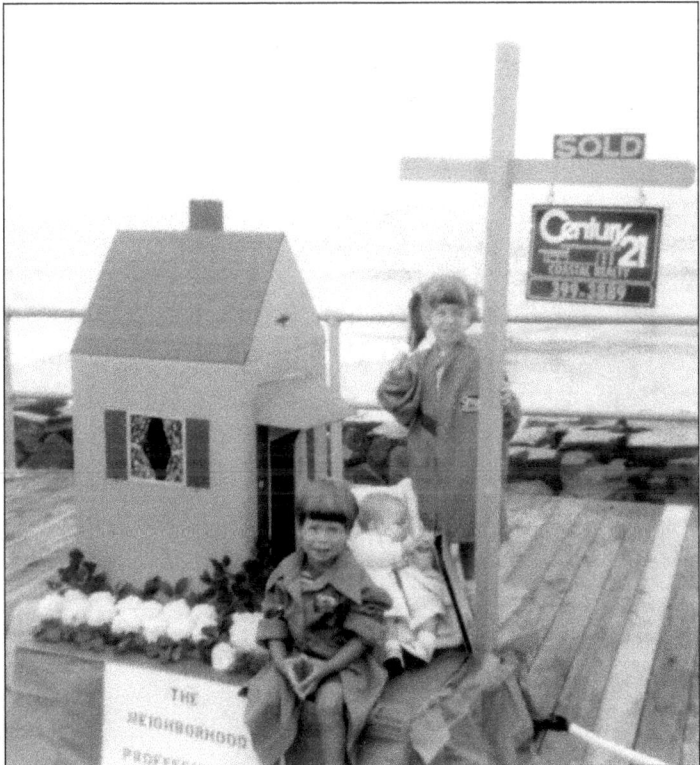

Century 21-Coastal Realty had this small float in the commercial float division in the August 10, 1978, baby parade. From left to right are two-year-old Jeffrey Keich, six-month-old Lori Doll, and four-year-old Sheri Doll. Sue and Don Doll, who owned Century 21-Coastal Realty, are the parents of Sheri and Lori Doll. (Courtesy of Sue and Don Doll.)

Frank Ruggieri was manager and bassoonist of the Ocean City Municipal Orchestra on the Music Pier. For 50 years, he helped build and maintain the longest-running series of summer concerts on the Jersey Shore. Ruggieri was honored at the last concert of the season on September 8, 1978. This entry pays tribute to Ruggieri during the August 10, 1978, baby parade. Here Ruggieri and his wife, Anne, look at Johnny Johnson, who is portraying a young Ruggieri.

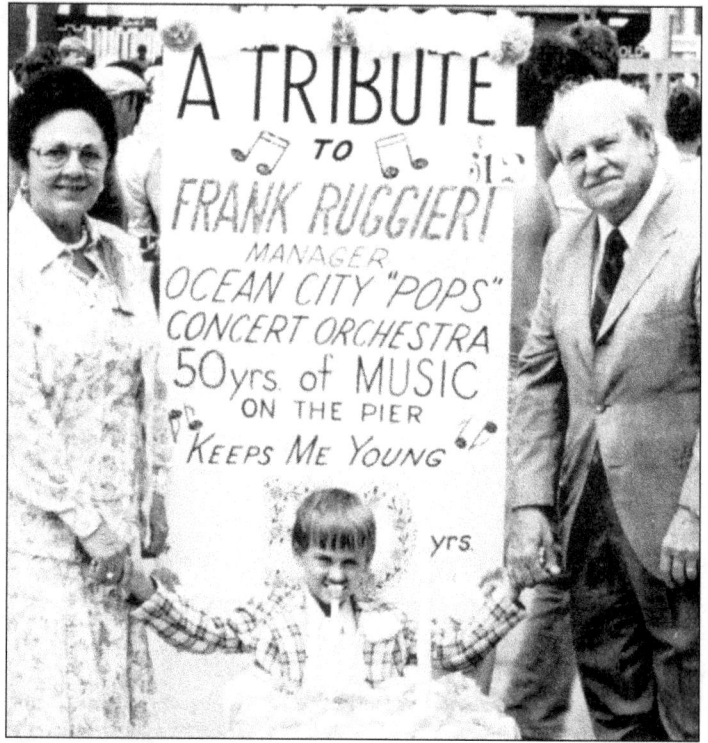

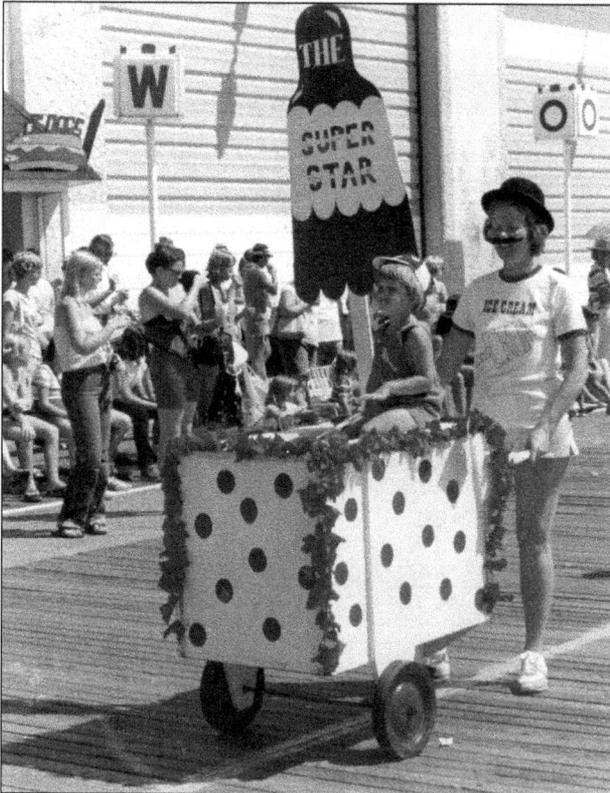

Rita Stauffer pushes an ice-cream cart, "the Super Star," during the August 10, 1978, baby parade. John Stauffer Jr. is hitching a ride. (Courtesy of Rita and John Stauffer.)

Four

ONE HUNDRED YEARS YOUNG

Founded in 1879 by five Methodist ministers wishing to establish a Christian seaside resort, Ocean City has evolved into a multicultural, multiethnic community of year-round and summer residents and visitors. In 1979, Ocean City held a yearlong commemoration for its centennial. Mayor Chester J. Wimberg, in a proclamation, stated, "I proclaim the year of 1979 for a celebration of Ocean City's Century of Progress and urge every man, woman, and child to rededicate themselves to the advancement and progress of our fine community."

The residents did what the mayor asked. There were centennial projects in the schools and in the community. There were centennial events, centennial sports meets, and centennial souvenirs. A glass capsule was filled with centennial memorabilia, including the mayor's proclamation and those from the county, the state, and Congress. Local photographs and certificates and a scroll with signatures of residents who had signed it throughout the year were also added. The capsule was stored in the historical museum to be opened in 2079.

The baby parade, held on August 9, played a part as well. There were birthday cakes with 100 candles, floats with gift-wrapped boxes representing presents for the city, and one very special float—a cooperative effort between the city and Procter and Gamble's Ivory Soap, which was also 100 years old. The float was called "Ocean City, a Century of Serenity" and had a sign with two of the city's 1979 emblems, depicting a youngster on a bicycle with the rest of his family strolling the boardwalk. Seagulls and the ocean can be seen behind them. The float also held a gold bathtub filled with Ivory Soap.

With the 1979 baby parade, Evelyn and Russell Hanscom, who had been involved with the parade since the 1930s and organized it since 1946, officially retired as parade directors. They handed it over to the capable hands of Priscilla Parker and Doris and Dutch Dalhausen. Under Parker and the Dalhausens, more floats and bands were added, and the baby parade continued to attract more and more entries, spectators, and publicity.

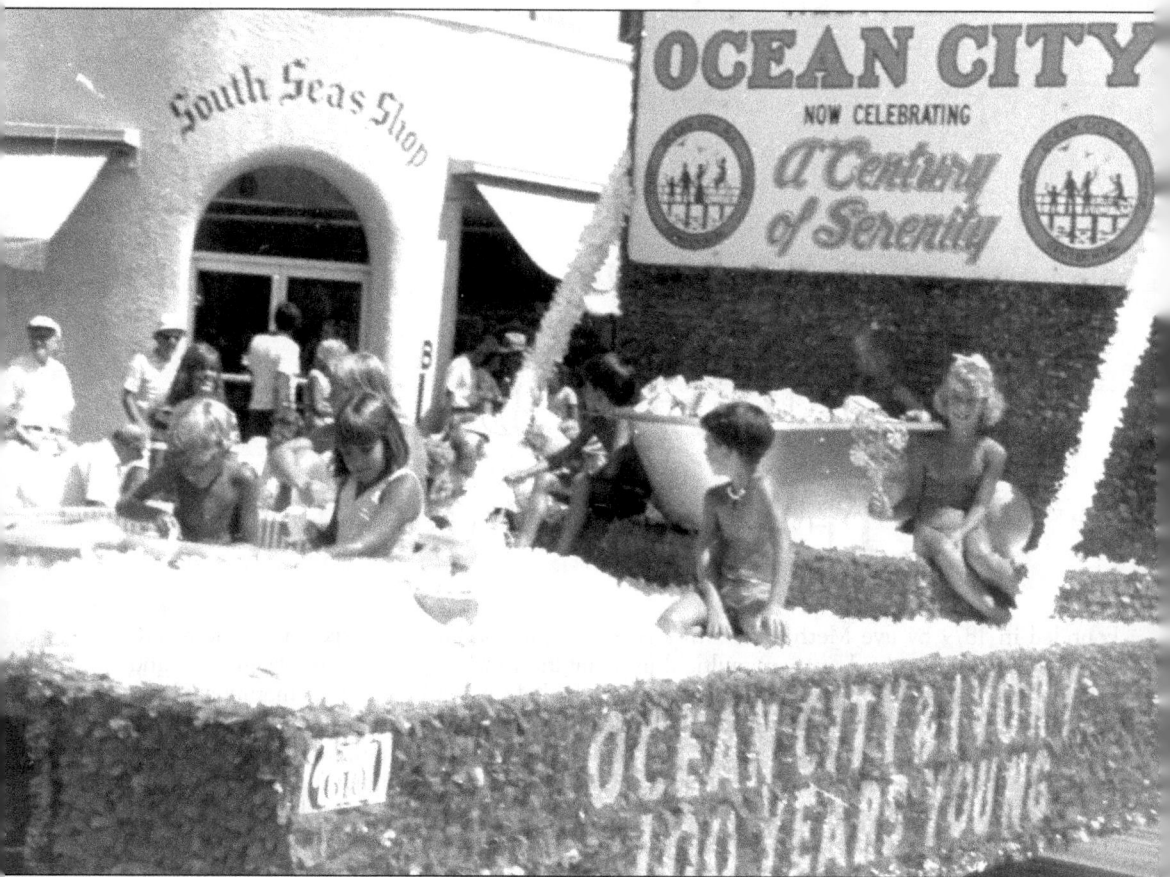

In 1979, Ocean City celebrated its centennial. Procter and Gamble was also celebrating 100 years of its soap Ivory Soap. This float in the August 9, 1979, baby parade was a joint effort of the city and Procter and Gamble. On the far left are Michael Allegretto and his sister Christie, children of assistant recreation director Mike Allegretto. The children on the far right are not identified. Many of the other entries also recognized Ocean City's centennial. First place in the fancy dress division, aged 6 to 10 years, went to Betsy and Deborah Pruitt for "Happy Birthday Ocean City." The winner for the greatest distance traveled went to Elizabeth A. Gimbel from Foster City, California. She was wrapped up as a happy birthday box with a big pink ribbon on her head for her entry "To O. C. from Foster City." (Courtesy of Kathy and Mike Allegretto.)

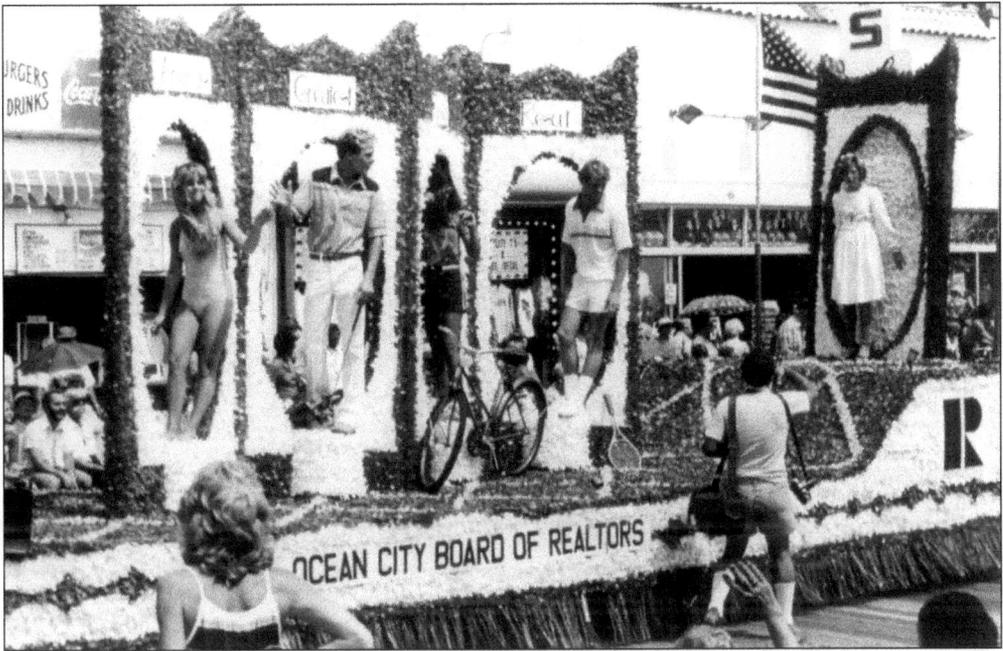

The Ocean City Board of Realtors entered this float in the August 14, 1980, baby parade. Entered in the commercial float division, it depicts "America's Greatest Family Resort." From left to right are Joanne Murray, Denny Powell, Michelle Scioli, Charlie Bowman, and Trisha Bowman. (Courtesy of Priscilla Parker.)

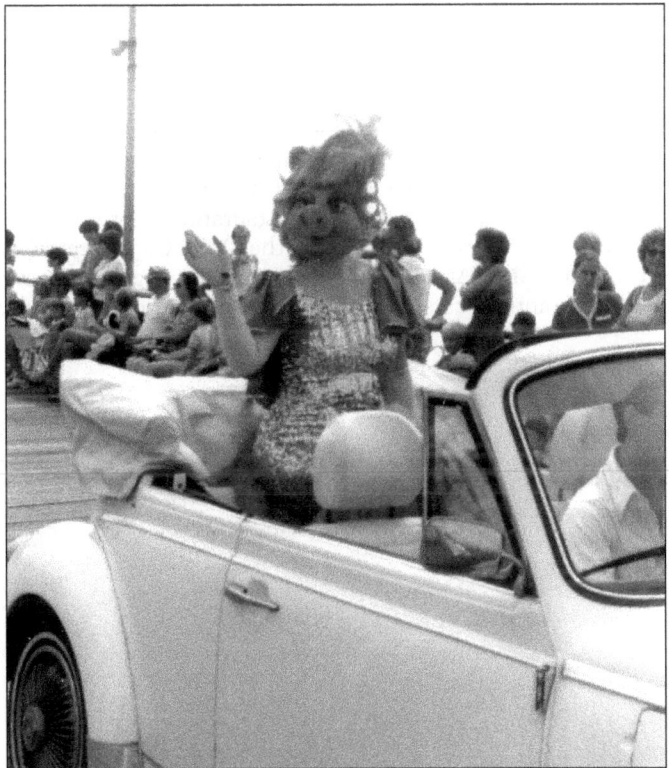

Miss Piggy was a special guest at the August 14, 1980, baby parade. One of the attractions under Priscilla Parker's direction was the addition of cartoon characters. They were always received with glee by the children in the parade as well as by those in the crowd of spectators. (Courtesy of Wilma and Dan Murray.)

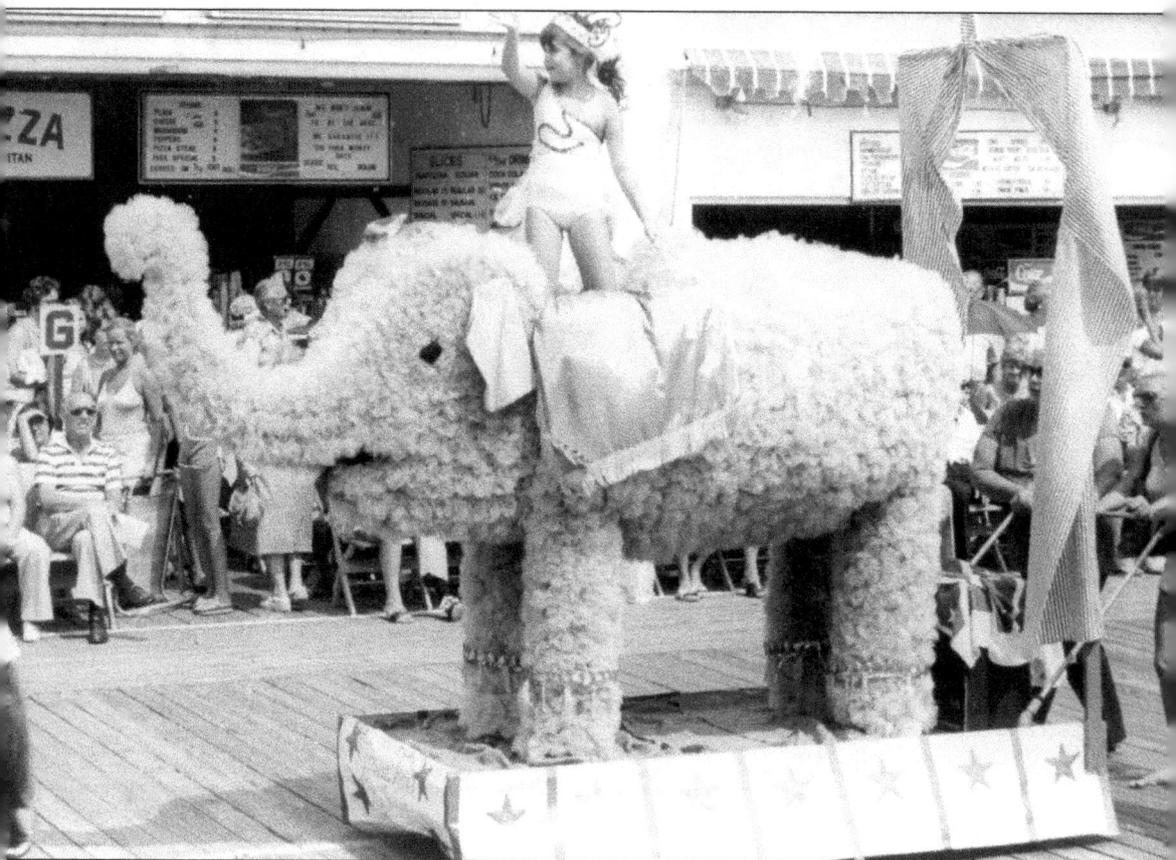

Seven-year-old Stacey Lane Brasberger placed third in her division as she rode down the boardwalk on her elephant. She was entered as "Circus Time in Ocean City" in the August 14, 1980, baby parade. Years later, her mother, Blondie, made many of the commercial floats for the parade. In 1980, there were 21 floats in the parade, including ones from the Ocean City Board of Realtors, the Chatterbox Restaurant, Stainton's Department Store, Shriver's Candies, Gillian's Fun Deck, the queen's float, the *Ocean City Sentinel-Ledger*, Simms' Restaurant, and the Ocean City Civic Association. There were also eight marching bands, 35 beauty queens, guest celebrities, antique cars, clowns, and acrobats. (Courtesy of Priscilla Parker.)

This flying saucer was one of the main attractions of the August 14, 1980, baby parade. It was a 30-foot-by-17-foot balloon covered with $3,000 worth of lights made and flown by Bob Kemp. Kemp created the giggling Pillsbury "Poppin' Fresh" Doughboy. His balloons were featured in major parades throughout the country. (Courtesy of Wilma and Dan Murray.)

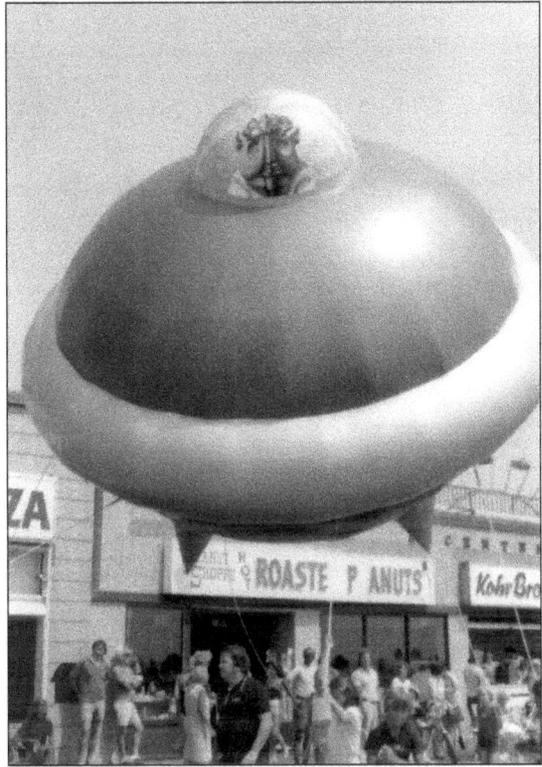

Suzanne Leonetti won first prize in the children's float division of the August 14, 1980, baby parade. Her entry was "Ocean City's Daisy May." Sitting in front of her ramshackle house, complete with an outhouse, Leonetti is a typical country girl. (Courtesy of Betty Chandler.)

The Philadelphia Phillies mascot, the Phillie Phanatic, was grand marshal of the August 13, 1981, baby parade. Here Mayor Chester J. Wimberg (left) and Ocean City publicist Mark Soifer celebrate with the Phillie Phanatic as they give him a "Piece of the Walk" to commemorate his performance. Parade director Priscilla Parker (far right) talks to police officer Nicholas Impagliazzo. (Courtesy of Mark Soifer.)

Jimmy Lowe (left) and his brother Matthew are pushed down the boardwalk by their mother, Candelle Lowe, during the August 12, 1982, baby parade. They are in a "hot-air balloon," complete with sandbags to keep them from flying too high, in their entry, "Palin' Around." (Courtesy of Candelle and Jim Lowe.)

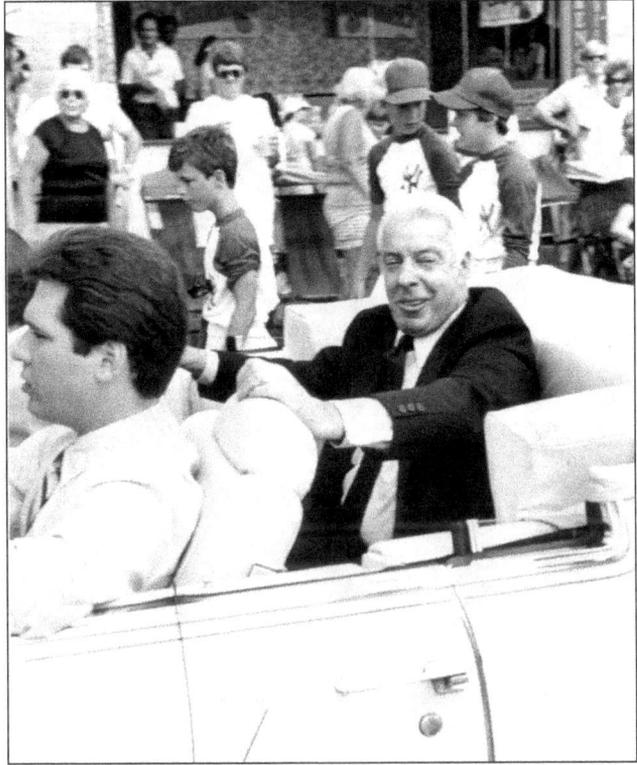

"Joltin' Joe" DiMaggio, the legendary New York Yankee, was grand marshal of the 1983 Ocean City Baby Parade. The boardwalk was lined with 100,000 spectators, many admitting they came to get a glimpse of the "Yankee Clipper" as much as to watch the annual baby parade. DiMaggio presented the Founder's Day award in memory of parade founder Leo Bamberger. (Courtesy of Mark Soifer.)

Candelle Lowe holds her son Matthew while her son Jimmy and his father, Jim Lowe, prepare to take their float down the boardwalk during the August 11, 1983, baby parade. The float, "Judges Rule Ocean City #1," took third place in the small float division. (Courtesy of Candelle and Jim Lowe.)

Ocean City councilman Henry S. Knight (left) congratulates the Lowe family of Ocean City, from left to right, Matthew, Jimmy, father Jim, and mother Candelle, for their second-place win in the August 9, 1984, baby parade. Their plane, "Spirit of Ocean City," pulled a banner, "Happy 75th," celebrating the 75th year of the baby parade. Seventy-five years of baby parades made for some interesting stories, as told in an article in the *Ocean City Sentinel-Ledger*. According to the article, one year a woman was allowed to walk her dressed-up pet poodle in the parade and was incensed when it did not win a prize. Another year, a parent wore a costume just like the child. Other parents did not think that was proper, but Evelyn Hanscom, parade director at the time, felt it "finished the picture," and those entries winning the Hanscom Award frequently are the ones doing just that. (Courtesy of Candelle and Jim Lowe.)

City councilman Henry S. Knight presents a silver bowl to Susan E. McCaughey, as her mother, Flossie McCaughey, looks on. Susan won for her entry, "A Campbell Soup Kid," in the August 9, 1984, baby parade. (Courtesy of Marion and Ned McCaughey.)

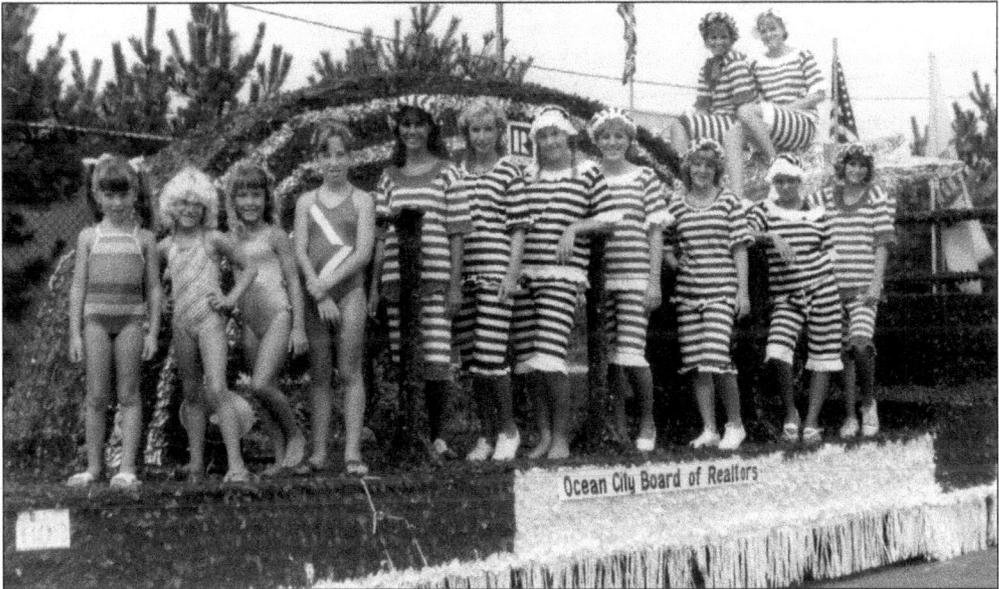

This was the board of realtors float in the August 9, 1984, baby parade. The float was signaling the old and the new. From left to right, the little girls in new bathing suits are Debbie Keich, Lori Doll, Holly Palermo, and Sheri Doll. In the striped, old-fashioned bathing suits are Kelly Baker, Diane Edwards, Leslie Serber, Cindy Myers, Kelly Dougherty, Gwen Goldberg, and an unidentified young woman. At the top, Sue Stover is on the left with Tricia Bowman. (Photograph by Senior Studios, courtesy of Beth Bowman.)

The grand marshal of the August 9, 1984, baby parade was Martin Z. Mollusk, the city's relatively famous hermit crab. Martin Z. Mollusk, created by Ocean City publicist Mark Soifer, has gained publicity around the world for the baby parade and the city. Here he greets Matthew (left) and Jimmy Lowe as they go down the boardwalk in their banner plane. (Courtesy of Candelle and Jim Lowe.)

Bob Dalhausen, the son of baby parade organizers Doris and Dutch Dalhausen, drives Miss Ocean City Tricia Bowman during the August 8, 1985, parade. Once the boardwalk was rebuilt with a cement foundation after the devastating 1927 fire, convertibles carrying young women who won contests in Ocean City or the surrounding communities became an integral part of the baby parade. (Photograph by Senior Studios, courtesy of Beth and Charlie Bowman.)

Five-year-old Erica Wolf, dressed as She-Ra, waits patiently in the staging area, ready to line up for the August 14, 1986, baby parade. She-Ra was a fictional character that appealed to young girls via cartoons and toys. (Courtesy of Alice Wolf.)

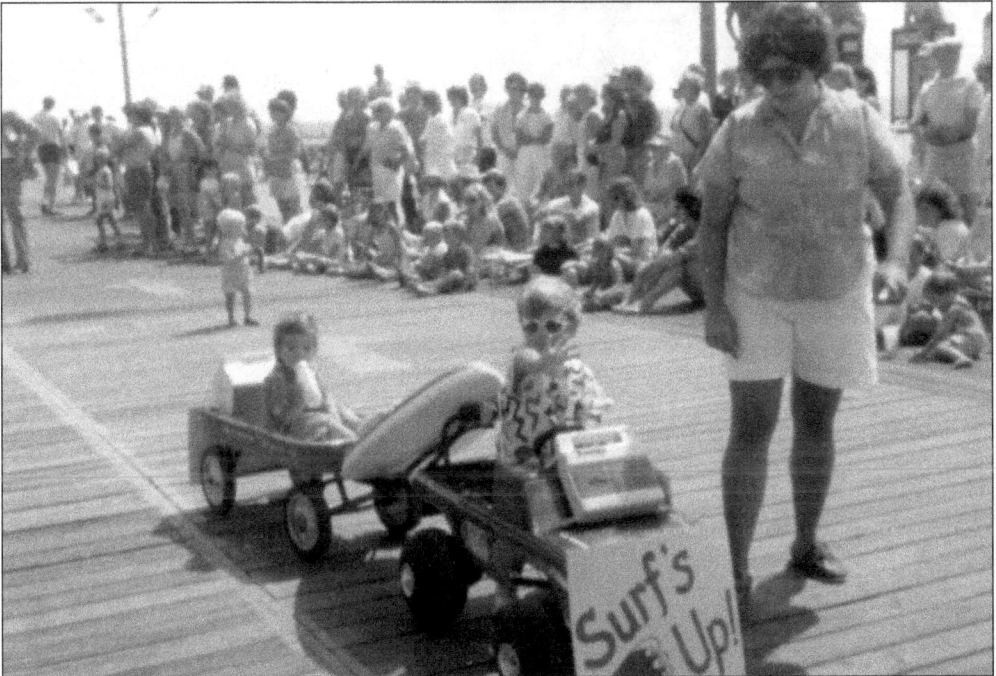

"Surf's Up" for the Hink boys, Brian (left) and Gary, who are accompanied by mother, Donna Hink, during the August 14, 1986, baby parade. Over 200 children took part in that year's parade. (Courtesy of Donna and Gary Hink.)

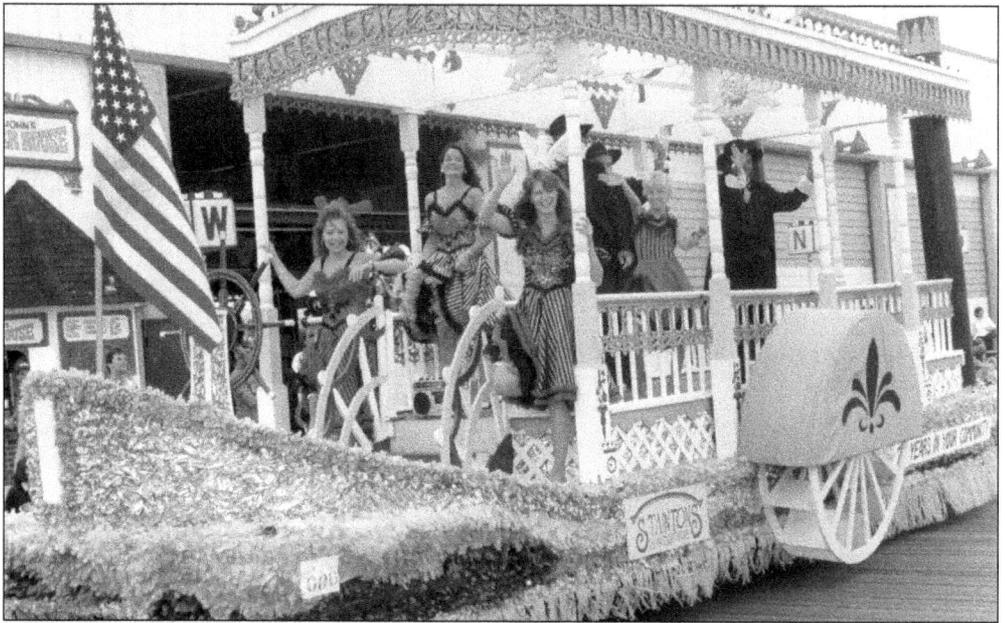

Stainton's Department Store in Ocean City took third place in the commercial float division of the 1987 baby parade. Howard S. Stainton opened his store on Asbury Avenue in 1913. Before the parade began, commentator Fred Rexon announced that the parade was dedicated to the late Evelyn Hanscom, who, along with her husband, Russell, directed the parade for many years. (Courtesy of OCHM.)

Amanda Charles was Queen Infanta in the August 10, 1989, baby parade. Behind her is Esther Weil, a longtime supporter of the parade. Spinning Wheel Florist provided Charles's flowers. Mark Videtto and his wife Linda have been making the bouquets for Queen Infanta and her court since he opened the shop on Asbury Avenue in 1972. (Courtesy of Jane and Don Charles.)

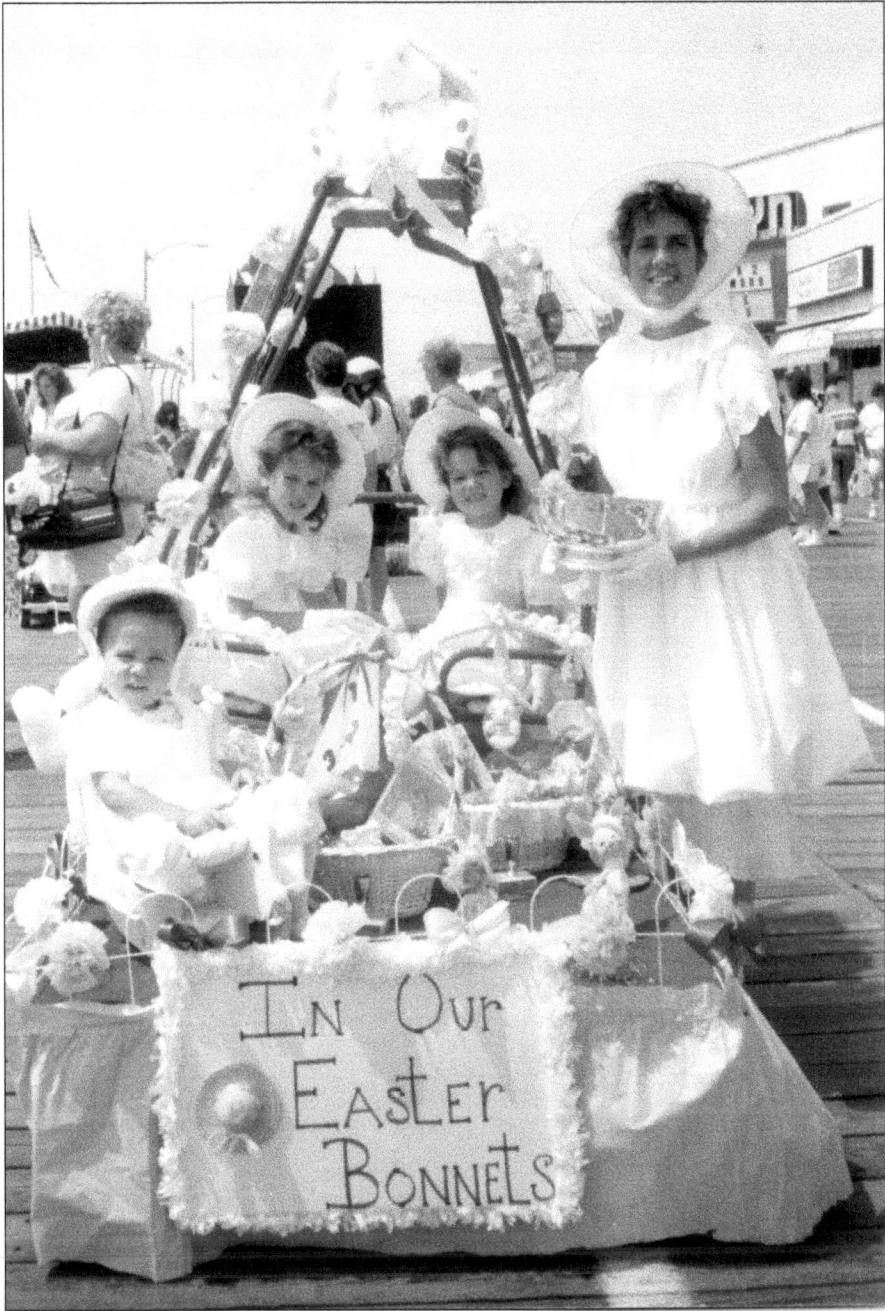

From left to right, Jena, Jamie, T. J., and their mother, Paula White, are "In Our Easter Bonnets" during the August 8, 1991, baby parade. The Whites, from Lansdowne, Pennsylvania, won the Hanscom Award, named for Evelyn and Russell Hanscom, longtime parade directors. The White family has won the Hanscom or another award at the baby parade a record 15 times. Their entries have included "Sweet as Cotton Candy" in the 1986 parade, the Hanscom Award winner; "Ocean City's Carousel Girls," which took first place in their division in 1987; and "Surrey with the Fringe on Top," which took first place in their division in 1990. (Courtesy of Helen Kelly and Paula White.)

Sally Starr, one of Philadelphia's first children's television personalities and much beloved by two generations of youngsters, was the grand marshal of the August 12, 1993, baby parade. Here Starr (second from left) stands with Toby Soifer, "Little Trash Buster" John Brian Burkhart, and Ocean City publicist Mark Soifer in his persona as the "Canned Crusader." Soifer created the Canned Crusader as the city's environmental symbol. He wears his costume when he goes to schools to talk about the importance of recycling. Trash Buster has its own theme song, "Stand by Your Can." (Courtesy of Mark Soifer.)

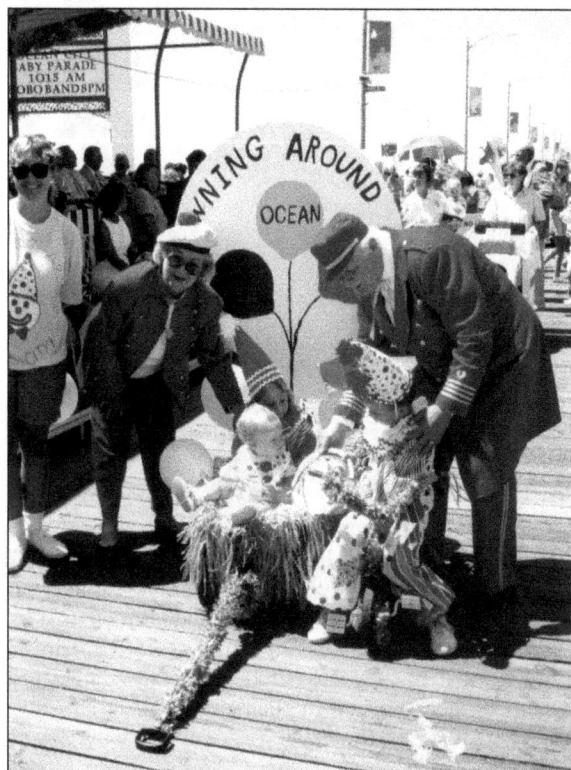

W. Carter Merbrieier and his wife Patricia, dressed as Captain Noah and Mrs. Noah, longtime children's television favorites and Ocean City residents, were grand marshals of the August 10, 1995, baby parade. For 27 years, *Captain Noah and His Magical Ark* was a children's television staple. (Courtesy of Mark Soifer.)

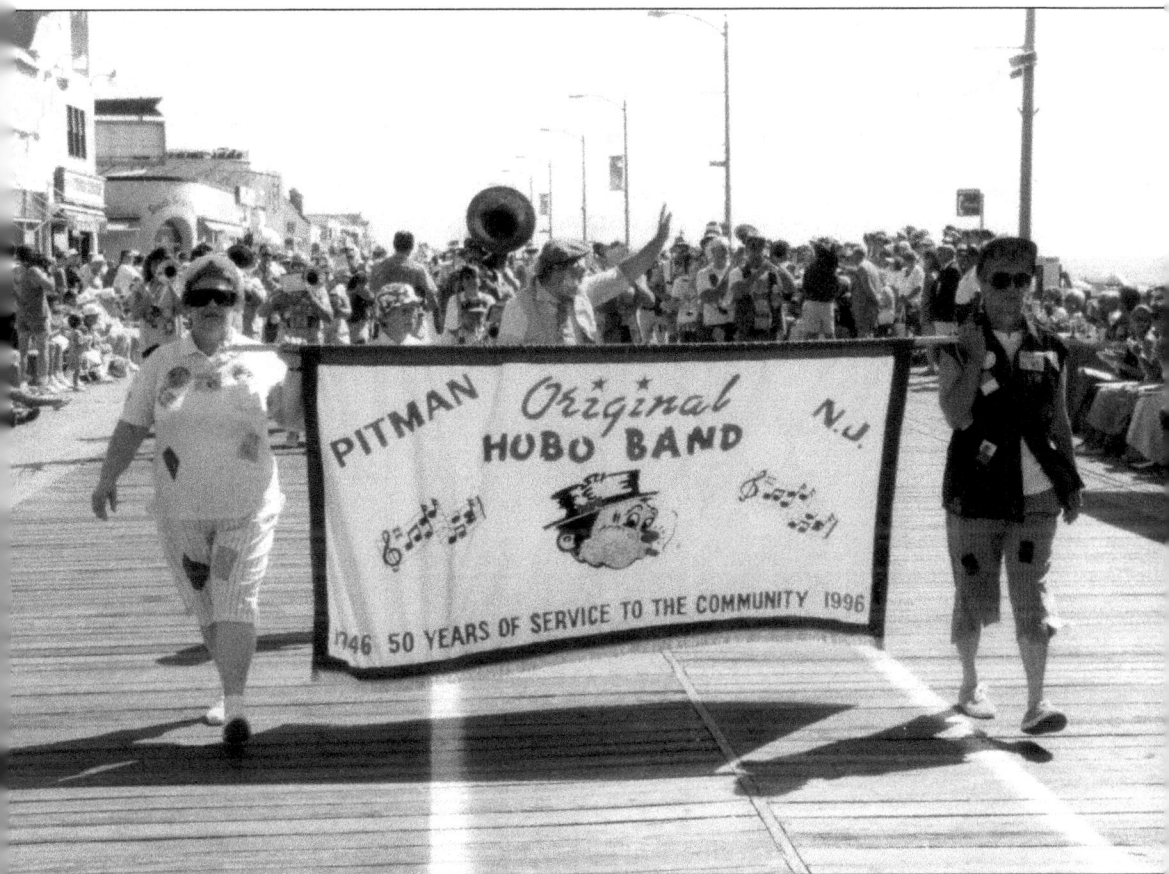

The Original Hobo Band of Pitman celebrates "50 years of service to the community," as members march down the boardwalk during the August 8, 1996, baby parade. The band, with both women and men marching, had been in the parade for several years by the time this picture was taken. The band also participates in other Ocean City parades. Nine other bands, including the Mummertime String Band, Drs. of Rhythm Dixieland Band, the Interboro High School band, and Echoes of Liberty Fife and Drum Corps also played for the crowd. (Courtesy of Don Kravitz.)

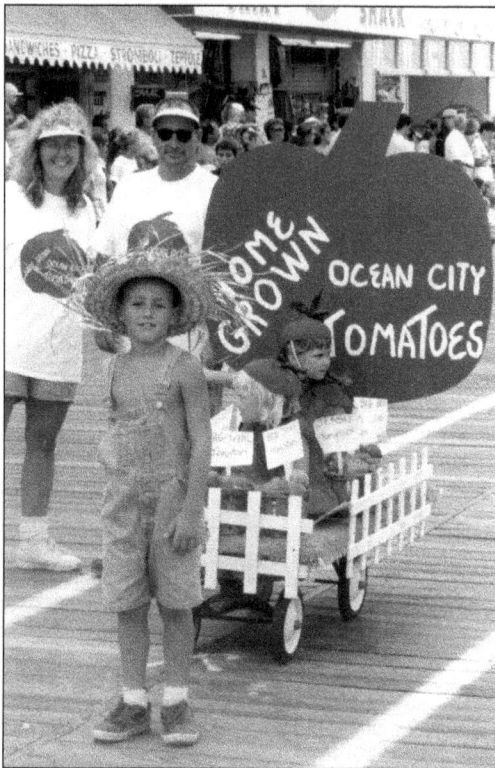

Patrick Lavin and his sisters Hannah (left) and Molly are "Home Grown Ocean City Tomatoes." Their mother, Kathy Lavin, and father, Pat Lavin, accompany them down the boardwalk. The Lavins placed third in their division in the August 14, 1997, baby parade. (Courtesy of Don Kravitz.)

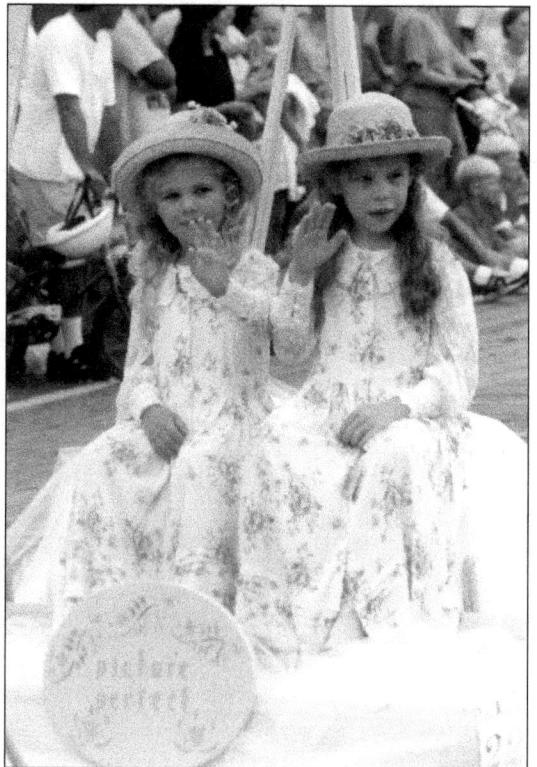

Rachel Hanscom (left) and her sister Courtney are "Picture Perfect." They won first place in the fancy dress division of the August 14, 1997, baby parade. The girls are the daughters of Cynthia and Russell Hanscom and grandchildren of the late Evelyn and Russell Hanscom, longtime directors of the parade. Popular television personality Don Tollefson was the grand marshal. About 300 youngsters up to age 10 participated in the parade. (Courtesy of Don Kravitz.)

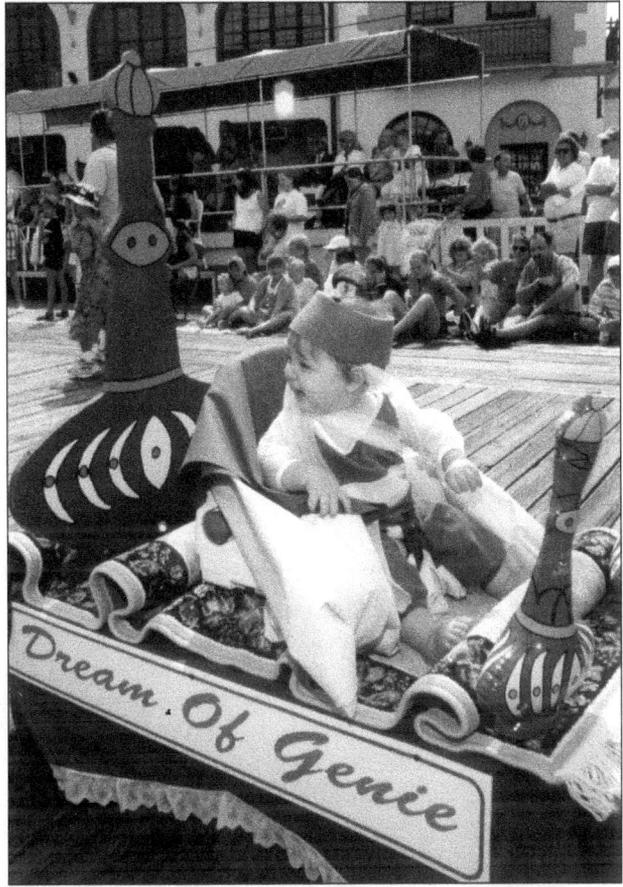

Little Eugenia Santarpio of Philadelphia is having a grand time being in the August 13, 1998, baby parade. She took home a second-place award for "I Dream of Genie." (Courtesy of Don Kravitz.)

Grand marshal William J. Hughes, a former congressman and ambassador to Panama, joins lifeguards, from left to right, J. P. Berenato, Pete Downham, Chris Denn, Ray Clark, and Bill Long before the August 12, 1999, baby parade. (Courtesy of Ocean City Lifesaving Museum.)

The Oves twins, Dustin and John, of Ocean City, "Future Ocean City Beach Patrol Rowing Champions," are in the August 12, 1999, baby parade. Their grandfather and uncles were Ocean City Beach Patrol rowing champions. Every year several pairs of twins are entered in the parade, and there is an award just for them. That year, the Oves boys won the most outstanding twins award. Mack and Manco Pizza on the boardwalk donated the trophies for the parade winners.

Dads John Ridgway (left) and Brian Propp pull their children, from left to right, Paige Propp, Jackson Propp, and Brooke Ridgway, down the boardwalk during the August 12, 1999, baby parade. They were "Headed to Ocean City, a Hermit Crab's Favorite Family Resort." They won first place in the small float division. (Courtesy of Don Kravitz.)

Radio personality and writer Chuck Betson and Atlantic City Surf baseball team mascot, Splash, are honored guests in the August 9, 2001, baby parade. Honored guests are a tradition in the parade. (Courtesy of Don Kravitz.)

Lily Rene Hogan won first prize in Division A, fancy decorated go-carts, strollers, coaches, kiddie cars, and express wagons, during the August 8, 2002, baby parade for "Lily's Diner." Hogan's mother and grandparents were also in costume and added to the theme of her float. The judges prefer to see that anyone accompanying the child also is in costume. (Courtesy of Dave Nahan.)

Grand marshal of the August 14, 2003, baby parade was Angie Pileggi, who was retiring from her position as city clerk after 32 years. Her husband, Don Pileggi, who was Ocean City's director of recreation for over 30 years, accompanies her.

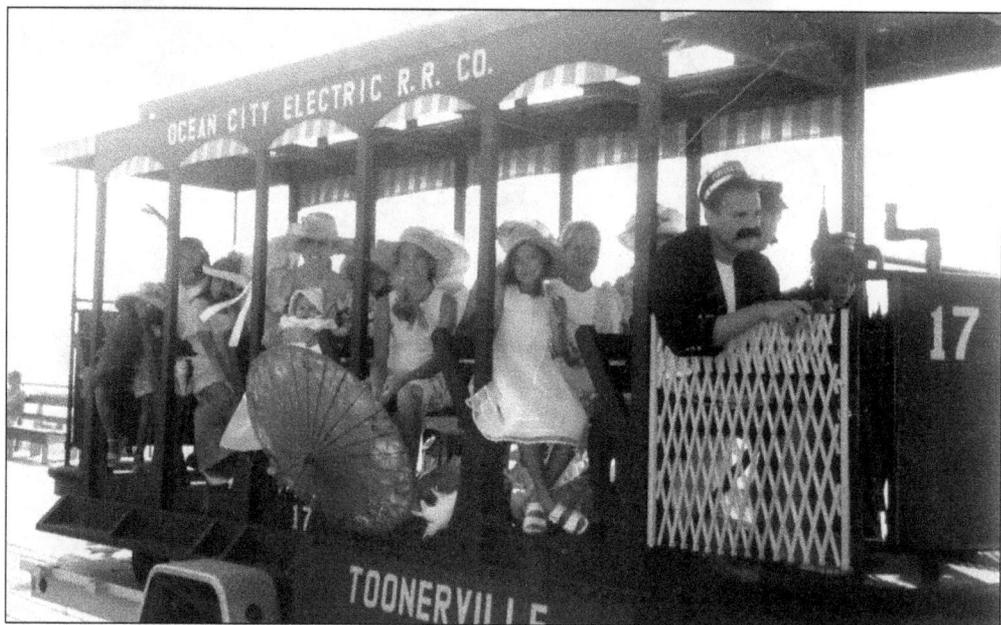

Donna and Bill Dorney built the "Ocean City Electric R. R. Co. Toonerville Trolley" to help celebrate Ocean City's 125th anniversary in 2004. They used it in the Night in Venice parade and for the August 12, 2004, baby parade. The trolley ran in Ocean City between 1893 and 1929. The Dorneys filled it with babies, children, and adults, all dressed in period costumes. (Courtesy of Rosemarie Vetter.)

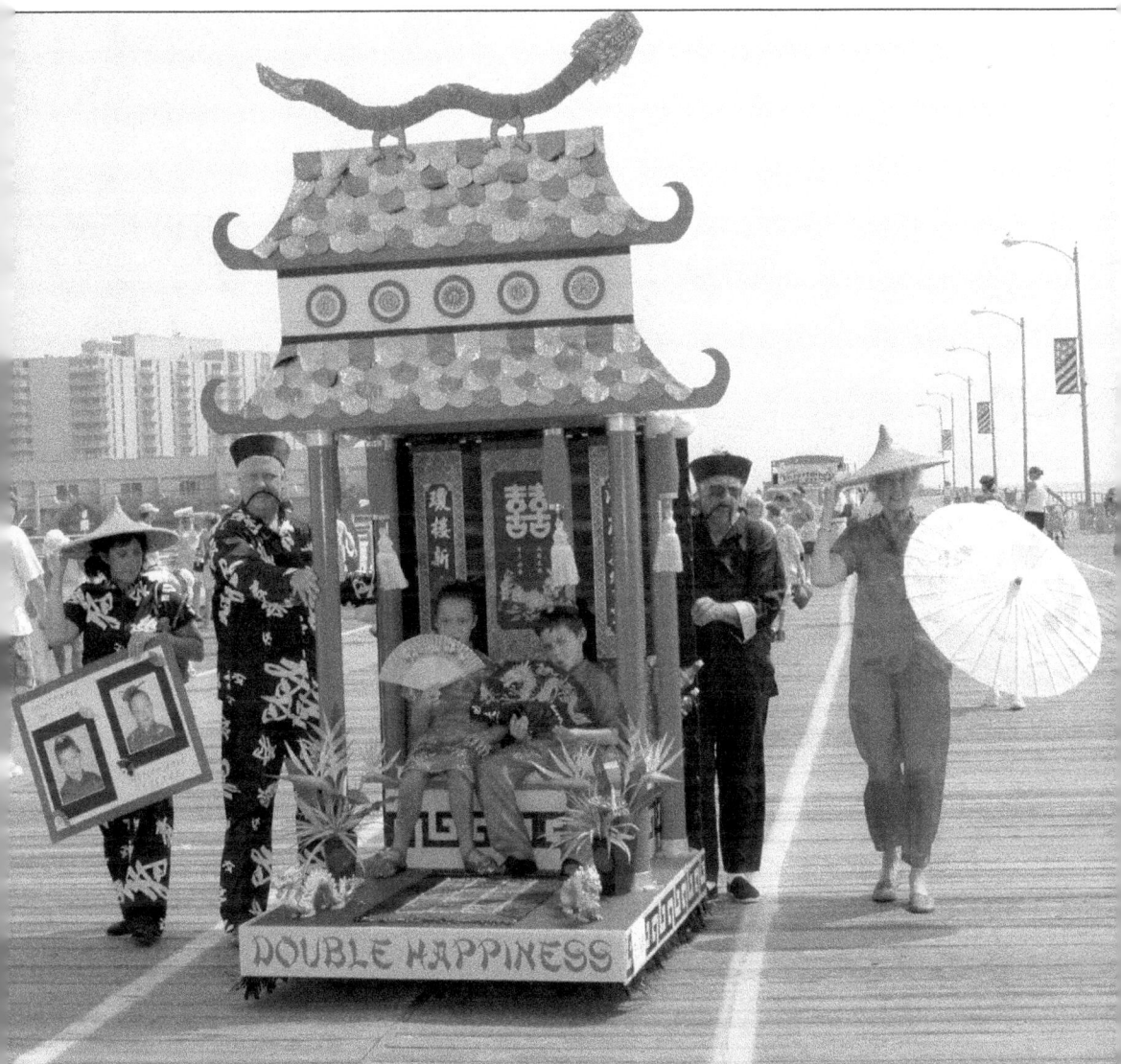

"Double Happiness" is the title of the Green family float in the August 11, 2005, baby parade. This float features twins Jordan (left) and Noah Green, who were named outstanding twins in the parade. The family float won an award each of the prior nine years. The Green family lives in West Springfield, Massachusetts. They plan their summer vacation so it coincides with the baby parade. (Photograph by Kristen Riley, courtesy of Dave Nahan.)

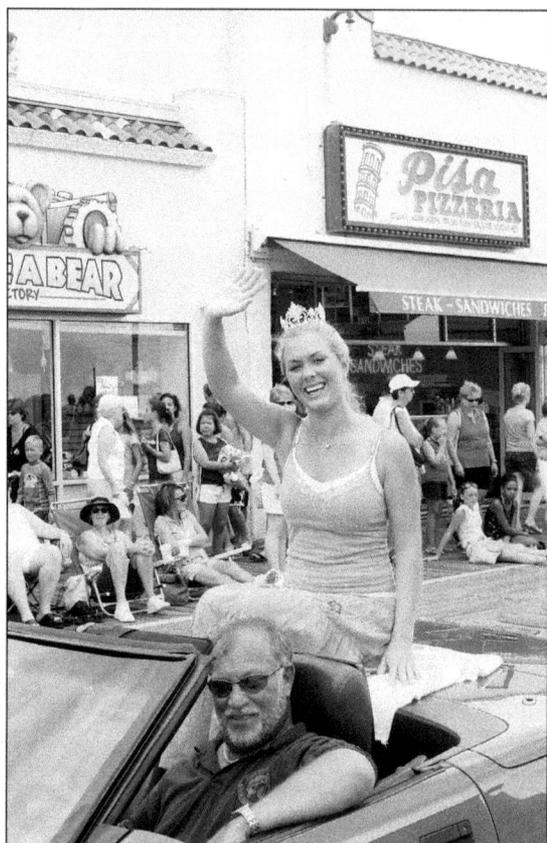

Stu Sirott drives Miss Ocean City Aubre Naughton in his red Corvette during the August 11, 2006, baby parade. Ocean City and the surrounding communities have several contests for young women and girls, many of whom participate in Ocean City's parade, usually riding down the boardwalk in a convertible. (Courtesy of Don Kravitz.)

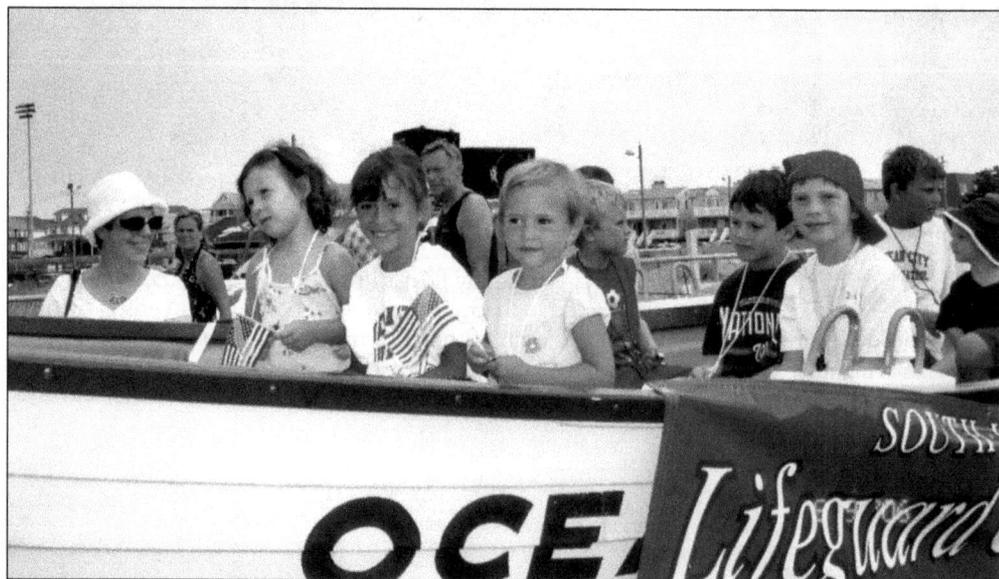

From left to right, Natalie Leventhal, Jenny Currens, Nicole Currens, Bradley Leventhal, and Davey Leventhal wait for the parade to start. They are riding in the Ocean City Beach Patrol boat during the August 11, 2006, baby parade. The lifeguards were celebrating their South Jersey championship win.

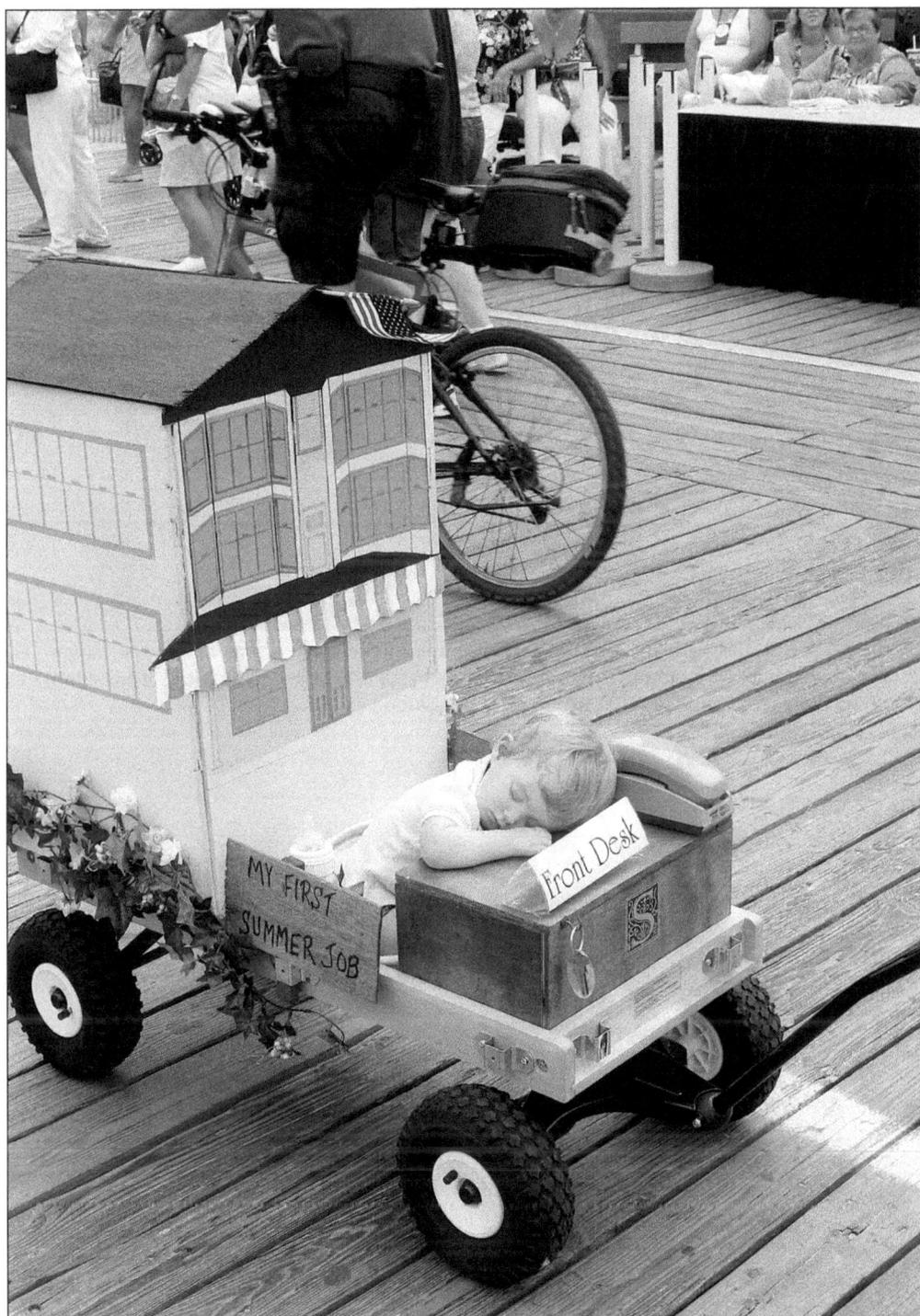

Oona Prudence Freeman was having her 11-month birthday the day of the August 11, 2006, baby parade. She fell asleep at the front desk on "My First Summer Job." The building on her backdrop is the Scarborough Inn, built in 1895 on Ocean Avenue. Her mother, Jennifer Freeman, was the manager of the Scarborough Inn. (Courtesy of Don Kravitz.)

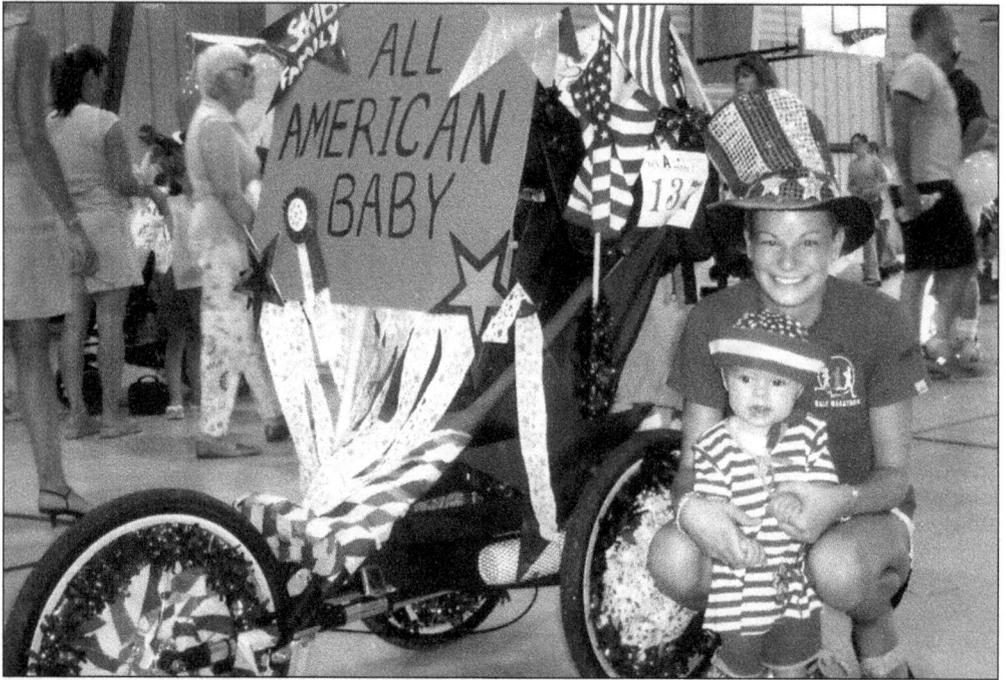

Morgan Skibo stands with her mother, Catie Skibo, in the staging area before the August 11, 2006, baby parade. Morgan, an "All American Baby" is the sixth generation of her family to enjoy summers in Ocean City. (Courtesy of Leslie Skibo.)

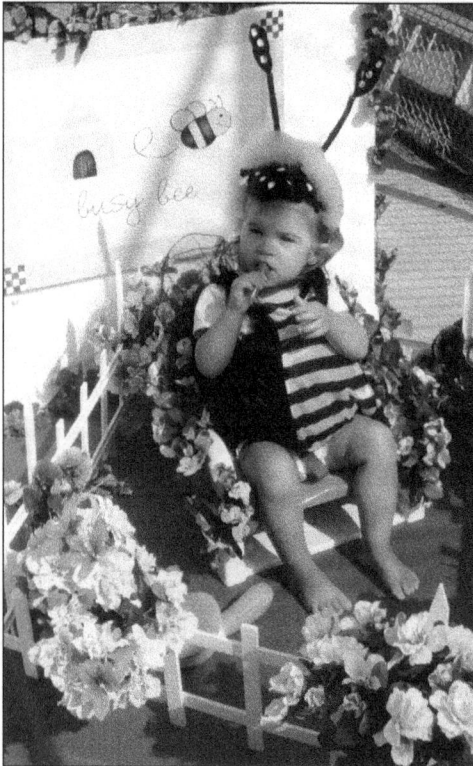

Alexis Allegretto is a "Busy Bee" as she rides down the boardwalk in her flower garden during the August 9, 2007, baby parade. As a fourth-generation Ocean City child, she follows her family into the parade. Her father and grandmother were in the parade as children, as were an aunt, a great-uncle, and cousins. (Courtesy of Joan Shaw.)

Johnson's Popcorn, now with three locations on the boardwalk, has been an Ocean City tradition since 1940. Riley Patricia Taylor received honorable mention in the small floats division of the August 14, 2008, baby parade for her entry, "An Original Johnson's Popcorn Baby." Roy Gillian's Wonderland Pier sponsored the trophies for the winners in the 2008 parade. (Photograph by Kristen Riley, courtesy of Dave Nahan.)

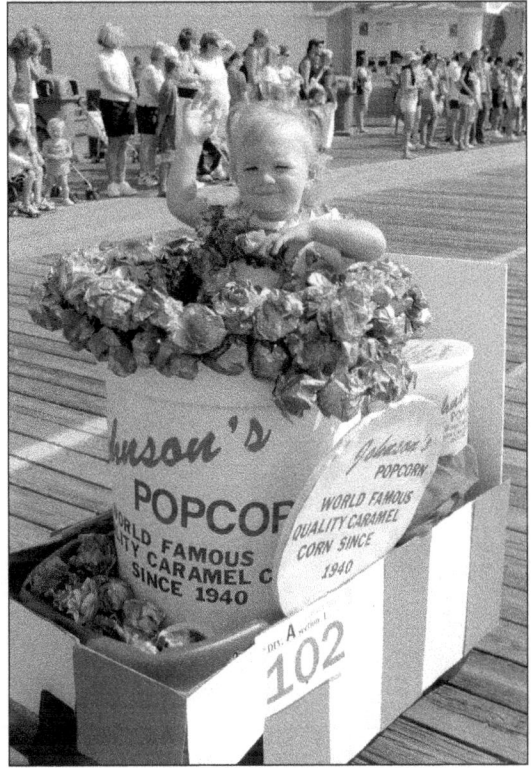

Ocean City's beach tag for 2009 will commemorate the 100th baby parade. Ocean City publicist Mark Soifer is inviting anyone who has ever been in the parade to come and participate. The Ocean City Historical Museum will be having an exhibit of pictures, trophies, and other parade memorabilia during the summer. The parade is scheduled for Thursday, August 13, at 10:15 in the morning.

Visit us at
arcadiapublishing.com

······································